AN ARTIST'S VISION

Josephine Crawford

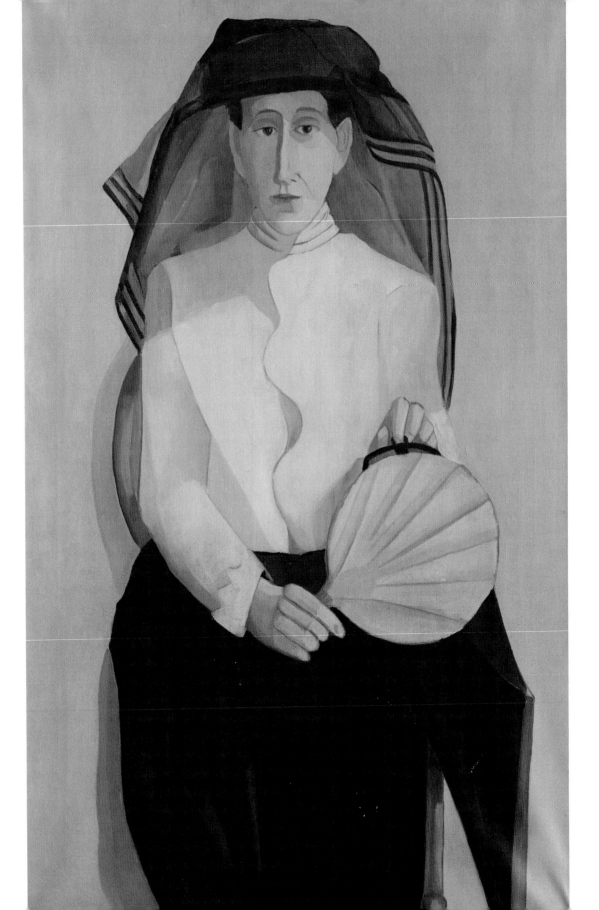

AN ARTIST'S VISION

Josephine Crawford

BY

LOUISE C. HOFFMAN

For Kelly and Matt,
Wonderful friends!
With love,
Lou April 2009

PUBLISHED BY

THE HISTORIC NEW ORLEANS COLLECTION
2009

The Historic New Orleans Collection is a museum, research center, and publisher dedicated to the study and preservation of the history and culture of New Orleans and the Gulf South region. The Collection is operated by the Kemper and Leila Williams Foundation, a Louisiana nonprofit corporation.

Library of Congress Cataloging-in-Publication Data

Hoffman, Louise C.
 Josephine Crawford : an artist's vision / by Louise C. Hoffman. — 1st ed.
 p. cm.
 Includes bibliographical references and index.
 ISBN 978-0-917860-53-9 (alk. paper)
 1. Crawford, Josephine Marien, 1878-1952. 2. Painters—Louisiana—New Orleans–Biography. I. Crawford, Josephine Marien, 1878-1952. II. Title.
 ND237.C8149H64 2009
 759.13—dc22

 2008039905

© 2009 The Historic New Orleans Collection
533 Royal Street
New Orleans, Louisiana 70130
www.hnoc.org

First edition. 2,000 copies
All rights reserved
Printed by Imago USA

Priscilla Lawrence, *Executive Director*
Mary Mees Garsaud, *Editor*
Jessica Dorman, *Director of Publications*
Keely Merritt, *Photographer*
Jan White Brantley, *Head of Photography*

Book design and production by Michael Ledet Art & Design, Hammond, Louisiana
Print production management by Kaye Alexander, Westford, Vermont
Typography by Eugenie Seidenberg Delaney, North Ferrisburgh, Vermont
Printed in Singapore

JACKET ILLUSTRATION, FRONT COVER: *Young Woman Wearing White Gloves*, between 1928 and 1935, oil on canvas, 28⅛ x 18¹⁄₁₆"; The Historic New Orleans Collection (1978.23.4), bequest of Charles C. Crawford

FACING TITLE PAGE: *Rue Kerlerec*, 1934, oil on canvas, 38½ x 24"; courtesy of Micheline M. Bator; photograph by Michael Gould

END PAPERS: *Girl Under Mosquito Net*, between 1930 and 1940, oil on canvas, 34 x 44"; courtesy of Louise Chapman Hoffman

CONTENTS

Foreword
by Priscilla Lawrence vii

Acknowledgments ix

Prologue xiii

CHAPTER 1 Paris 1

CHAPTER 2 Beginnings 17

CHAPTER 3 Josephine at the Arts and Crafts Club 39

CHAPTER 4 Art at Home and Away 73

CHAPTER 5 From Royal Street to East Beach 85

CHAPTER 6 Considering Josephine 99

CHAPTER 7 An Artist's Vision 133

Selected Bibliography 147

Index 153

In memory of Helen Hardie d'Heur and Jack Bartlett Kelleher

Foreword

O
NE OF MY FIRST ASSIGNMENTS at The Historic New Orleans Collection nearly thirty years ago was to examine the entire collection of Josephine Crawford paintings and drawings with art historian, critic, and dealer George Jordan. The Collection had engaged Mr. Jordan to appraise the collection, item by item. As we looked carefully at each of the 389 works of art (some of them sketchbooks), it was impossible not to be fascinated. George's knowledge of Miss Crawford's life and times created a learning experience for me that I will never forget and for which I will always be grateful. Recording his comments on a worksheet for every piece created an invaluable record for posterity.

Although Josephine Crawford had studied both in New Orleans and abroad and was known to have been influenced by Braque and Picasso, her work is distinctly different from that of any specific movement. She simplified her subjects in a way resembling Cubism, but objects depicted are less geometrically dimensional and retain much more of their inherent naturalistic form. When compared to the Louisiana landscapes, French Quarter courtyard scenes, and still life paintings of local contemporaries, Josephine Crawford's work is not only "modern" but radically modern. Light and delicate with very little bright or heavy color, her style is unique and non-derivative.

Lou Hoffman's biography gives us a glimpse of the personality of the enigmatic woman responsible for this art. The lyricality of Josephine's poetry is reflected in the nimble lines and simple colors of her paintings as well as in Lou's prose. Lou's good fortune, as a little girl, of having walked and talked with the artist brings an added dimension to the project. Having served as our *Quarterly* editor for many years and as publications director, Lou Hoffman is a fitting biographer and we are grateful to her for accepting the project.

It is with pleasure that The Historic New Orleans Collection commemorates the generous 1978 bequest of Charles C. Crawford, Josephine's brother, of so many of her works of art. We are proud to present this book, the third in the Louisiana Artist Biography Series, to celebrate the life and work of Josephine Crawford. And we thank the Laussat Society, whose membership funds have made this publication possible.

—*Priscilla Lawrence*
Executive Director
The Historic New Orleans Collection

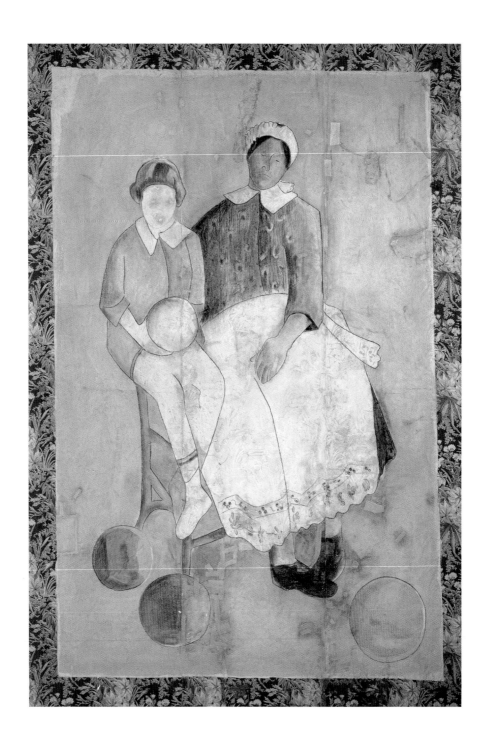

Acknowledgments

ONE JANUARY, ALMOST TEN YEARS AGO, Patricia Brady and I were reviewing the publications budget before sending it to Priscilla Lawrence, director of The Historic New Orleans Collection. One of the categories we submitted was a proposal to begin a series of artist biographies focusing on artists whose works—or papers—constitute significant holdings within The Collection. George Louis Viavant was to be the subject of the first biography. We also included Josephine Crawford. "Who will write the Crawford biography?" I asked Pat. "You," she replied. "Oh," I must have said, pleased but wary at the same time. A nice vote of confidence, I thought, but I wondered if it would ever get done—the list of other publications in line before the Crawford was a long one. But when I retired from The Collection, the biography was very much on my mind. And so a debt of gratitude to Pat, former director of publications, and, of course, much appreciation to my former colleague Lynn Adams, whose expertise with the fine points tucked away in *The Chicago Manual of Style* is inspiring.

Priscilla Lawrence always believed in the Josephine project, which we discussed over many good lunches. I appreciate her support more than I can say. And to ask John Lawrence, director of museum programs, for assistance is to consider it done.

Mary Mees Garsaud has been nothing short of heroic in her role as editor, fact checker, and organizer of illustrations, corresponding with lenders both near and far (France). I am forever grateful for her many skills and for her unfailing good humor. The support of Jessica Dorman, director of publications, has been invaluable. Along with her excellent suggestions and judicious editing, she proclaimed, after reading the manuscript, "I love Josephine!" Mary and Jessica made the journey from first draft to completed book an enjoyable one—and never dull.

LEFT: Charles Henderson with His Nurse, Francis Gains, *between January 27 and December 31, 1934; pastel, charcoal, and wash over white and gray grounds on patterned wallpaper, 83⅛ x 57⅞"; The Historic New Orleans Collection (1978.23.63), bequest of Charles C. Crawford*

Acknowledgments

I can't imagine completing the Crawford biography without Michael Ledet, book designer par excellence. He brings to this project the same talent that distinguishes all of his work. An artist himself, he is particularly suited to design *Josephine Crawford: An Artist's Vision*.

The Collection's photography department, true to form, reproduced flawless images for the book in record time, thanks to the expertise of photographers Keely Merritt, Teresa Kirkland, and Melissa Carrier, who followed the high standard set by photographer Jan White Brantley.

Days spent at the Williams Research Center reading the Crawford Papers have impressed me once again with the professionalism and good will of Sally Stassi, John Magill, Pamela Arceneaux, Mary Lou Eichhorn, Siva Blake, and Daniel Hammer. John Magill, who has the history of New Orleans in his pocket, easily brought forth just the right maps I needed to locate certain addresses related to Josephine Crawford's life. I relied upon the scholarship of Judith Bonner, senior curator at The Historic New Orleans Collection and authority on the Arts and Crafts Club. She cheered me on and graciously agreed to read my manuscript. I am grateful also for the assistance of Alfred Lemmon, director of the Williams Research Center. Alan Williams, Mark Cave, and Goldie Lanaux provided me with information that proved extremely helpful. Warren Woods, collections manager, and Anna Hilderbrandt, registration assistant, handled the Crawford works on loan with efficiency and great care, ably assisted by preparators Terry Weldon, Scott Ratterree, Douglas Stallmer, and Tony Rodgers.

I often wondered if the staff of Tulane University's Special Collections thought I had taken up residence in their reading room. Always patient and helpful were Wilbur E. Meneray, Kenneth Owen, and Leon Cahill Miller. Greg Osborn at the New Orleans Public Library's Special Collections grew quite accustomed to the sound of my voice over the telephone. He never failed to find the information I needed.

I am indebted to those who have written about Josephine Crawford: Judith Bonner, Mariea Caudill Dennison, Catharine "Kitty" Farley, and George Jordan. It is with gratitude that I acknowledge Kitty Farley's very fine work, "The Life and Art of Josephine Marien Crawford, 1878–1952." And George Jordan, whose knowledge of Louisiana art is exemplary, inspired me to begin the story of "Miss Josie."

I remember a November afternoon shortly after Hurricane Katrina when Newcomb College professor emerita Jessie Poesch and I discussed the proposed biography over tea. Her suggestions pointed me in the right direction. John Clemmer and I took tea together as well. Mr. Clemmer, who has long been a part of the New Orleans art world, shared with me his memories of Josephine.

Kay Eshleman Rapier, an essential part of the Crawford biography, explained the relationships among the Westfeldts, Eshlemans, and Crawfords. Kay's aunt, Mrs. William H. Fitzpatrick—"Coo"—and Kay's sisters, Sidney Eshleman Thornton and Martha Eshleman, were welcoming and helpful as well. I was delighted to talk to Charles Henderson, Josephine's nephew, and with Leigh Henderson Burton, Josephine's great-niece. I deeply appreciate Virginia McIlhenny's interest in the biography as well as her contribution of photographs to include in the book.

Carol Butcher at Christ Church Cathedral and Sandy Courvoisier, Trinity Episcopal Church, assisted with marriage and baptismal records. Susan Tucker at the Newcomb College Center for Research on Women located

Josephine's student records. Conversations with Robbie Cangelosi, Jane Fox, Henry Krotzer, Andrew Labrot, Rose Monroe, Sally Reeves, and Mary Irene and Guy Scoggin expanded my knowledge of Josephine Crawford's world. For help with French, I relied upon Colette Hood Stelly and Elizabeth Poe. Erin Greenwald, exhibitions editor at The Historic New Orleans Collection, very kindly translated messages going back and forth from the publications department to André Lhote's niece in France, Mme Dominique Bermann Martin. William de Marigny Hyland, Fernando J. Estopinal III, and Patricia L. Duncan very helpfully responded to my questions about St. Bernard Parish. John Bullard, director of the New Orleans Museum of Art, had just the information I was looking for on the tip of his tongue. The Speed Museum in Louisville, Kentucky, the Morris Museum of Art in Augusta, Georgia, and the Greenville County Museum of Art in South Carolina promptly answered my requests for information. Complicated property transactions did not prevent title researcher Judy Bethea from unearthing important dates related to the Crawfords' Biloxi property.

My sincere thanks go to those individuals and institutions who loaned Crawford works for inclusion in the book: Catherine and Hunter Babin, Micheline M. Bator, Jean Bragg, Penny Brown, Jackeen Kelleher Churchill, Stephanie and Robin Durant, Martha Eshleman, George Jordan and Michel Delhaise, Monroe Kelly, Allison McAshan, Virginia McIlhenny, the Morris Museum of Art, Alice Nelson, the New Orleans Museum of Art, Kay Eshleman Rapier, Anne Strachan, Sidney Eshleman Thornton, and Deborah and Eli Tullis.

I am grateful for the encouragement of John E. Walker, past president of the Kemper and Leila Williams Foundation board, to Mary Louise Christovich, chairman of the board, to Charles Snyder, president, and board members Drew Jardine, John Kallenborn, Hunter Pierson Jr., Fred M. Smith, and Alexandra Stafford. Josephine Crawford's life coincided with the emergence of the Arts and Crafts Club and the resurgence of the French Quarter—a time of great promise and commitment to art. It is an honor to write about Josephine and to recreate some of the scenes from that exhilarating era, a high point in the cultural history of New Orleans.

I extend my gratitude to the staff of the publications department at The Historic New Orleans Collection, past and present, who can deftly make their way through thickets of hyphens, em-dashes, small caps, large caps, single quotation marks, and ellipses (not to mention prepositions).

The support of my sister, Catherine Chapman Babin, was essential.

And to Don, Donald, Richard Rainey, and Katharine, thank you, as always. You heard about Josephine Crawford for a very long time.

—Louise C. Hoffman

EDITORIAL METHOD

THE TRANSCRIPTIONS of Josephine Crawford's poems and journal entries and the family's letters are literal, with a few exceptions. Obvious mistakes in spelling have been corrected for ease of reading.

André Lhote's last name is also commonly spelled L'hote. The author has chosen Lhote as the preferred spelling for this book.

Prologue

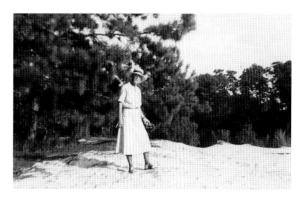

Josephine Crawford at The Mound (behind Biloxi's Back Bay) *by Louise Hoffman, 1948; courtesy of Louise Chapman Hoffman*

What happens every day, virtually every moment, can be an amazement still that I have to put down in writing.
—ALFRED KAZIN
The Past Breaks Out

My photograph of Josephine Crawford shows a woman in her sixties, maybe seventy, wearing an American Golfer dress and sensible English walking shoes. Her elbow is cocked on her hip, her straw hat partially shading her eyes as she squints into the sun. She is at The Mound, her property near Biloxi, Mississippi, where she grows wildflowers. She is an artist and so possesses special powers. I am the eight-year-old holding the Brownie camera.

TO TELL MY STORY OF JOSEPHINE CRAWFORD I must begin with summer trips to visit Kitsie, my great-aunt, in New Orleans and my grandmother Louise in Biloxi. I think back to that long-ago time when our land seemed less fragile and our waters more benign, when Josephine Crawford painted images from her Creole world and flowers from her garden.

Summertime. Mother and I boarded the Southern in Raleigh, North Carolina, bound for New Orleans. "The Southern Serves the South," stenciled in white across the cars, could hardly be read as the train sped through small towns and endless countryside. We rumbled down through the Carolinas, on through Georgia, past Mobile, until finally after a night and a day we started to cross Lake Pontchartrain on a railroad bridge stretching almost out of sight across an immensity of water.

After weeks in New Orleans with Kitsie, we again boarded a train, this one called the Hummingbird,[1] for the Gulf Coast to stay with my grandmother in Biloxi at 1200 East Howard Avenue. Originally a one-story gardener's cottage situated at the back of the Crawford property that fronted on the beach, the house had

1 The Louisville and Nashville Railroad's Hummingbird train ran from New Orleans to Mobile.

assumed another identity when Josephine Crawford's older sister, Louise Crawford—"Miss Tweety"—enlarged it to include a second story. My Louise—grandmother Louise Hardie—lived in the upstairs apartment. From the windows I could look out to the tops of live oaks and to the "garden," almost a park, it seemed to me. Modest bungalows and fishermen's cottages, with nets drying in the front yards, filled out the neighborhood.

Biloxi! The name called up a rich past and a present defined by the scent of water, the sinuous limbs of live oaks, the driveway bordered by dark-green aspidistra leaves, and the view toward Deer Island in the Mississippi Sound. North Carolina was far away. I slept in a bed called a *lit de repos* and put my clothes in an armoire. Porches and galleries shaded us while a *courrant d'air* from windows on each side of the house assumed the importance of a lifeline. The grownups always talked about a *courrant d'air*.

Miss Josephine Crawford became my friend during those long Biloxi summers, a friend who seemed ageless to my child's eye, someone who knew the names of all the flowers, someone who sent me a tiny, preserved seahorse wrapped in cotton when I had returned to North Carolina after the summer.

I remember her cottage on the East Beach road that adjoined the property of her sister, Jeanne Crawford Henderson, who also spent summers on the Coast. Jeanne Henderson would often invite us to visit in the late afternoon, and I suppose it was then that Miss Josie sought me out. I would half listen to adult conversation, concentrating instead on the painting of an enormous red poppy above the mantel, which I later discovered was the work of Georgia O'Keeffe. I ate cherry tomatoes and was very good, but after a time Miss Josie would suggest that we go outside to sit in the "tree house," a beautiful white-latticed structure with steps that led up to a circular seat built around the trunk of a huge live-oak tree.

Soon we were friends. Josie showed me a bog of pitcher plants and swamp mallows. We found coreopsis and French mulberry. She taught me to see with a seeing eye, an artist's eye that delighted in the shape of leaves, the texture of petals. We delved into scrapbook making—collecting and pressing wildflowers, naming them, and adding Latin names spelled out for me by Josie.

When Jeanne Henderson invited us for Sunday midday dinner, the cook served us bowls of velvety gumbo, redolent with spices and fresh crabmeat, a marvelous treat for everyone but me. I, of course, would eat the gumbo and think about an escape to the garden, or better yet, a chance to see Josie's collection of miniature boxes. But dinner stretched on into the afternoon until finally I could follow the brick walk that separated the dining room from the main house, continue past the red poppy painting, and rush into the garden. If Josie had escaped as well, we would look together toward the beach fringed with gray piers and down the road to the white mass of the Biloxi lighthouse punctuating the shore.

This friend who introduced me to wonderful curiosities was herself an artist. The story of her pursuit of art calls up a time of great creative energy in New Orleans and in Paris's Montparnasse, a time when the slow pace of life in Biloxi would encourage an artistic retreat. Josephine Crawford had the good fortune to live in these places when there was a convergence of talent and opportunity, a certain magic in the air of the French Quarter in the 1920s and '30s, in Montparnasse, and in Biloxi between the wars.

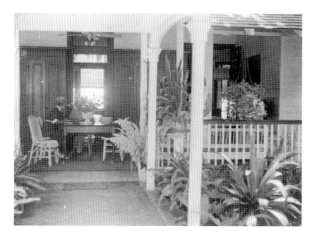

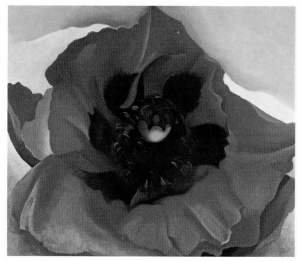

TOP: Porch at 829 East Beach in Biloxi (home of Jeanne and Hunt Henderson); *courtesy of Louise Chapman Hoffman. One of the Crawford sisters is pictured at the table.*

BOTTOM: Poppy *by Georgia O'Keeffe, 1927, oil on canvas, 30 x 36"; courtesy of the Museum of Fine Arts in St. Petersburg, Florida, gift of Charles C. and Margaret Stevenson Henderson in memory of Jeanne Crawford Henderson (71.32)*

Years after his sister's death in 1952, Charles Crawford invited my husband and me to see his large collection of Josephine's paintings. By this time, the mid-1960s, air conditioning had liberated many New Orleans houses from the thick heat of summer, but the Crawford house on First Street, in true Creole fashion, was not among the liberated. Mr. Crawford met us at the front door, attired in a white linen suit, the old uniform for a gentleman in the city in July. After a cocktail, our host led us to the attic, heat rising as we climbed to the third floor of the high-ceilinged old house, to view the enormous collection of his sister's work. No *courrant d'air* penetrated those thick walls. We saw rows of canvases and drawings and boxes of sketches and art materials that Charles Crawford had the foresight to gather and keep intact. I now remember that hot July afternoon as a privileged moment, one to look back upon and savor. Mr. Crawford later bequeathed Josephine's artwork to The Historic New Orleans Collection, a holding of almost 500 items, along with the wallpaper paintings removed from the walls of the family house at 612 Royal Street. The collection, now housed at the Williams Research Center, also includes Josephine's sketchbooks, personal papers, and poetry.

What follows is an evocation of Josephine Crawford, a chance to renew acquaintances, or perhaps to meet her for the first time. She was a fine companion. Somehow she knew that poems about a lamb and a tiger would please an eight-year-old—these to be found in William Blake's *Tales of Innocence and Experience*, her gift to me, still among my books. She knew many things. Most of all she knew how to paint.

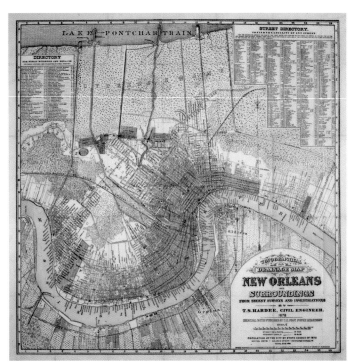

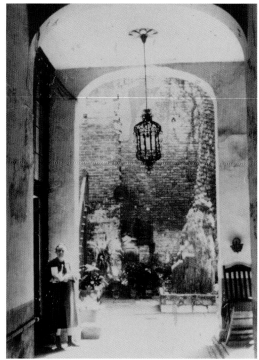

TOP LEFT: Topographical and Drainage Map of New Orleans and Surroundings *by Thomas S. Hardee (printed by Lewis Graham), 1878; The Historic New Orleans Collection (00.34a,b)*

TOP RIGHT: Carriageway and Courtyard at 612 Royal Street, *ca. 1940; courtesy of Louise Chapman Hoffman. Pictured is Bessie Colomb, a family friend who rented one of the apartments at 612 Royal Street from the Crawfords.*

BOTTOM: Looking Down St. Peter Street from Royal Street Toward the River *by John N. Teunisson (published by F. F. Hansell and Brother, Limited), between 1900 and 1908; The Historic New Orleans Collection (2001.51.2)*

Paris

*It is no use trying to be an impressionist—
that was a phase that has passed.*
 —ANDRÉ LHOTE

1878. ON THE LAST DAY OF THE YEAR, Louise Bienvenu Crawford and Charles Campbell Crawford celebrate the birth of their daughter Josephine Marien in New Orleans.[1] This is the year that engineer Thomas S. Hardee's topographical map of New Orleans reveals a city that hugs the Mississippi River, with cypress swamps stretching toward Lake Pontchartrain. The original settlement—the French Quarter—is well placed on a riverside crescent of land. A bird's-eye perspective reveals the symmetry of the old section, the low scale of buildings, and streets running in a military grid, with Royal Street, home of the Crawfords, piercing the middle of the Quarter from Canal Street to Esplanade Avenue.

Now the vantage point changes, closing in upon slate roofs and balconies and the spire of a cathedral. A palm tree emerges from a courtyard in the 600 block of Royal Street—the court-yard of "The House of the Palm," as the Crawford place was known. Picture a young Josephine at home in the 1830s townhouse, shielded from the world by massive double doors. She listens to Great-Aunt Titine conversing in French with Uncle Octave. Through the French windows, she observes the gens du quartier, remembering names and faces that will find their way into her poems and paintings. Her large Creole family, her nurse Thérèse, a sense of place, and an eye for detail—all helped shape the artist she would become. Poetry came first, until she realized, finally, that her life's work would be in the world of art.

1 Josephine's name probably had an accent on the first "e" in the French manner. The accent was eventually omitted.

Josephine Crawford, *ca. 1910; courtesy of Mrs. Edmund McIlhenny*

Forty-eight years old, soon to be forty-nine, Josephine Marien Craw-ford sailed for France in the fall of 1927 to attend the Académie Lhote in Paris's Montparnasse district. Here, André Lhote, an undisputed mas-ter, taught the principles of art (and intimidated a few students in the process). A few years before, Josephine had enrolled in the art school of the newly organized Arts and Crafts Club in New Orleans. Now, despite a late start, she had decided to study abroad. A bold move, but Josephine, raised in a French-speaking family, would be at home in the language. It was unusual perhaps to find a middle-aged woman from Louisiana in the heart of Montparnasse, venturing forth to an art academy. But Josephine's presence in Paris was no surprise to those who understood her courage and compelling desire to be an artist—qualities she would need to meet the demands of Monsieur Lhote.

Josephine was one of scores of Americans who flocked to Mont-parnasse in the 1920s to pursue art—some at the Académie Lhote, some at the Académie Fernand Léger or the Académie de la Grande Chaumière, others at the American Student School on boulevard Ras-pail. Painting academies fanned out across the district from the Académie Colarossi on rue de la Grande Chaumière to the Académie Vassilieff on the impasse du Maine.[2] American artists had long looked to France for education and inspiration (and a taste of *la vie bohème*), but the 1913 Armory Show—America's first real encounter with "modern art"—had created a new sense of urgency.[3] American photographer Man Ray arrived in Paris in the early 1920s. Sculptor Alexander Calder lived on rue Daguerre. Artist Stuart Davis had a studio on rue Vercingé-torix and a favorite café, Le Sélect.[4]

Josephine's arrival came at a particularly auspicious time. That year, 1927, had seen the publication of Eugene Jolas's avant-garde magazine *transition*, and the rescue, by Berenice Abbott, of a large number of

2 In the nineteenth century the Académie Julian was one of the few institutions to offer women artists a place where they could study the figure. The Ecole des Beaux-Arts excluded women until 1897. Gabriel P. Weisberg and Jane R. Becker, eds., *Overcoming All Obstacles: The Women of the Académie Julian*, exhibition catalogue (New York: Dahesh Museum, in association with Rutgers University Press, 1999), 127.

3 Officially titled the *International Exhibition of Modern Art*, the Armory Show ran from Feb. 17 to Mar. 15, 1913, at the Armory of the National Guard's Sixty-Ninth Infantry Regiment. Among the artists featured were Cézanne, Matisse, Duchamp, and Picabia.

4 Valérie Bougault, *Paris Montparnasse: The Heyday of Modern Art, 1910–1940* (Paris: Finest SA/Editions Pierre Terrail, 1997), 78, 155.

Eugène Atget's iconic images of Paris.[5] Antoine Bourdelle had a studio on a dead-end street, the impasse du Maine, where a young woman from New Orleans, Angela Gregory, was learning the sculptor's art. And at the Musée de l'Orangerie, workers had begun installing Claude Monet's *Nymphéas*—his oversized canvases of water lilies.[6] Much later, Maria Jolas, Eugene Jolas's widow, would say, "[T]here just seemed to have been a sort of extraordinary rendezvous in Paris at that time."[7] And in Montparnasse, above all.

Alice B. Toklas would recall that "everyone was moving to Montparnasse from various parts of Paris, it had become the center of the modern painters." And artist Marcel Duchamp remarked, with only slight hyperbole, that the whole of Greenwich Village could be found walking down boulevard du Montparnasse.[8] Unnoticed by the avant-garde, Josephine nevertheless could drink in the excitement, frequent the galleries where the best art was hung, and compare one crowded Parisian café to another. One critic hailed the opening of La Coupole on boulevard du Montparnasse the December after Josephine arrived as the outstanding event of the 1920s.[9]

Josephine at forty-eight could have been mistaken for any American in Paris—until you realized her seriousness of purpose. She had a jaunty walk, brown hair in a short bob, a good, strong nose, and lively eyes that suggested a keen sense of humor. Engaging and understated, she was attractive in the best sense of the word.

And yet it must have been daunting for her to head out the first week of November in diminished daylight to find the academy on rue d'Odessa, number 18.[10] During the winter, she recorded her impressions in a small French notebook. Under the heading "Chez Lhote," she described rue d'Odessa and the narrow lane leading from the street to the school: "A flower booth, and behind it the passage, cobbled and angled and dirty—From one of the dark windows a girl in lavender looks down on the students . . . as they turn the sharp corner to mount the academie's stairs." She captured the voice and gestures of André Lhote—admonishing, instructing—and the anxiety of the new student: "I feel very much discouraged—I am too old to learn and there is no going back to follow the dead."[11]

5 Berenice Abbott, an assistant to photographer Man Ray in the 1920s, was a great admirer of Atget's photographs. When Atget died in 1927, Abbott acquired a large number of his prints and negatives and was instrumental in publicizing the work. The Museum of Modern Art purchased Abbott's Atget collection in 1968.

6 The installation came the year following Monet's death. See *New York Times*, May 16, 2006.

7 "Then and Now: A Symposium on the Expatriate Tradition in Paris," presented at the American Center for Students and Artists (Paris, 1964). Remarks from the symposium's round table discussion were published in the *Paris Review* 33 (Winter–Spring 1965).

8 Alice B. Toklas, *What is Remembered* (New York: Holt, Rinehart and Winston, 1963), 66; Herbert R. Lottman, *Man Ray's Montparnasse* (New York: Harry N. Abrams, 2001), 19.

9 La Coupole opened Dec. 20, 1927, with great fanfare and flowing champagne. The café quickly became the place to be seen. La Coupole was known for its huge main room, high ceiling, and columns and pilasters decorated by local artists. La Coupole, or cupola, was in keeping with the architectural names of neighboring cafés Le Dôme and La Rotonde.

10 We can assume that Josephine settled in or near the Montparnasse district. She did not record her address, although she recorded almost everything else in her two notebooks.

11 Josephine Crawford Papers, MSS 248, acc. no. 78-36-L (hereafter Crawford), The Historic New Orleans Collection (hereafter THNOC), folder 158, notebook.

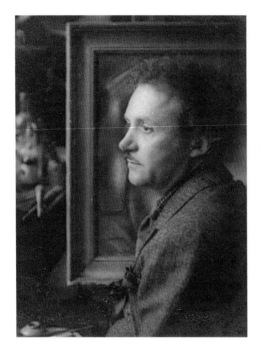

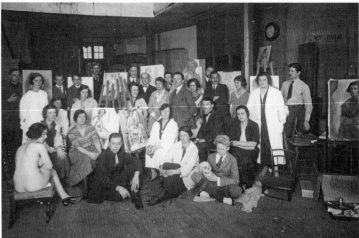

LEFT: André Lhote, *1928; courtesy of Dominique Bermann Martin*

RIGHT: Lhote with Students; *courtesy of Dominique Bermann Martin*

First impressions are lasting. On November 12, Josephine described her teacher:

> André l'Hote came hurriedly into the classroom. He called loudly to the models to be at their poses. He spoke hurriedly first to this one and then to that, asked for attention, swore at the commotion and began his criticisms.[12]

One of many students with easels aligned to catch light from a northern exposure, Josephine gradually settled into the routine of the academy. She took careful notes, absorbing instruction in French, writing in both French and English. "The new students come in waves," she observed.

> Three and four at a time, rushing headlong, only to recede, by and by, into oblivion. They look at the strange faces about them for recognition, but even a friendly smile is missing.[13]

What was not missing was the firm manner and impassioned teaching of André Lhote. The master's voice, as

12 Crawford, THNOC, folder 157, memo book.
13 Crawford, THNOC, folder 158, notebook.

transcribed by Josephine, is clear and strong: "Do not combine line with shadows—in other words do not unite Cranach with Rembrandt." Technique is essential:

> If necessary make deformities, so that they have a pattern and fit into the
> picture. Exaggerate an arm to give it strength—An arm is small when it is relaxed—[14]

And another entry in French:

> *Faites la peinture en demi-teinte—Accentir avec la lumière et le sombre—Faites les directions*
> *opposées—Les accents opposés*[15]

> (Use colors in half strength—accent with light and dark—make contrasts—
> contrast in lines and accents)

Lhote was known for his authoritarian manner, his firmly held opinions on art, and the exacting standards he set for his students. Upon entering the academy, students saw Lhote's words written on the blackboard:

> *Il est interdit de parler de sa personnalité et de s'en inquiéter avant d'avoir appris son métier.*
> *Ne pas confondre sincérité et personnalité. Avant de chercher à être personnel, il faut se livrer*
> *à des expériences picturales.*[16]

> (You should not insert your personality [into your artwork] or worry about it before learning your
> trade. Do not confuse sincerity and personality. Before trying to be personal, you must devote
> yourself to the exercise of creating a picture.)

One of the era's most important art schools, the Académie Lhote trained a whole generation of painters, sculptors, and photographers. Henri Cartier-Bresson studied under Lhote, as did Tamara de Lempicka, Hans Hartung, Aurelie Nemours, and New Orleans artist Paul Ninas.[17] A cosmopolitan group of students numbering around eighty came each year: French, American, Japanese, Slavic, and German. The daily regime included drawing and work from a model, with Friday afternoons reserved for critiques of student work. The academy offered

14 Crawford, THNOC, folder 157, memo book. Catharine Jean Farley writes that Lhote divided drawing into two schools: one emphasized line as found in the work of Lucas Cranach; the other emphasized shadow and light, as found in Rembrandt. Catharine Jean Farley, "The Life and Art of Josephine Marien Crawford, 1878–1952" (master's thesis, Tulane University, 1988).

15 Crawford, THNOC, folder 158, notebook.

16 Letter from Lhote to one of his students, n.d., archives Lhote, Le Raincy, quoted in Claudine Grammont, "Un académisme abstrait? Lhote et l'enseignement des Beaux Arts," in *André Lhote, 1885–1962: Rétrospective présentée au Musée de Valence du 15 juin au 28 septembre 2003*, exhibition catalogue (Paris: Réunion des musées nationaux, 2003), 106.

17 Grammont, 100.

instruction in painting the nude, *natures mortes*, and portraits, as well as a fifteen-day composition course with special direction from Monsieur Lhote offered every three months.[18]

"Les commandements de l'Académie Lhote" emphasize fundamentals:

> *Peindre c'est vivifier le dessin, c'est faire fleurir la forme. On n'apprend à peindre qu'en dessinant*[19]
>
> (To paint is to make a drawing come alive, to bring life to the form. One only learns to paint by drawing.)

Josephine recorded Lhote's pronouncements in a second notebook, turning his words into English with only the slightest creak of translation:

> Imagination plays a favorable role in plastic art—by eliminating unnecessary values and by concentrating interest on the essential.[20]

Despite his relative youth—he was seven years younger than Josephine—Lhote was well established in the French art world. Born in Bordeaux in 1885, he studied wood carving as a boy and later decorative arts at the Ecole des Beaux-Arts in his native city. He exhibited at the Salon des Indépendants beginning in 1906 and at the Salon d'Automne beginning in 1907; he participated in the Salons for most of his career. Lhote contributed art criticism to *La Nouvelle Revue Française* (beginning in 1919) and throughout his life wrote about art theory; two of his better known works are *Traité du paysage* (*Landscape Painting*), 1939, and *Traité de la figure* (*Figure Painting*), 1950.

Lhote had given art instruction since 1916. The addresses of his teaching positions become, in effect, a tour of the *quartier*—boulevard du Montparnasse, rue du Départ, rue Notre-Dame-des-Champs, boulevard Raspail.[21] In 1925, he sent a flyer to his students saying he would no longer give art critiques at the Académie Montparnasse but would open a school in the former Ateliers Dumesnil on the passage du Départ, just off the rue d'Odessa, in what he described as a spacious hangar. Doors opened March 30, 1925.[22]

Although his own work was Cubist inspired, Lhote did not pursue complete abstraction in his art—nor did he encourage his students along this path. He participated in debates on the nature of Cubism as a member of

18 "Circulaire envoyée aux élèves de l'académie," n.d., archives Lhote, Paris, quoted in Grammont, 100.

19 "Les commandements de l'académie Lhote," n.d., archives Lhote, Le Raincy, quoted in Grammont, 106.

20 Crawford, THNOC, folder 157, memo book.

21 Grammont, 102.

22 "Circulaire de Lhote à ses élèves" (Paris, Mar. 28, 1925), archives Lhote, Le Raincy, quoted in Grammont, 102n11.

André Lhote, *1928; courtesy of Dominique Bermann Martin*

Léonce Rosenberg's Galerie de l'Effort Moderne and, beginning in 1918, criticized developments in the movement. Cézanne, he would say, was the one to follow; the work of Braque and Picasso had become too cerebral, too abstract, at the expense of *sensation*—the world of the senses (feeling). Lhote promoted a particular kind of Cubism, in which a subject is recognizable, and maintained that the movement—as he defined it—was the latest embodiment of the grand classic tradition of Poussin, Ingres, and Cézanne.[23]

Lhote advocated *un retour à l'ordre*—a "return to order" that became a theme at l'Académie Lhote—and warned against certain tendencies in art:

> *Pour se guérir des déliquescences de l'impressionisme et des errements du cubisme "chaque conscience studieuse" devra revenir à "l'évaluation juste des procédés picturaux."*[24]

(To rid yourself of corruptions that have come about in impressionism and cubism, "each studious conscience" [each artist] must return to "a proper understanding of the pictorial process.")

In other words, discipline. Lhote condemned *la non-figuration* (abstraction). The artist must start with *la petite sensation* (feeling or inspiration) based in reality.[25]

And so Josephine learned that "the Cubist takes a slice of reality—and builds about it a bloc of plastic imagination."[26] She learned, too, that "it is no use trying to be an impressionist—that was a phase that has passed, and besides you young people can copy the method but it is not possible for you to feel it. It is dead so far as you are concerned. So far as you are willing to live by candlelight."[27]

23 Grammont, 104. Cubism was concerned with breaking up subjects into geometric forms, then realigning these elements to emphasize the two-dimensionality of the canvas. As Cubism became more abstract, the subject was often unrecognizable.

24 André Lhote, "Totalisme," *L'élan* 9 (Feb. 1916), quoted in Grammont, 103.

25 Grammont, 106.

26 Crawford, THNOC, folder 157, memo book.

27 Ibid.

Seated Woman with Hands in Lap, between 1929 and 1934, pencil on wove paper, 9 x 6"; The Historic New Orleans Collection (1978.23.102), bequest of Charles C. Crawford

Josephine was hesitant to begin: "I feel the inability of soiling a canvas, already a beautiful thing."[28] And she found Monsieur Lhote over-bearing:

> He comes in late. He bends and backs between the crowded easels, and calls the class to order. He is brusque and impatient. He scolds the model and yells once more for silence. The new student fears the moment when he will lay his work before the professor. Nothing escapes his scrutiny. He espies the timid fright-ened face of the newcomer above the badly modeled drawing, and some where on the canvas he finds a bit of color too lovely to be lost.[29]

That "bit of color too lovely to be lost" served as encouragement. Josephine preserved another critique, most likely of her work: "You have talent. But you do not know how to make the most of it. Do not scatter your flowers, but arrange them to advantage in a vase."[30] Then, in a practical vein, she made a list of colors, in French: "*ochre, ochre rouge, cadmium, citron, terre de sienne brûlée, emeraud, vermilion, blanc, noir.*"[31]

Josephine went every day to the academy, listening to Lhote's instruc-tion to "put cold color next to warm—warm next to cold—straight next to curve, curve following straight."[32] Later, after class, she headed out to explore the art galleries dotted about Paris. She saw a beautiful still life by Raoul Dufy (she noted the price) and an exhibition of young artists on rue Royale. She remarked that "L'Art Nègre is in vogue" after visiting one of the Salons and purchased a catalogue at the Musée Rodin.[33] The year Josephine arrived in Paris, Lhote's works could be seen in several exhibitions, notably the Salon d'Automne et des Tuileries and in two *expositions particulières* (one-man shows) at Galerie Druet and

28 Ibid.

29 Crawford, THNOC, folder 158, notebook.

30 Ibid.

31 Crawford, THNOC, folder 157, memo book.

32 Ibid. Lhote advocated warm colors in the ground and cool colors in the subject in order to achieve a flattened image true to the two-dimensional nature of the canvas. Farley, 113.

33 Crawford, THNOC, folder 157. African sculpture and ceremonial masks were popular in the early years of the twentieth century, particularly in France.

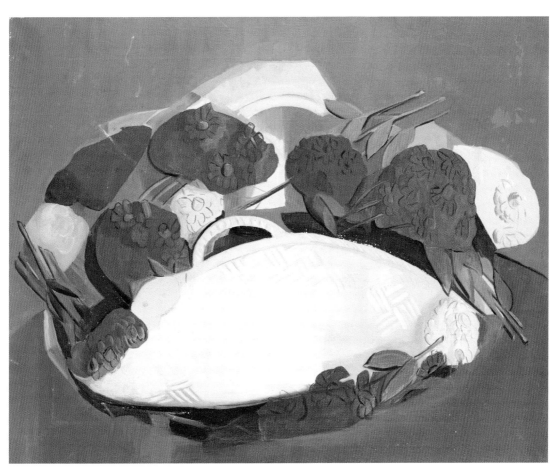

*Still Life with Flowers in Basket, ca. 1932, oil on canvas, 22 x 26⅞";
courtesy of Allison Crutcher McAshan*

Galerie Montelet. "Pleased to see," Josephine observed, "six canvas[es] of L'Hotes—a nude very charming."[34]

Josephine met Maria Blanchard, a Spanish artist who had studied under Lhote, "now showing in galleries and well thought of." The meeting, over tea in Lhote's studio, marks a high point during the gray Parisian winter. Josephine found a more relaxed teacher as he showed his guests "choice pieces of Art Nègre which he collected at the Port of Bordeaux before they were the vogue." They also saw his paintings, many of the same subject. "He told us that whenever he got a desired effect he began a new canvas before carrying it on—Lest he spoil what he had accomplished."[35]

André Lhote; *courtesy of Dominique Bermann Martin. Examples of Art Nègre can be seen in the background.*

During class hours, however, Lhote rarely dropped his brusque manner. One day, discovering a young student working during the hour of criticism, his voice rose "like a trumpet." "He is ungentlemanly," Josephine observed,

> but his words are thrust with intelligence. "Why do you come to my class if you can do without my criticism? Unless you listen to me how are we to get on together? . . . Learn to know your colors so as to get their value and importance The more colors you use the less important they become. God alone is the genius who is at liberty to be prodigal of color You are not God."[36]

But a *café crème* and a smoke at Le Dôme, the popular café on boulevard du Montparnasse, could lift spirits. Josephine enjoyed the scene—crowded and smoke-dimmed—where a "sickly youth was drinking absinthe with a florid loving companion—a group of American students were noisy near by."[37]

Montparnasse in the 1920s could be described as a state of mind. But it nourished the body as well in its lively cafés. Le Dôme, La Rotonde, and La Coupole were "adapted both for mixing with one's peers—and for solitary writing, sketching, or simply brooding."[39] When Josephine left her preferred café, walking past the tables and chairs spread out on the sidewalk, she found herself at the intersection of boulevards Raspail and Montparnasse. She would be near the center of the quarter, the carrefour Vavin (now the place Pablo Picasso), with the

34 Ibid.

35 Crawford, THNOC, folder 158, notebook.

36 Ibid.

37 Ibid.

38 Lottman, 9.

Young Woman, *between 1896 and 1941, watercolor, charcoal, and pencil*
on wove paper, 13⁵/₁₆ x 13⁹/₁₆"; The Historic New Orleans Collection
(1978.23.78), bequest of Charles C. Crawford

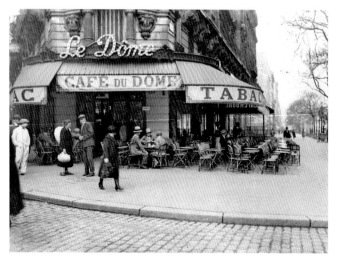

Café du Dôme, Paris, *around 1925;* © Agence Roger-Viollet
(1949-8)

Luxembourg Gardens to the north and, in the opposite direction, the Montparnasse Cemetery and the Observatoire. Picasso had left Montmartre for boulevard Raspail; Fernand Léger worked on rue Notre Dame-des-Champs; Piet Mondrian had settled on avenue du Maine and later on rue du Départ.[39]

Josephine had come to Paris for art, but she also enjoyed a social life beyond the academy. The "Sallie" mentioned in her notebook is Sarah Henderson, a relation by marriage and a benefactor of the New Orleans Arts and Crafts Club. "Sallie introduces us to Rattner," Josephine observed, on the occasion of a visit to Abraham Rattner's studio on rue Lepic in Montmartre. He had exhibited in New Orleans at the Arts and Crafts Club earlier that year, most probably at Sarah Henderson's invitation. Josephine noted that Rattner rented a studio from a Miss Bedwell, who was the Paris correspondent for *Harper's* magazine.[40] Good conversation and interesting people offset any frustrations at the Académie.

One day, she described tea with the well-known violinist Jan Hambourg at his apartment on rue de Lille: "Jan played and talked about Marcel Proust, his short interesting life—his Albert—" (Proust's intimate friend and one-time secretary, Albert Nahmias).[41] A spacious apartment on rue du Cherche-Midi was the setting for dinner with the widow of sculptor Paul Bartlett.[42] Josephine met a man named Deitrich, also a sculptor, who was "in ecstasy over some bit of frieze he had seen" at Père Lachaise Cemetery, although he had arrived too late for his aunt's cremation service. Josephine attended a Schoenberg concert—a "delightful experience"—and found a book of Matisse drawings for a friend at Galerie Le Portique.[43]

With Lhote's words in her head ("I refer you to Matisse and to Fragonard. Their pictures are in harmony Your canvas should be a whole in color and design Work for harmony"),[44] Josephine went about

39 Bougault, 8, 205.

40 Crawford, THNOC, folder 158, notebook.

41 Ibid.

42 Paul Bartlett (1865–1925), a noted sculptor, was born in Connecticut but spent most of his life in Paris.

43 Crawford, THNOC, folder 158, notebook.

44 Ibid.

Paris in search of art. She wrote of galleries showing Francis Picabia, Henri Laurens, Juan Gris, Maurice de Vlaminck. She found Picasso on rue de Seine, Fernand Léger on rue de Beaune, Delacroix at the Paul Rosenberg gallery.

And back at the academy there was always a model to sketch and paint. Lhote reminded his students: "First find out what it is you want to see in the model Do not go to the model to find a way Paint with your back to the model. Refer to her when you are in need of fresh impulse."[45] But Josephine went a step further. She rendered the model in words:

> The model sits at the piano during her rest period. Her cloak hangs loosely from her shoulders, and unconscious of her white form against the somber folds, she sings with a light heart. She does not feel the curious eyes upon her. Her eyes half closed, she dreams away in song. Perhaps she too is wishing for expression, this little model from the Rue du Départ.[46]

Josephine enjoyed jotting down story ideas interspersed with notes on art technique. There is a short description of someone she called the "boy Cézanne," inspired by a student at the Académie. She may have preferred following the boy in her imagination rather than reading a text on art theory recommended by Lhote—nevertheless, she dutifully recorded the title, Albert Gleize's *Du Cubisme*.[47] Her journal is also where we find a suggestion of melancholy. Paris in the winter is gray, many shades of gray, but gray nonetheless. November, December, January, the length

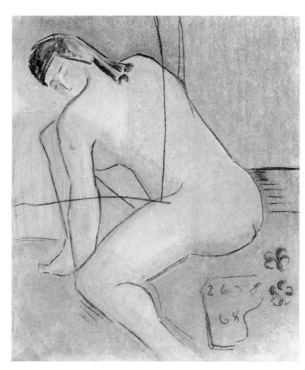

Kneeling Nude, 1928, pastel over pencil, 9 x 7¾"; The Historic New Orleans Collection (1978.23.378.22), bequest of Charles C. Crawford

45 Ibid.

46 Ibid.

47 Crawford, THNOC, folder 157, memo book. The book Josephine is referring to is *Du Cubisme et des moyens de le comprendre* by Albert Gleizes and Jean Metzinger.

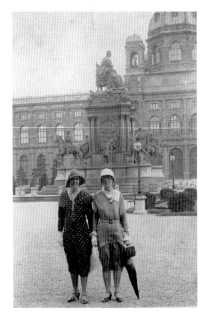

Jeanne Crawford Henderson and
Josephine Crawford in Vienna,
*1928; courtesy of Mrs. Edmund
McIlhenny*

of time Josephine lived in the city, are the grayest of all. "It is a gray day," she wrote, "and the students can hardly see the model. They paint without knowing their colors. They paint diligently although tomorrow they will undo what they have done. Something pushes them on."[48] The voice of André Lhote rang in their ears—"Do not let any part of your picture come out of the frame. Let the background hold it into place."[49]

Josephine captured Lhote's voice, rising again to instruct his students, "Do not think in black and white but in cool and warm color."[50] And, in a more supportive tone, "Every artist has a rhythm—It is something that expresses itself in spite of us."[51]

But Josephine's thoughts turned toward home. A poem fragment, tucked among her notes, recalls with longing the island view across Mississippi Sound: "For I must touch Deer Island / To bring my yawl ashore." It was time to leave. "Last Friday at Lhote's Academie—2nd favorable criticism—I do not know how I shall go on—I have learned too much—I feel bound in a chrysalis of laws and notions."[52]

Josephine left for Cannes after "three months of short dim days in Paris" and traveled throughout the South of France. Her sketches provide a record of places visited: Villefranche, Cagnes-sur-Mer, Avignon, Beaucaire, Nîmes, Marseilles, Carcassonne. She deplored the "unimaginative villas that spilled here and there," despite the beautiful drive along the coast from St. Raphaël. She thought of Cézanne ("He painted with flexible brushes—polecat or sable") and appreciated her solitude.[53]

Josephine completed her trip abroad in Vienna at the Kunstgewerbeschule (School of Applied Arts) where she shared a class with Czechs, Poles, Australians, and other Americans. Her younger sister Jeanne joined her in Vienna, always good company. The sisters were quite pleased with themselves when a photographer posed them in front of the Maria Theresia Memorial. It was spring and Josephine decided to take up lithography. The

48 Crawford, THNOC, folder 158, notebook.
49 Ibid.
50 Ibid.
51 Crawford, THNOC, folder 157, memo book.
52 Crawford, THNOC, folder 158, notebook.
53 Ibid.

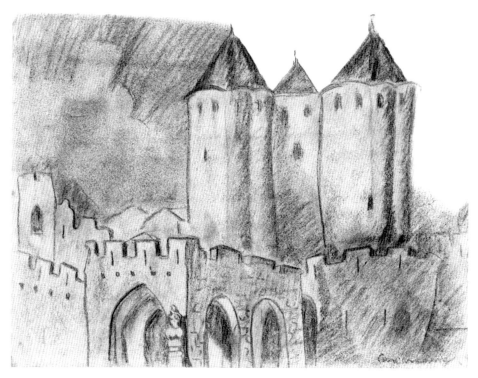

Carcassonne, between January 31, 1928, and April 26, 1928, charcoal on wove paper, 10¼ x 13¾"; The Historic New Orleans Collection (1978.23.301), bequest of Charles C. Crawford

instruction "chez Lhote" had been intense and demanding and the winter long and gray. It was time for a respite from Lhote's rules of color and form. And so Josephine decided "to get away from further instruction in painting . . . much to Herr Kernig's disgust—He thinks lithography old-fashioned and commonplace—But I do nothing else."[54]

The July 15, 1928, edition of the New Orleans *States* announced Josephine's return to New Orleans "from a year's study in Europe."[55] A return to New Orleans meant a return to Royal Street—her home in the 600 block, and to the Arts and Crafts Club just one block away.

54 Ibid. Herr Kernig was Josephine's instructor.

55 The actual length of Josephine's stay in Europe was closer to eight months.

Beginnings

*What of me is singularly mine, and
would be so regardless of whom I was
born to . . . or where I grew up?*
　　　　　—GAIL GODWIN,
　　　　　A Southern Family

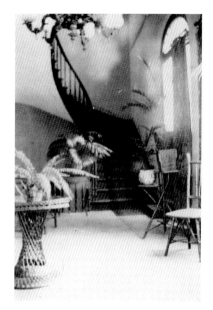

ABOVE: Staircase at 612 Royal
Street, ca. 1900; courtesy of Louise
Chapman Hoffman

LEFT: 612 Royal Street, *July 1939;
Vieux Carré Survey at The Historic
New Orleans Collection (square
42)*

SIX-TWELVE ROYAL STREET had been in Josephine's
family since its purchase in 1839 by François Méli-
court Bienvenu, Josephine's grandfather. Home, for
Josephine, meant nurture not only by family but by the character
of the building itself, enhanced by courtyard, loggia, and high
ceilings. Josephine's creative spirit found expression, early on, in poems about her ancestors,
her home on Royal Street, and everyday life in the French Quarter. The house as refuge is a
theme that flows through her poetry:

> The House. . . .
> The wall
> So high
> That shuts our neighbors out—
> And shuts us in. . . .
> The square court
> Full of phantoms. . . .
> Surely it's a sacred spot
> Where they lived:
> And where they died![1]

1　Crawford, THNOC, box 1, folder 78.

During the antebellum years, the Royal Street address probably served as the family's town house while the Bienvenus continued to live on a plantation downriver in St. Bernard Parish. Mélicourt's name appears in the 1860 census, where he is listed as a planter.[2] He is named again in an "Agreement with Freedmen" (1865) granting his former slaves one-eighth of the proceeds from future crop sales. The agreement includes the names and ages of fifty-one freedmen and grants them housing, medical attention and commissary privileges, a garden plot, and a guarantee of the required hours of work.[3] Around this time, Mélicourt moved his family permanently to the city. The city, of course, was the old city, where the names of the streets were in French and forts—St. Charles, St. John, St. Ferdinand, Bourgogne, and St. Louis—had once defined the boundaries.[4]

Mélicourt would not live to see his granddaughter Josephine. Just a month before her birth, the newspaper *L'Abeille de la Nouvelle-Orléans* printed his death notice:

> *Décédé hier soir à onze heures et demie, à l'âge de 74 ans, F. M. Bienvenu. Ses amis et connaissances, ainsi que ceux des familles Bienvenu, Crawford, Montgomery, Delabarre et de son fils J. G. Bienvenu, sont priés d'assister à ses funérailles qui auront lieu cette après-midi à 4 heures et demie, du No 140 rue Royale.[5]*

> (Died yesterday evening at 11:30, 74 years old, F. M. Bienvenu. His friends and acquaintances as well as those of the Bienvenu, Crawford, Montgomery, Delabarre families and those of his son J. G. Bienvenu, are invited to attend his funeral which will take place this afternoon at 4:30 from number 140 Royal Street.)

The funeral service would take place at home, followed by a procession to the cemetery. Servants were part of the *cortège* following immediately behind the coffin.[6]

Louise Bienvenu Crawford inherited 612 Royal after her father's death. She had married William Gordon Crawford in 1865. Two children were born, William Gordon and Louise Harriet ("Miss Tweety"), and shortly thereafter, 1867, William Sr. died. Most likely it was at this time that Louise moved back to the family house. Some six years after being widowed, she married William's brother, Charles Campbell Crawford, a custom that

2 U.S. Eighth Census, 1860, quoted in Joseph Karl Menn, *The Large Slaveholders of Louisiana, 1860* (Gretna, LA: Pelican Publishing, 1964), 341.

3 "Agreement with Freedmen," 1865, THNOC, acc. no. 72-62-L.9.

4 John Magill writes in "New Orleans Through Three Centuries" that the use of the term Vieux Carré for the French Quarter dates to the early twentieth century (prior to 1903). Alfred E. Lemmon, John T. Magill, and Jason R. Wiese, eds., *Charting Louisiana: Five Hundred Years of Maps* (New Orleans: The Historic New Orleans Collection, 2003), 306.

5 *L'Abeille de la Nouvelle-Orléans*, Nov. 9, 1878. The street numbering system in the French Quarter officially changed in 1894. The old Bienvenu house, formerly 140 Royal Street, became 612 Royal Street.

6 James S. Zacharie, *New Orleans Guide* (New Orleans: New Orleans News Company, 1885), 35.

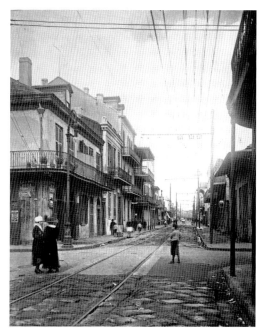

Looking Down Royal Street from Governor Nicholls Street, *November 1928; The Historic New Orleans Collection (1987.25), gift of Mrs. Charles Belik*

was both practical and honorable. Josephine came from this second marriage, the *deuxième lit,* along with Charlotte, John de Morant, James Charles, Lewis Bienvenu, Jeanne, and Charles Campbell, with Josephine's place in the birth order between James and Lewis.[7]

Josephine was indisputably Creole.[8] The family spoke French at home, valued privacy and thrift, and kept their house long after other families had moved away from a French Quarter rapidly filling with a poor immigrant population.[9] The household probably included an old cousin or two, maybe a great-aunt. Josephine grew up surrounded by family members whose French names are sprinkled throughout her poems— Bonne-Bonne (her grandmother), Léontine, Tante Lizette, Cousine Sophie, Cousin Neville, Arthémise. They were never far away:

> But times gone by, old times . . .
> Take everlasting hold on me
> Their memories enthrall
> Old faces, names, old places.[10]

Josephine cherished the tales told by her mother of genera-tions past. Louise's own father, Mélicourt, had told her—so many times!—about the progenitor of the Louisiana Bienvenus, Antoine, a Frenchman who came to America with his father in the mid-1700s. Antoine first went to the upper Louisiana territory (the Kaskaskia settlement in present-day Illinois) before settling in the lower Louisiana territory in an area near New Orleans (now St. Bernard Parish). This was plantation land: the soil was rich and Antoine prospered as a planter, prominent and respected. The first Bienvenu plantation had previously belonged to the

7 Josephine referred to Charlotte in a handwritten note as Charlotte Agnes Dagmar and to Jeanne as Alice Jeanne and elsewhere as Jeanne Montgomery, but there is no official evidence of the additional names. Crawford, THNOC, folder 156.

8 The Crawfords were from Belfast, but the prevailing customs in Josephine's family came from the Bienvenus, the French (Creole) side of the family. In its broadest sense, the term "Creole" refers to people of Old World ancestry born in the Americas. The term also connotes a certain joie de vivre.

9 Royal Street was described in 1933 as "almost the last stand of the aristocracy in the French Quarter." See Nathaniel C. Curtis, *New Orleans: Its Old Houses, Shops and Public Buildings* (Philadelphia: J. B. Lippincott, 1933), 106.

10 Crawford, THNOC, folder 118.

Marquis de Vaudreuil, who had arrived in New Orleans to become governor of the territory in 1743. A second Bienvenu plantation was one of the largest along this stretch of the Mississippi River. The manor house on the property, constructed in the late 1700s, had galleries that encircled the two-story building, with a view of lemon and orange trees, live oaks and pecan trees.[11] Louise Bienvenu Crawford would tell her children, as her mother had told her children, that their sugar plantation was where the Battle of New Orleans was fought—there and on the neighboring plantations: Languille, Jumonville de Villiers, Macarty, Rodriguez, de Chalmet, Lacoste, de la Ronde, Villeré. Children love stories, and one they must have heard and begged to hear again was the tale of a young Englishman, killed in battle, who was buried in the Bienvenu garden.[12]

Arsène Lacarrière Latour's map of the Battle of New Orleans placed the Bienvenu house squarely in the line of fire in January 1815. The family had fled to other lodgings, and the plantation house, deserted, became a temporary shelter for a British artillery officer whose memoir describes an elegant mansion with marble floors, "two magnificent globes, and a splendid orrery."[13] He found a library of valuable books and noticed in a bedroom a volume of Buffon's *Histoire Naturelle*:

> On entering a bed-room, lately occupied by a female of the family as was apparent by the arrangement of toilet, etc., I found that our advance had interrupted the fair one in her study of natural history, a volume of Buffon was lying open on her pillow; and it was evident that her particular attention had been directed to the domestic economy of the baboon and monkey tribe, slips of paper marking the highly colored portraits of these charming subjects for a lady's contemplation.[14]

The Bienvenu house survived the battle, although some slave quarters were burned. On October 15, 1831, an advertisement in the *Louisiana Courier* describes the property, citing a dwelling house with sixteen rooms and numerous outbuildings: a sugar house; a circular building containing a steam engine and sugar mill; a curing house, kitchen, and storehouse; thirty-three slave cabins; a hospital; a pigeon house and blacksmith shop; and a barn and other dependencies. The land was situated "two leagues below the city of New-Orleans . . .

11 Samuel Wilson, *Plantation Houses on the Battlefield of New Orleans* (1965; reprint, New Orleans: Louisiana Landmarks Society, 1996), 23.

12 Benson Earle Hill, *Recollections of an Artillery Officer* (London: R. Bentley, 1836), quoted in Wilson, 58.

13 An orrery is a device with balls representing the planets that are moved by clockwork to illustrate the motions of the solar system.

14 Hill, quoted in Wilson, 57–58. Buffon's *Histoire Naturelle*, published in thirty-six volumes over the second half of the eighteenth century, was a foundational natural history treatise. A volume of Buffon, in the Crawford family library on Royal Street, found its way into the hands of young Josephine. Here she would encounter *le sanglier*, *le cerf*, *l'ours noir*, *l'aigle*, *le lion*, and *l'éléphant*. (A few of the pictures have been colored, not too expertly, by a child. Perhaps it was Josephine who imagined a swan—*le cygne*—blue.)

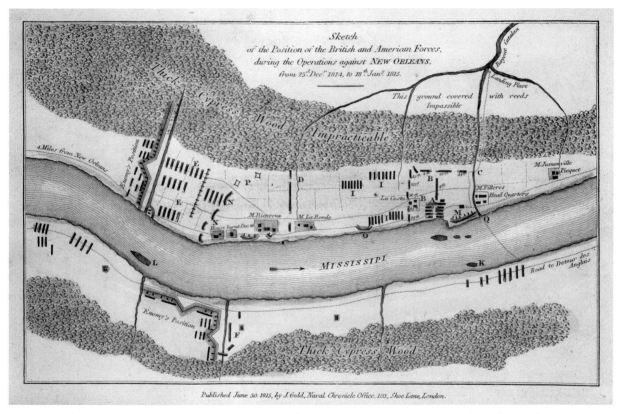

Sketch of the Position of the British and American Forces, during the Operations against New Orleans from 23d. Decr. 1814 to 18th. Jany. 1815 *by Arsène Lacarrière Latour, June 30, 1815; The Historic New Orleans Collection (1971.98), bequest of Richard Koch. The Bienvenu Plantation is designated at center left above the river.*

measuring eighteen arpents fronting on the Mississippi, with all its depth extending to the lake, dimi[ni]shing in width at forty arpents from the river. . . ."[15]

No pictures survive of the old plantation, but the Crawford children would hear about another family house—still standing—about ten miles downriver, on Bayou Terre-aux-Boeufs. This was the place Josephine was thinking of when she included the name Terre-aux-Boeufs—land of oxen—in a poem. (The Bienvenus did not name their plantations. Subsequent owners named this plantation Kenilworth.)[16] Acquired in the 1820s or early

15 The advertisement in the *Louisiana Courier* (Oct. 15, 1831) was published after the death of widow Charlotte la Barre Bienvenu. An arpent was a French unit of land measure (approximately 0.85 acres).

16 Kenilworth Plantation in St. Bernard Parish survived Hurricane Katrina (2005) but sustained damage from flooding.

1830s, the property remained in the family for more than forty years. Facing south on the bayou, the plantation was a classic French Creole house: brick on the first floor, brick-between-posts on the second, galleries on four sides, a double-pitched, hipped roof. Mélicourt and Josephine (Josephine Crawford was named for this grandmother) lived on Bayou Terre-aux-Boeufs. Our Josephine would listen to her mother tell about doors open to the galleries to catch the breezes (the all-important *courrant d'air*), the excursions to the city for shopping, the precautions against yellow fever—all would spark Josephine's own curiosity about family lore. "Tante, ma tante, tell us your story," she implores in a poem, perhaps invoking her Tante Lizette or Tante Delzira.

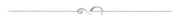

Family ties were strong: Letters went back and forth to keep everyone informed. "I hope Josephine"—age 6— "will soon recover from her illness," half-brother William wrote to his mother from Towle's Institute for Boys in Mobile, Alabama.[17] And news from home came when the youngest sister was born: Charlotte informed "Willie" that "our little baby is named Jeanne, the French for Jane."[18] The large, vigorous Bienvenu-Crawford family fed Josephine's imagination, the living as well as the departed—ancestors were lodged comfortably in her mind and in her poetry. In some of her poems, Josephine assumed the nom-de-plume "Guy de Morant," harking back to the aristocratic de Morants on the maternal side of her family.[19]

Léontine emerges as an important figure, still present in the "lofty walls":

I love the House.
Standing thus, above the others.
Worn of face and flecked with shadows.

The balcony, the winding stairs
And the vision of Léontine
Exquisite
In green and gold.

I have a remnant of her dress
I know the quiet sound
Of her foot fall

17 William Crawford to Louise Crawford, Mar. 2, 1884, Crawford Family Papers, MSS 371A, Special Collections, Tulane University (hereafter Crawford Family Papers, Tulane), folder 2.

18 Charlotte Crawford to William Crawford, Feb. 22, 1883, Crawford Family Papers, Tulane, folder 2.

19 Josephine's papers include a de Morant family tree; the de Morant name also reappears as brother John's middle name. Crawford, THNOC, folder 202.

The flavor of vanilla
Still perfumes the vaulted rooms. . . .

Still about the old house
Linger spirits of the past . . .
Prisoned in the lofty walls . . .[20]

Images spill out of Josephine's poems. She remembered a Sunday dinner at St. Avid's (perhaps a family friend), the meal of peppered soup and roast fowl,

French Market, ca. 1890 (printed by Clarence John Laughlin, ca. 1955); Clarence John Laughlin Archives at The Historic New Orleans Collection (1981.247.12.96)

And after dinner
The long room
Where we sat in patient order
Hearing the great clock tick
And nibbling "fondants"
While St. Avid read aloud
From Fénelon or "Mort d'Arthur."

While she listened, or half listened, Josephine noticed the bookshelves with first editions in calf, hand-tooled, and the Audubons on the walls,

Wild Turkey, Rattlers, The Mockingbird and Crow
In the dim light of winter
Seeming to flutter
Out of their frames. . . .[21]

The incipient artist, piling image upon image, was inspired by neighborhood scenes as well as domestic arrangements. "A Street Scene in New Orleans," a story idea in one of Josephine's notebooks, brings the French Market to life with its description of Italians, Indians, gypsies with prayer beads, cooks jabbering in French and English. "When they bought fruit they bargained in French, when they bought meat they bargained in English—A negress with a straight nose, hair combed over her ears and a scapular hanging down her back was walking beside me."[22] Josephine's word pictures would eventually lead to the easel. Louisiana artist Elemore Morgan Jr.

20 Crawford, THNOC, folder 159.

21 Crawford, THNOC, folder 188.

22 "A Street Scene in New Orleans," 1895, Crawford, THNOC, folder 156.

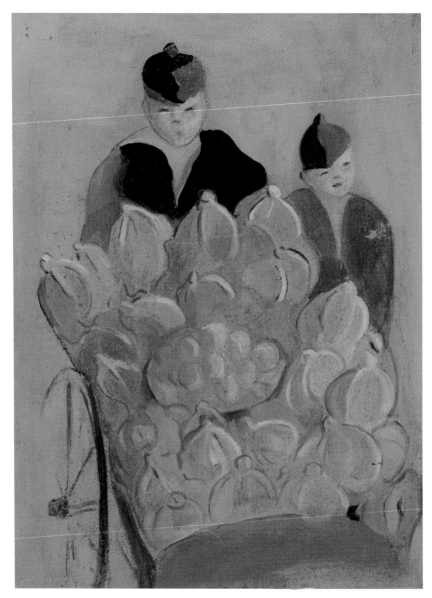

*Chinese Melon Sellers, between 1930 and 1940, oil on canvas, 15 x 11¼";
courtesy of Anne Strachan Eichin*

could have been speaking of Josephine when he described the artist as someone who has no choice but to create.[23] For Josephine, creativity was as natural as breathing.

Josephine's poems are not groundbreaking but simply reflect, in slightly elegiac tones, the small world where she grew up—the French Quarter in the late nineteenth century.[24] She described the funeral horses of Monsieur Bonet, the undertaker, and the bottle man "calling up to the half-shut windows."[25] Close by was the shop of Monsieur Donatel, who made plaster saints ("Joseph and Mary / and Saint Expedite, / Rosa of Lima / and Peter"), and Anker's shop "where prayer beads sell / and beaded immortels."[26] And not far away was Reichart the bookbinder, afflicted with "palsey," as he bound "Hugo and Flamarion / Tooling, / Wreaths on ladies albums / Printing / Gilded titles, authors / 'Friendship' or 'Louise.' "[27]

Religious imagery infuses Josephine's poetry: visits to mass, the crucifix above the bed, "the China Virgin / In the candlelight." And her visual memory would always include a Sacred Heart sampler, not quite finished, that had hung in the Royal Street house for as long as she could remember, evoking thoughts of a grandmother's handiwork. The Crawfords were Church of England, the Bienvenus, Catholic. Records show that Charles and Louise were married at Christ Church (Episcopal) and had Josephine baptized at Trinity Church (Episcopal).[28] The Right Reverend Davis Sessums, Episcopal bishop of Louisiana, signed Charlotte's confirmation certificate. The family may have drifted toward Protestantism, but Josephine's poetry reminds us that Catholic roots went deep.

Josephine's ladies "Dressed in mull and valencienne / Sipping orgeat from blue glasses" were visiting cousins or, more likely, friends paying a social call.[29] But "painted ladies" at Turbère's establishment, just across the street from the Crawford house, are scathingly described. Her nurse Thérèse was far superior.

> I was afraid of painted ladies
> In rustling silk
> And dangling chatelaine:
> Full bosomed, musky,
> Strange and leonine . . .

23 "Peculiarly afflicted" is how Morgan described those who are compelled to paint. Elemore Morgan Jr., gallery talk, Ogden Museum of Southern Art, New Orleans, July 30, 2006.

24 Josephine probably began writing poetry as a young girl, but the mature outlook reflected in the majority of her poems could only come from an adult who is remembering her childhood.

25 Crawford, THNOC, folders 5 and 10.

26 Crawford, THNOC, folder 61.

27 Crawford, THNOC, folder 110.

28 The marriage took place Oct. 21, 1873 (Christ Church marriage records). Josephine was baptized June 12, 1879 (Trinity Church Parish Record, vol. 1, 1847–83).

29 Crawford, THNOC, folder 25. Orgeat is a syrup flavored with almonds and water in which orange flowers have been steeped.

Amanitas of the night. . . .
I thought: Thérèse, your skin though brown
In calico, you are more elegant than they.[30]

The admirable Thérèse is one of many servants whose names are woven throughout the poems: Roselle, Circe, Françoise, 'Tasie, and Philomène. Prosper, "the old Swiss," is evoked, card tray in hand, with keys rattling in his pocket.

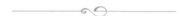

Drawing, as well as writing, was on Josephine's mind. "These / pencils / for the written / word? / Or meant / For drawing / (Such eager points)."[31] She studied at home, using learn-to-draw instruction books from the Librarie Française on Chartres Street. *Le dessin pour tous. Méthode Cassagne* by Armand Cassagne had exercises for drawing, with one chapter devoted to the head, another to bones and muscles. *Cassell's popular drawing copies* advised on figure drawing.[32]

Josephine's more formal education took place at the Cenas Institute for Young Ladies at Esplanade and Claiborne avenues.[33] But sometimes her schooling was interrupted when the family spent time at their home on the Gulf Coast. And it seems that Josephine's health caused her mother to seek the salubrious effect of sea air for her daughter. A letter from A. M. Cenas acknowledged Louise Crawford's decision to winter in Biloxi, asked for Charlotte as a boarder—"do not let the price deter you"—and expressed the hope to have Josephine when she was stronger.[34]

Instruction, of course, included French. A poem leads the reader to Dumaine Street where Josephine practiced the language of her ancestors:

Three little ladies Quimpère. . . .
Queer little cottage
On rue Dumaine. . . .
Taught us French
And fine writing.[35]

30 Crawford, THNOC, folder 82.

31 Crawford, THNOC, folder 74.

32 Crawford Family Papers, Tulane, folder 1.

33 Herman Boehm de Bachellé Seebold, *Old Louisiana Plantation Homes*, vol. 1 (Gretna, LA: Pelican Publishing, 1941), 69.

34 A. M. Cenas to Louise Crawford, Oct. 18, year omitted, Crawford Family Papers, Tulane, folder 7.

35 Crawford, THNOC, folder 60.

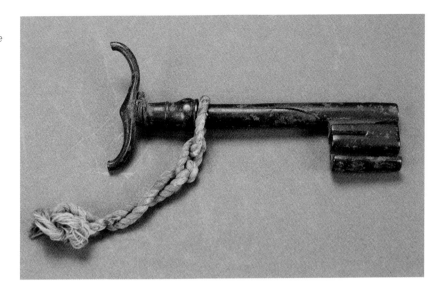

Key to 612 Royal
Street; *courtesy of Louise
Chapman Hoffman*

Comportment was learned at home. A description of Louise Crawford at this time, the 1880s and early '90s, comes from daughter Josephine, who saw her mother in regal terms, certainly someone who presented herself very correctly. Again a poem, this one entitled, "My Mother never rocks or hums." At the end of the poem, Josephine continued with a description of her mother in prose, "I remember when I saw Olivia's mother rocking . . . My mother seemed to sit just like a queen . . . her train touched the floor . . . I felt a tender warmth but never told her . . . when she sang . . . head held high." Louise, Josephine writes, carried a key basket on her arm with a big brass key threaded on a ribbon; in her daughter's eyes, she assumed the role of chatelaine. The prose piece ends with mother telling daughter "to be silent and quiet—for only silent and quiet are little girls allowed."[36] But Josephine certainly was of a different mind!

As befitting a lady of her station, Mrs. Crawford received on Wednesdays, also the day that Mrs. Castellanos and Mrs. Baldwin were "at home," from 1:00 to 4:00 p.m., the usual hours for visiting. An 1889 "visiting list" provides the rest of the week's schedule: on Monday, Cenas, Claiborne, and Cassard; (no mention of Tuesday); on Thursday, Zacharie, Henderson, Lavillebeuve, and Dunbar; on Friday, Denègre, Wogan, Eshleman, Rainey, Bienvenu, Sarpy, and Hoffman.[37] While Louise was receiving socially, her husband Charles was

36 Crawford, THNOC, folder 129.
37 Visiting list, 1889, Crawford Family Papers, Tulane, folder 25.

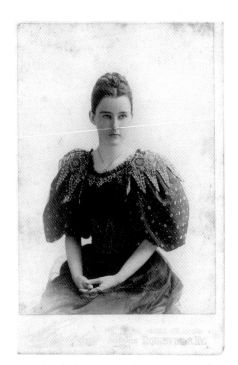

Sarah Henderson, 1890s; courtesy of Andrew G. Labrot. A fellow student of Josephine's at Newcomb College, Sarah Henderson would become one of New Orleans's leading art patrons.

receiving as well—importing from Liverpool, via the steamer *Marseille*, sacks of beans, Dundee bags, alpaca (cloth), corduroys, and hempseed.[38]

If Josephine decided to be "silent and quiet," she could make scrapbooks with pictures of the latest fashions—*la mode*—or of exotic places, a popular pastime. She could also peruse the library at home to discover the *Dictionnaire de L'Académie Française, Tome Premier* and *Tome Second*, a small education in itself; *Petit Larousse Illustré; The Reader's Handbook; Aesop's Fables; Histoire Naturelle, extraite de Buffon et de Lacépède; L'Histoire Moderne;* and *Lycée ou Cours de Littérature.*[39] Josephine saw dusty volumes at Uncle Neville's house but more interesting were his ivory-headed cane and red-tasseled bell cord.[40]

For secondary schooling Josephine left the French Quarter to attend McDonogh High School No. 3 on Spain Street below (down-river from) Elysian Fields Avenue, situated between St. Claude Avenue and Rampart Street.[41] Streetcars provided access down Rampart.

In October 1895, Josephine enrolled at Newcomb College, located until 1918 in the Garden District. Thirty-five dollars covered tuition for a term. Josephine chose the Modern Languages Course of Study, which required French and German, Physics and Chemistry, Astronomy and Geology. Ten of the eighteen students in the freshman class chose Modern Languages; the other eight chose the Scientific Course. Sarah ("Sally" or "Sallie") Henderson, listed as a Special Art Student that year, would become one of Josephine's good friends. The young women attended classes on a campus of several acres, the former James Robb estate, a square bounded by Washington Avenue, Camp, Chestnut, and Sixth streets "in the best residence section of the city."[42] In April of the following year, Josephine

38 Praschkauer and Co., London, to Charles C. Crawford, 1888, Crawford Family Papers, Tulane, folder 27. A Dundee bag was a type of all-purpose bag made of jute and manufactured in Dundee, Scotland.

39 Crawford family books now owned by Louise Chapman Hoffman.

40 Poem, Crawford, THNOC, folder 123.

41 Student records, H. S. Newcomb Memorial College, 1895–96, Newcomb College Center for Research on Women.

42 Newcomb College Catalogue 1895–96, Newcomb College Center for Research on Women. Robb (1814–1881), a wealthy banker and entrepreneur, was a leading art collector in antebellum New Orleans.

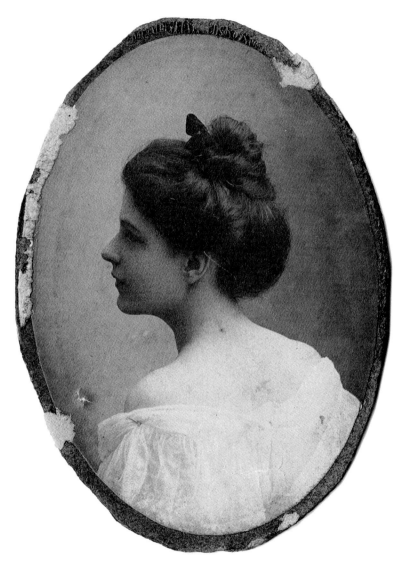

Josephine Crawford, ca. 1896;
courtesy of Mrs. Edmund McIlhenny

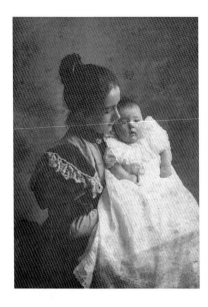

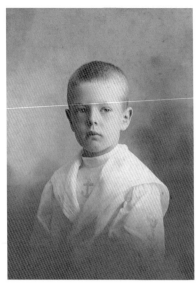

LEFT: Charlotte Crawford d'Heur with Three-Month-Old Josephine d'Heur, *December 9, 1897; courtesy of Crawford Family Papers, Special Collections, Tulane University Library*

RIGHT: Allard d'Heur, *July 1904; courtesy of Crawford Family Papers, Special Collections, Tulane University Library*

withdrew from Newcomb. Had illness caused her to withdraw?[43] Lack of interest? Whatever the reason, the academic path was not for Josephine.

In 1900, four years after withdrawing from Newcomb, Josephine left New Orleans for an extended stay with her sister Charlotte. Charlotte had married a Belgian, Pierre Joseph d'Heur, who had settled in Shelbyville, Indiana. Josephine's visit meant that Charlotte would have a companion and someone to help with the d'Heurs' two young children, Josephine ("Josézite") and Allard.[44] (Lewis wrote Charlotte that he was proud to be an uncle.)[45] Charlotte was protective of her sister: "Josey goes to a party on Friday—She will wear her piqué skirt and tucked body—her waist is a beauty, so she will be fine," she commented in a letter to her mother.[46] And Charlotte fussed: Josephine "spent the morning in the kitchen making kisses—ordering around generally—of course I don't pay any attention to her but she certainly has got a good opinion of herself." And this: "I made strawberry shortcake—I must surely be a Yankee."[47]

43 In the past, family letters had referred to Josephine's getting stronger or spending the winter on the Gulf Coast.

44 Pierre Joseph d'Heur died in 1900 after Josephine's visit had concluded. After his death, Charlotte and her children, Josephine and Allard, no doubt traveled frequently to New Orleans. Josephine d'Heur kept a scrapbook (1914) of her time at Newcomb High School, Newcomb College's preparatory school for girls. The scrapbook is in the holdings of the Historical Center of the Louisiana State Museum.

45 Lewis Crawford to Charlotte d'Heur, Oct. 20, 1898, Crawford Family Papers, Tulane, folder 3.

46 Charlotte d'Heur to Louise Crawford, 1900, Crawford Family Papers, Tulane, folder 4.

47 Charlotte d'Heur to Louise Crawford, May 18 and May 1, 1900, Crawford Family Papers, Tulane, folder 4.

John Crawford in Delta Chi House at Cornell University, Ithaca, New York, *August 4, 1900; courtesy of Crawford Family Papers, Special Collections, Tulane University Library. On reverse of picture, John Crawford wrote: "For Josephine Marien Crawford. As a peace maker. Will you forgive this for not having answered your last letter? . . . Your affectionate brother, John M. Crawford"*

Brothers William, James, and John could be called Yankees as well. Correspondence finds William in New York, John in Philadelphia, and James in Washington, D.C. In 1900, William wrote to Louise: "I have decided that John must go to Cornell University. . . . This course is absolutely necessary if he expects to reach the height of his [engineering] profession."[48] And in May 1900, John wrote of his plans to study analytical geometry, trigonometry, and calculus at Cornell, telling his mother that he will begin his studies "with you as an inspiration."[49] "Willie," some twelve years Josephine's senior, was a faithful correspondent. One of his early letters home describes his visit with Crawford relations in Belfast, Ireland, where he learned that Fortbreda was the ancestral home of one branch of the family.[50] The family had originally settled at Crawfordsburn, County Down, in the early 1600s.[51]

48 William Crawford to Louise Crawford, 1900, Crawford Family Papers, Tulane, folder 7.

49 John Crawford to Louise Crawford, May 28, 1900, Crawford Family Papers, Tulane, folder 4.

50 William Crawford to Louise Crawford, June 16, 1889, Crawford Family Papers, Tulane, folder 2. In a previous letter, written just before he sailed from New York, he mentioned meeting Bessie Bisland, a Louisiana native, who would become assistant editor of *Cosmopolitan Magazine* (William Crawford to Louise Crawford, June 7, 1889).

51 Hugh Crawford, "An Account of the Crawford Families of Baidland in Ayrshire and Crawfordsburn, County Down," 1972, private collection.

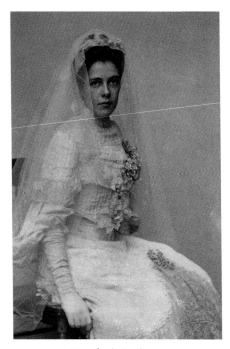

Jeanne Crawford Henderson; courtesy of Louise Chapman Hoffman. Jeanne married Hunt Henderson, brother of Josephine's good friend Sarah, in 1904.

Although the three older Crawford sons were living in the East, Josephine, in Shelbyville, was looking homeward: "I was glad to hear Mr. d'Heur ask me to stay until next year, but to me it is too long to be away from home."[52] She had written Tweety, hoping her sister would visit, but there is no evidence that she made the trip. Soon, Josephine was on her way back to Royal Street and familiar surroundings.

The early years of the century brought times to celebrate and a time to mourn. Lewis earned a brilliant score on his medical school exam.[53] Younger sister Jeanne was presented as a maid of honor in the *bal masqué* of the High Priests of Mithras, a carnival organization.[54] In 1905, the youngest Crawford, Charles Campbell, graduated from Tulane University's Department of Mechanical Engineering. Louise Crawford did not live to see Charles graduate. She died in 1903.

Charles Crawford, *père*, survived Louise by twelve years. He died in 1915 at the age of eighty. Although born in Baltimore, he had lived in New Orleans for most of his life.[55] The Crawfords, allied with an old French family through marriage, were now firmly established in New Orleans. From a modest position as bookkeeper for Henry Charnock, a dry goods concern, Charles, by 1887, was employed as a commission merchant and importer. Hosiery was imported from County Tyrone, canary seed from London, gunny bags from Calcutta by way of Liverpool, tissue paper for copying letters from Belfast.[56] The Crawford office, number 6 Tchoupitoulas Street, was on the corner of St. James Street in the First District (today's Warehouse District), close to the Water Works Reservoir and a multitude of cotton presses.[57] In the 1890s, Charles also worked as a traveling agent for Standard Guano and Chemical Manufacturing Company.[58]

52 Josephine Crawford to Louise Crawford, May 28, [1900], Crawford Family Papers, Tulane, folder 7.

53 Lewis Crawford received a medical degree and practiced medicine in New Iberia, Louisiana.

54 Perry Young, *The Mistick Krewe: Chronicles of Comus and His Kin* (New Orleans: Louisiana Heritage Press, 1969), 263.

55 *Times-Picayune*, May 29, 1915.

56 Business correspondence, 1887–89, Crawford Family Papers, Tulane, folders 11, 18, 2.

57 Farley notes that Charles C. Crawford was a principal partner in Crawford and Moore, General Storage Warehouse, 37 and 39 Tchoupitoulas Street. Farley, 10. More than likely the warehouse was connected to his importing business.

58 New Orleans city directory 1884, 1896.

The Crawfords maintained ties with Belfast throughout the nineteenth century. John Crawford IV, the first Crawford in the family to come to America, arrived in 1821 and served as British consul for a time in Baltimore. He went back to Northern Ireland, married Harriet Mackintosh, and returned to Baltimore, finally settling in New Orleans about 1835. Five children were born to the couple: William (Louise Bienvenu's first husband), Charles (Louise's second husband), John M. (probably Mackintosh), Marion (Mary), and Theodosia.[59]

John M. Crawford may have been the one who first established the importing business, as records show his name on receipts for a new building at the corner of St. James and Tchoupi-

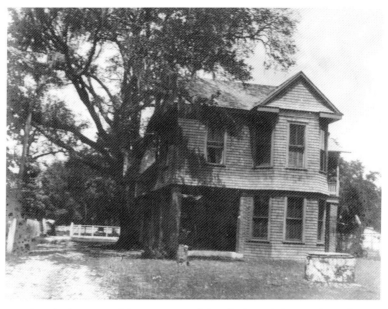

Crawford House in Biloxi; *courtesy of Crawford Family Papers, Special Collections, Tulane University Library*

toulas streets. Another receipt indicates John's good will: he paid the dental bill for Willie and Louise, his nephew and niece. John and his sisters also paid bills related to the Biloxi property that had been purchased by the Crawfords in 1871.[60] On February 23, Mathilde Pradat, widow of Christoval Toledano, sold "a lot of land" for $3,900 to Mary (Marion) and Theodosia Jane Crawford, about thirty-five acres fronting on the Gulf of Mexico and extending to the Back Bay of Biloxi.[61] A house existed on the property. As early as March 1, 1871, receipts indicate that the family made "repairs to the house at Biloxi" and owed eighty dollars to Mrs. Toledano for furniture. A wharf and bathhouse came later, paid for by John Crawford in 1881.

If the French Quarter was home, Biloxi became a haven. The Crawford letters are filled with Biloxi references. "Lewis has come home with news of a terrible storm in Biloxi," Louise Crawford wrote in July 1901 and later, "It's too bad about the water—Of course we get it all, since that Toledano pond has been filled."[62] Biloxi

59 Hugh Crawford, 16.

60 Receipt and bills, Crawford Family Papers, Tulane, folder 9.

61 Land and Deed Record, copy 5, Feb. 23, 1871, Second District, Harrison County, MS, C. J. Darby, Chancery Clerk, Book 11, 531–32.

62 Louise Crawford to Louise Harriet Crawford, July 24 and 25, 1901, Crawford Family Papers, Tulane, folder 5.

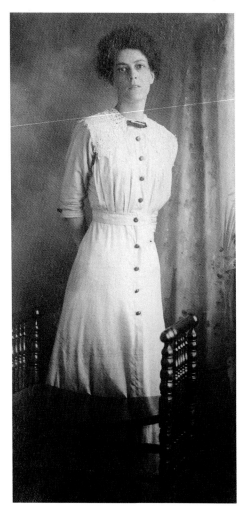

Josephine Crawford, ca. 1900; courtesy
of Mrs. Edmund McIlhenny

was both a retreat from the stresses of city life and a place for recuperating from exhaustion or illness. "José was run down so we sent her to Biloxi," Louise Crawford wrote to son John.[63] And in another letter she reminded John that he owed his good health "to your trip to Biloxi—the air and salt water . . . purified your blood! And the wharf!"[64] When Louise's own health began to fail, she informed John, "The doctor urges Biloxi."[65] Louise savored her time spent on the Coast and confided to "Mon cher M":

Je suis de retour de Biloxi. . . .
J'y ai laissé tous les enfants,
une séparation toujours pénible. . . .
Il fait bon là bas . . .
charmant et parfait—[66]

(I have returned from Biloxi. . . .
I left all the children,
always a painful separation. . . .
the weather is good over there . . .
charming and perfect—)

Biloxi, so central in the lives of the Crawfords, was the place where Charles Crawford died. His death notice stated that his funeral would be held in New Orleans upon arrival of the Louisville and Nashville morning train.[67] The road between Biloxi and New Orleans was well traveled.

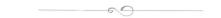

Curiosity and creativity go hand in hand. Josephine was a collector. She recreated the world around her in sketches, poems, and stories.

63 Louise Crawford to John Crawford, 1900, Crawford Family Papers, Tulane, folder 6.
64 Louise Crawford to John Crawford, May 12, 1900, Crawford Family Papers, Tulane, folder 6.
65 Louise Crawford to John Crawford, June 28, 1902, Crawford Family Papers, Tulane, folder 7.
66 Louise Crawford to "Mon cher M," n.d. (first draft), Crawford Family Papers, Tulane, folder 7.
67 *Times-Picayune*, May 29, 1915.

French Market during Mardi Gras, *1904; The Historic New Orleans Collection* (1993.137.17), gift of Robert E. Develle

Yet her life is mostly unrecorded between the early years of the century and the commencement of her studies at the Arts and Crafts Club. There is no diary to chronicle the comings and goings, accomplishments, and frustrations of that time, only artifacts that tell incomplete stories about the people involved—calling cards and recipes in French (vinegar taffy and fudge). And receipts from Mannessier's (at the corner of Royal and St. Peter streets) with a tantalizing list of edibles—vol-au-vents, king cake, sponge cake, wine cake, Paris bread, St. Honoré bread, babas, and jelly cake. F. Fellman and Company supplied satin, silk, and lace.[68]

The Crawfords were comfortable financially and well-connected socially. If ever there was a time when money was a little tight, good Creoles understood how to make economies. Madame knew just the seamstress to sew a dress. And she could train the cook, who was almost a part of the family, to bargain to her advantage at the French Market. Josephine and her sisters, well brought up—*bien élevées*—were not expected to work; their brothers pursued medicine or engineering. Families took care of their daughters who did not choose to marry.

68 Recipes, calling cards, receipts, Crawford Family Papers, Tulane, folders 23, 24, 13.

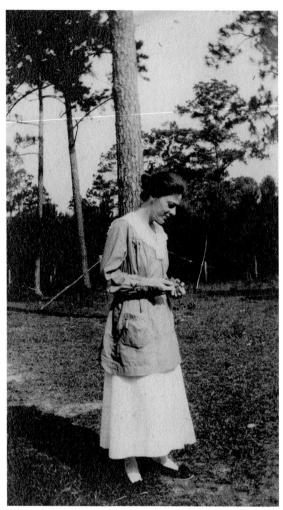

Josephine Crawford in Biloxi, *ca. 1910; courtesy of Mrs. Edmund McIlhenny*

And so Josephine—and Miss Tweety, thirteen years older—would be free to follow their interests.

If the French Quarter was in decline, there still remained a settled elegance when a visitor entered the carriageway of the Royal Street house. Some people may have thought of the old families as "marooned Creoles" and their courtyards, "wreathed with oleander or myrtle," as gloomy places;[69] but Josephine relished this very setting. She was familiar with polished armoires and vases from France. She collected maps and fine prints. The Quarter in all its diversity intrigued her, yet poverty aroused her compassion. When she looked outside to the "dormer windows opposite," she questioned herself:

> How can I play
> In flagged corridor
> And hear the silver fountain flow
> And smell the jasmine flower—
> What if the barred gates
> Enfold us safe from prying—
> Yet see the garret children
> From dormer windows opposite
> Look out into the dawn.
>
> How can I sleep
> Beneath the tufted canopy
> And coverlet of silk
> Where lilies mingle with the rose . . .
> Yet know the garret children wander:
> Hearing a shrill voice from the roof
> Calling: "Johny, come home, come home."[70]

69 Bernard Lemann, *The Vieux Carré: A General Statement* (1966; reprint, New Orleans: Louisiana Landmarks Society, Samuel Wilson Jr. Publication Fund, in cooperation with Tulane University School of Architecture, 2001), 24.

70 Crawford, THNOC, folder 16.

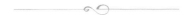

Josephine traveled, always curious about her surroundings. She painted an early watercolor of trees and houses when on vacation in Kenosha, Wisconsin (signed José C.). She sketched in the mountains of North Carolina. From Colorado Springs she wrote (1920) to the Colorado Agricultural College asking for several bulletins describing birds. "Have observed the following birds on my way up here from train through Louisiana and Texas," she wrote, providing approximate wing measurements and concluding the list with birds "all familiar on Mississippi and Louisiana Coast"—flycatcher/king bird, tree swallow, night hawk, killdeer, and tufted titmouse.[71] In 1922, Josephine traveled to France, not yet an art student but an unusually attentive observer. During her trip abroad, she drew designs of parterre gardens observed in Versailles and Fontainebleau and noticed, with an eye to the less obvious, a crane's-foot violet in the Tuileries and a bluet-type flower in the Luxembourg Gardens.[72]

Art had always hovered in the background of Josephine's world. But now, with an art movement taking hold in the French Quarter, Josephine began lessons at the Arts and Crafts Club shortly after her return from France.[73] This would be the decisive moment in her life.

71 Josephine Crawford to the Colorado Agricultural College, July 1, 1920, Crawford, THNOC, folder 1.

72 Josephine Crawford's sketchbooks, THNOC, acc. no. 1978.23.380.1–.8.

73 Sarah Henderson may deserve at least partial credit for Josephine's decision to enroll in art classes.

Valentinien Grocery Store on Chartres Street at Toulouse Street, *between 1905 and 1910; The Historic New Orleans Collection (1994.124.13), gift of Inez Grieshaber, Mary Lou Hardy, Joan Perret, and Karen McGoey in memory of James E. Steiner*

Josephine at the Arts and Crafts Club

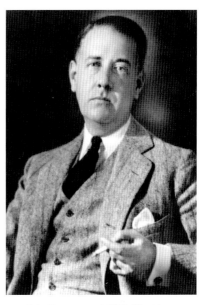

Lyle Saxon, ca. 1930; The Historic
New Orleans Collection
(1983.215.75), gift of Gretchen
Crager Sharpless

*Art students find living cheap here and now, in the New Orleans
Art School . . . they are finding instruction as good as any in
America, and at incredibly low rates.*

—DANIEL WHITNEY, Times-Picayune

OW TO DESCRIBE THE FRENCH QUARTER in the early years of the twentieth
century? Neglected, in a word. And beginning to lose its landmarks: the St. Louis
Hotel was severely damaged by a hurricane in 1915, and the famed French
Opera House burned to the ground in 1919. Some saw the Quarter as melancholy and musty.
But others saw the former elegance of the Creole neighborhood. A few of the old families
resisted leaving—the Crawfords and their next door neighbors, the Puigs—as did a number of
businesses. Those who knew where (or how) to look sensed a romantic quality in the shabbi-
ness and a feeling of "motley buoyancy."[1]

Indeed, a movement was afoot. Lyle Saxon, journalist and bon vivant, loved the decaying
buildings—he lived among them—and he used his pen to capture the public's imagination.
Saxon and others envisioned a flourishing of the arts, while civic leaders helped galvanize
interest to keep the old square safe from demolition by design or by neglect. As perceptions

1 Lemann, 25.

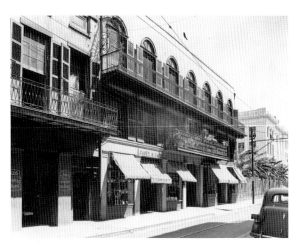

520 Royal Street (first home of Arts and Crafts Club), July 1939; *Vieux Carré Survey at The Historic New Orleans Collection* (square 41)

changed, critics no longer described the French Quarter as *déclassé*—instead they called it mellow and worn. And arts organizations were opening throughout the Quarter: Le Petit Théâtre du Vieux Carré in 1916, the Quartier Club in 1920.[2]

This sense of promise inspired a number of artists to meet at Alberta Kinsey's apartment, 628 Toulouse Street, to discuss an art school.[3] (Kinsey, a Midwesterner, would become one of the best known of the Quarter artists.) The Artists Guild was organized during a subsequent meeting attended by prominent New Orleanians who could offer ideas and financial backing: George and Martha Gasquet Westfeldt, architect Richard Koch, Sarah Henderson.[4] Peripatetic at first, the group met at 619 St. Peter Street, corner of Exchange Alley (present-day Cabildo Alley); moved to a room in the old Mortgage Building on the corner of Royal and Conti streets; then settled again in the Green Shutter Tea Room at 633 Royal Street owned by Martha Westfeldt.[5] By this time, the Artists Guild had renamed itself the Arts and Crafts Club.

Finally, "the good angel" of the French Quarter, philanthropist William Ratcliffe Irby, offered the club a permanent home: the Brulatour (previously Seignouret) mansion on Royal Street, number 520, one block upriver from Josephine's house.[6] Irby's restoration of the Brulatour site and the Paul Morphy house in the 400 block of Royal helped prevent the Quarter from "rapidly passing into the land of forgotten things."[7] On June 2, 1922,

2 Some consider the Quartier Club the forerunner of Le Petit Salon, founded in 1924. A prestigious cultural organization for women, Le Petit Salon is still active today.

3 *Item-Tribune*, Apr. 15, 1928; Judith H. Bonner, *The New Orleans Arts and Crafts Club: An Artistic Legacy*, exhibition catalogue (New Orleans: New Orleans Museum of Art and The Historic New Orleans Collection, 2007), 6. The artists probably began meeting not long after the French Opera House burned in December 1919.

4 Newspaper clipping, Sept. 10, 1950, Arts and Crafts Club, Artists Files, THNOC.

5 Judith H. Bonner, "All the Artful and Crafty Ones," *The Historic New Orleans Collection Quarterly* 11 (Winter 1993): 4–6; *Item-Tribune*, Sept. 1929, art clippings file, Louisiana Collection, Special Collections, Tulane University (hereafter La. Coll., Tulane). Sources vary on the order of the temporary meeting places but all agree on the locations.

6 Art classes were held in the Brulatour mansion as early as June 1921, but the official charter of the club was not signed until June 1922. Judith Bonner, interview by author, July 24, 2008.

7 *Times-Picayune*, Jan. 2, 1923. The building at 417 Royal Street had been the residence of Paul Morphy, chess genius. Later, it was the site of the Patio Royale, a popular reception hall. Brennan's restaurant is now housed in the building.

the founding members signed the Arts and Crafts Club charter.[8]

Josephine, walking down the river side of Royal Street, had passed number 520 countless times. And she probably detected the "sweet winey fragrance," as one reporter put it, that lingered in the old plaster, a vestige from the days when wine merchants conducted business on the property. Anyone who entered the fine building would pause first to look up at the curled *garde-de-frise* that protected the end of the balcony before proceeding through the carriageway and across the flagstones of the courtyard. Muted colors and olive jars appealed to the senses—a perfect place for lessons in life drawing, painting, sculpture. Soon the public would come to hear lectures and to buy art and crafts in the salesroom.

A newspaper account described the setting:

> The old courtyard is surrounded with studios. A little shop has opened in one corner and the latest Parisian novelties are on sale. The main part of the house has been converted into apartments for artists, and the huge slave quarters, four stories high and extending the entire width of the house, houses the studios of the Arts Club.[9]

Courtyard at 520 Royal Street; *Vieux Carré Survey at The Historic New Orleans Collection* (square 41)

Members and students had access to an auditorium and a room for exhibitions, with workrooms and smaller studios above. Will Henry Stevens, Gertrude Roberts Smith, Alberta Kinsey, Lydia Brown—names prominent in local art circles—were among the first to exhibit in the gallery.

8 Mrs. Marguerite Mason-Smith, Mrs. David Burkenroad, Mrs. Martha Gasquet Westfeldt, Miss Sarah Henderson, Mrs. Noel F. Elliott, Walter Brown Keiffer, and George G. Westfeldt, founders of the club, signed the charter before notary Frank William Hart. Arts and Crafts Club Collection, MSS 247, acc. no. 76-159-L (hereafter ACC Coll.), THNOC, folder 27.

9 *Times-Picayune*, Jan. 2, 1923.

A reporter for the *Times-Picayune* could barely contain his enthusiasm for the new organization, writing that the Brulatour house "is now the center of artistic interest in the new New Orleans. It houses a club which is already playing an important part in the cultural development of the city. . . . In years to come this New Orleans club will be known from one end of the country to the other. Even now its fame is spreading."[10]

Josephine enrolled in the club's art school in the early to mid-1920s; the exact date is unknown.[11] In May 1926 a list of students included Josephine's name, mistakenly written "Julia."[12] That summer she went to the Ocean Springs Art Colony on the Mississippi Gulf Coast.[13] Her instructor, Daniel Whitney, who had studied at the Maryland Institute College of Art and the Pennsylvania Academy of the Fine Arts, conducted classes at Fairhaven, the home of artist Walter Anderson's parents.[14] And by September, visitors to the Arts and Crafts Club could see an exhibition of work from the summer colony. A few months later, January 1927, Josephine joined other students in a show of "six modern local artists." *An Interior* and *Avocados* evoked praise from Vera Morel, a stalwart of the club, who wrote that Josephine's "canvases seem almost empty, but in their textures and muted color, one may feel the stillness and silence and almost 'life' in the inanimate painted objects."[15]

As the year continued, appreciation grew for Josephine's work. Art columnists marveled at the discovery of a previously unknown talent in their midst:

> The paintings of Miss Josephine Crawford aroused a great deal of interest not only for their exceptional merit and individuality but also for the fact that this is the first year that Miss Crawford has ever done any sort of painting.[16]

At the same time that the club was becoming the center of artistic interest in New Orleans, writers were moving to the Quarter, adding their own energy and talent to the cultural scene. William Faulkner arrived in 1924. Sherwood Anderson spoke at the Arts and Crafts Club in the fall of 1925.[17] The *Double Dealer*, a literary

10 Ibid. The reporter added that the club could be reached by the Desire streetcar.

11 Josephine's 1925 voter registration card lists her occupation as "none" (and her party affiliation as Democratic). But her career, if she would have called it that, was soon to begin. Copy of voter registration card, Josephine Crawford, Artists Files, THNOC.

12 Newspaper clipping, May 2, 1926, La. Coll., Tulane.

13 *Morning Tribune*, Sept. 18, 1926, Arts and Crafts Club, Artists Files, THNOC; *Morning Tribune*, Sept. 22, 1926, Josephine Crawford, Artists Files, THNOC.

14 Noted artist Walter Anderson (1903–1965) was born in New Orleans and studied at the Pennsylvania Academy of the Fine Arts. He lived and painted in Ocean Springs, MS, where the Anderson family established Shearwater Pottery.

15 *Morning Tribune*, Jan. 12, 1927.

16 *Item-Tribune*, 1927, Josephine Crawford, Artists Files, THNOC. Josephine made early sketches and watercolors, but she did not turn her full attention to art until the 1920s.

17 *Times-Picayune*, Oct. 4, 1925. Sherwood Anderson (1876–1941), author of *Winesburg, Ohio*, lived in the French Quarter in the 1920s.

Lydia Brown, between 1922 and 1928, oil on Masonite, 20 x 16"; The Historic New Orleans Collection (1995.103.2i), gift of Laura Simon Nelson

magazine that published early work by Faulkner and Hemingway, among others, appeared in 1921 and continued until 1926.[18] That same year, 1926, saw the publication of the satiric *Sherwood Anderson and Other Famous Creoles*. Faulkner wrote the text; William Spratling, a denizen of the Quarter and associate professor at the Tulane University School of Architecture, drew caricatures of the Quarter's "Artful and Crafty Ones." Regardless of whether Josephine read the *Double Dealer* or . . . *Other Famous Creoles*, she lived in the middle of a literary and artistic renascence. The spirit of the times was catching. Knute Heldner's first one-man show opened at the Isaac Delgado Museum of Art under the auspices of the Art Association of New Orleans.[19] Childe Hassam, according to the *Times-Picayune*, would come soon and make the Arts and Crafts Club his headquarters while in town.[20]

Fortunately for the future of art in New Orleans, there were individuals willing to provide financial backing for the club and its art school. Mainstays such as Sarah Henderson and George and Martha Gasquet Westfeldt not only supported the organization financially but also served on the club's governing board. There were, of course, a few naysayers. One critic referred dismissively to "a lonely group in New Orleans who have an interest in Art. It is rather a sad age in that respect to be living in, is it not?"[21] The "lonely group," however, had founded a club that would make a difference in many lives.

The Arts and Crafts Club, along with other organizations throughout the South, was affiliated with the Southern States Art League, dedicated to the advancement of art in the region.[22] Representatives from the club attended the 1927 annual meeting of the League in Charleston and presented a report that affirmed their objectives:

> To foster higher artistic standards, to establish classes in different branches of art and crafts, to enable the artist, the craftsman, and the public to get in touch with one another, to maintain a club room, exhibition and sales room, and to assemble the current literature of the arts and crafts.[23]

18 Proofreading, as always, bedevils editors. A reader of the *Double Dealer* sent an indignant letter to Gideon Stanton, a member of the editorial staff, taking him to task and accusing him of being asleep. "Have you any proof reader?" he asked, before pointing out a number of mistakes. Stanton, a New Orleans businessman who was also an artist, strongly supported the various arts organizations in the city. William Beer to Gideon Stanton, Feb. 13, 1922, ACC Coll., THNOC, folder 190.

19 The Heldner show opened at Delgado in 1926. Heldner (Knute A.) Papers, MSS 3650, LSU Libraries, Special Collections, finding aid, www.lib.lsu.edu/special/findaid, consulted July 6, 2004. Heldner (1886–1952), born in Sweden, was a prolific artist active in both Duluth, Minnesota, and New Orleans.

20 *Times-Picayune*, Mar. 7, 1926. Childe Hassam (1859–1935) was a noted American Impressionist.

21 Ralph M. Pearson to Gideon Stanton, Jan. 14, 1922, ACC Coll., THNOC, folder 185.

22 Ellsworth Woodward (1861–1939), professor of art at Newcomb College, was president of the Southern States Art League for many years.

23 Report, typescript, Apr. 1927, Arts and Crafts Club vertical file, La. Coll., Tulane, folder 1.

Life-Drawing Class from Art School Pamphlet; *The Historic New Orleans Collection (ACC Coll., MSS 247, 76-159-L, folder 68), gift of Mr. and Mrs. John McCrady and Mr. and Mrs. Harry B. Kelleher*

Active membership cost $5 for the year; contributing membership, $10; sustaining, $25. The New Orleans Art School—the club's art academy—offered both day and night classes (no age limit, no entrance requirements, modest fees); free lectures; group shows that featured work by the school's teachers and students, with or without a jury; and one-man shows (chosen from the work of members or students). The club did not advocate one style of art over another; the goal, instead, was to present "the trend of the art-of-today, both conservative and modernistic."

Needless to say, New Orleans audiences could be easily shocked by the "art-of-today." To shock the public—*épater la bourgeoisie*—was something Caroline Durieux was only too happy to do. She was "one of the first to astonish New Orleans by exhibiting some paintings in the extremely 'modern' style that still scandalizes many."[24] A lecturer from Tennessee viewed the "modern" in a more positive light, pronouncing the Arts and Crafts Club "more in sympathy with the modern movement in art than any other institution of its kind in the South."[25]

New Orleans, far removed from art centers on the east and west coasts, nevertheless was a place that fostered creativity. This was not just any American city—the French Quarter, the port, the cosmopolitan mix of

24 Press release, Arts and Crafts Club vertical file, La. Coll., Tulane, folder 1.

25 *Item-Tribune*, Mar. 24, 1929.

Josephine Crawford's Studio in the Drawing Room at 612 Royal Street, photo by Richard Koch, ca. 1936; The Historic New Orleans Collection (1979.51.2), gift of Boyd Cruise

the population provided the backdrop that invited a response. Club members happily responded when planning their annual artists ball. The popular beaux-arts balls inspired costumes (obligatory) and provided an occasion for delicious gossip. It was hard to forget Salome (Genevieve Pitot) performing the dance of the seven veils.[26]

The Royal Street club had become a magnet. Instructor Daniel Whitney told a reporter that "already, in its one-year of existence, the school has drawn 200 students from every section of Louisiana, every southern state, and many of the middle western states."[27] Charles Bein, who had studied in Munich and Paris, served as the first director of the school, which sponsored a competition for a scholarship to the Pennsylvania Academy of the Fine Arts as well as awarding the annual Blanche Benjamin Prize for the best painting of a Louisiana landscape. The school also offered five student prizes of $25 each in various categories—painting, drawing, sculpture, architectural drawing, and etching.

Josephine found herself in the center of things, intimately associated with many club supporters. Martha Westfeldt, whose husband served as president in 1927, was a close friend and traveling companion. Another friend, Dr. Joseph Hume—Josephine painted his portrait—lent Japanese prints for an exhibition in the early days of the club.[28] Sarah Henderson was related to the Crawfords through marriage—her brother Hunt had married Josephine's younger sister Jeanne. Architect Richard Koch was an ardent preservationist and family friend. His photographs preserve the period look of many French Quarter buildings; he would later photograph Josephine's wallpaper paintings in her Royal Street studio.

Although she had begun to paint only a year or two before, Josephine was one of four artists asked to exhibit at the club's invitational show in November 1927.[29] She would not be in New Orleans to see the exhibition go up. The day the show opened she was in Paris, beginning her study under André Lhote.

26 W. Kenneth Holditch, "The Brooding Air of the Past: William Faulkner," in *Literary New Orleans: Essays and Meditations*, ed. Richard S. Kennedy (Baton Rouge: Louisiana State University Press, 1992), 48.

27 *Item-Tribune*, May 8, 1927.

28 Arts and Crafts Club brochure, 1922–23, Arts and Crafts Club vertical file, La. Coll., Tulane, folder 1.

29 *States*, Nov. 27, 1927.

Dr. Joseph Hume,
*between 1928 and
1935, oil on canvas,
32 x 15 1/16"; The Historic
New Orleans Collection
(1978.23.24), bequest
of Charles C. Crawford*

Despite the enthusiasm of Arts and Crafts Club patrons, many New Orleanians were dismayed with modern trends in art. A 1927 exhibition of the work of Abraham Rattner—whom Josephine would meet in Paris—raised eyebrows across town. "The general public," observed one columnist,

> in its usual superior and critical manner of art, thinks them [the paintings] "wild" and "crazy" and begs you to explain "what they mean" and why the Arts and Crafts Club "brings down such stuff."[30]

Another critic expanded on this theme:

> What of New Orleans? We are inclined to believe that art still slumbers in this balmy and culture-saturated air of New Orleans. . . . There are, however, small groups of artists, students, and real art lovers who are recording this beauty in paint and in verse, doing excellent work in spite of the handicap of an unawakened public and a lack of patronage.[31]

Vera Morel, secretary of the Arts and Crafts Club in 1927, added her voice to the chorus: "Were it not for a small group—mainly teachers and a few altruists—this big city would be artistically destitute."[32]

But one could take encouragement from the continuing excellence of the exhibitions at the club. Daniel Whitney expressed optimism about the club's prospects. "Mr. Whitney," a reporter stated, "believes that New Orleans will soon be in fact what it now claims to be, the art center of America. Art students find living cheap here and now, in the New Orleans Art School . . . they are finding instruction as good as any in America, and at incredibly low rates."[33] By November 1928, Josephine and sculptor Angela Gregory were featured in a joint show—both just back from Paris and both "beginning to set about memorializing the South in art." Artworks on view included Josephine's *Cathedral at Beauvais, Nude, Cat,* and Angela's *La Belle Augustine.* The *Morning Tribune's* critic found Crawford's entries surprising. "One would never believe," he commented, "seeing the canvases hanging at the club, that she has been painting only a couple of years. She has an instinctive color sense that makes each one of her pictures a veritable symphony. But it is her viewpoint that is most remarkable."[34]

Just after the first of the year the club exhibited an oil painting by Georgia O'Keeffe, on loan from Hunt Henderson.[35] This painting was probably the red poppy that eventually hung in the Hendersons' cottage in Biloxi.[36]

30 *States,* Nov. 6, 1927.

31 Newspaper clipping, Jan. 20, 1928, La. Coll., Tulane; the subject of the article was the Benjamin Prize, awarded to Adele Godchaux Eckles.

32 Newspaper clipping, Jan. 6, 1928, La. Coll., Tulane.

33 *Times-Picayune,* July 15, 1928.

34 *Morning Tribune,* Nov. 12, 1928.

35 Arts and Crafts Club bulletin, Josephine Crawford, Artists Files, THNOC.

36 *Poppy* by Georgia O'Keeffe was taken out of the Hendersons' Biloxi house before Hurricane Camille in 1969 by Charles Henderson, son of Jeanne and Hunt Henderson. The painting was given to the Museum of Fine Arts in St. Petersburg, Florida. (Information from Leigh Henderson Burton, daughter of Charles Henderson.)

Reclining Nude on Blue Empire Sofa, between 1928 and 1935, oil on canvas, 24 x 39¹⁄₁₆"; The Historic New Orleans Collection (1978.23.15), bequest of Charles C. Crawford

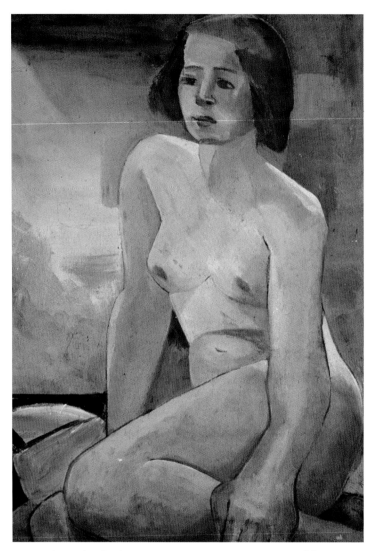

Nude, undated, oil on Masonite, 13³⁄₁₆ x 18⅞"; courtesy of the
Morris Museum of Art, Augusta, Georgia (1989.05.255)

The names Sarah and Hunt Henderson—brother and sister—were synonymous with art in New Orleans. A comfortable fortune derived from the family's Henderson Sugar Refinery provided the means for acquiring significant art collections. A loan exhibition from Hunt Henderson in the early years of the club gave the public a chance to see drawings and prints by Whistler, Matisse, Picasso, Cassatt, Rodin, Degas, Cézanne, and John Marin, among others.[37] Passionate about art, the Hendersons were the ones to urge Josephine to study in Paris, perhaps helping financially. And Hunt Henderson, with his art connections in New York, opened doors for Josephine and fifteen other club artists to exhibit at the influential Montross Gallery in 1929—"Work of N. O. Artists Is Sensation in N. Y.," ran a headline in the *States*. The New York show, the writer learned, resulted from the efforts of a New Orleanian whose wife is interested in the Arts and Crafts Club.[38] There was no doubt about the identity of the "New Orleanian." A columnist at the *New York Herald-Tribune* commented that "not frequently are we in New York made aware of what is going on in the provinces. How well other artists are painting in other parts is well exemplified in the exhibition of paintings by a group of members of the Arts and Crafts Club of New Orleans."[39]

The significance of the Montross exhibition cannot be overstated. The New Orleans artists were in excellent company. In 1914, the Montross—located at 26 E. 56th Street, just off Madison Avenue—had presented an exhibition of modern American art, the first commercial gallery to do so after the 1913 Armory Show. Exhibitions of works by Matisse and Cézanne followed, in 1915 and 1916 respectively, "providing the most comprehensive representations of each artist yet mounted in the United States."[40] In 1929, Josephine's three oils—*Nude*, *Flower Study*, and *Head*—joined paintings by Charles Bein, Douglas Brown, Adele Godchaux Eckles, Don Graham, Weeks Hall, Knute Heldner, Charles Woodward Hutson, Foster Jewell, Alberta Kinsey, Clarence Millet, Gertrude Roberts Smith, Gideon Stanton, Will Henry Stevens, Baroness Lucienne de St. Mart, and Daniel Whitney.[41] One New Orleans critic singled out the work of Bein (*Goats*) and Crawford (*Head*): they "realize the necessity for something more than photographic renderings of exotic swamplands, or of courtyards reminiscent of France."[42]

The year 1929 also brought Lyle Saxon back to New Orleans (he had been living in New York) for a reception in his honor at the Arts and Crafts Club. Elizabeth M. Gilmer (Dorothy Dix) introduced Saxon, who needed

37 Press release, prior to 1924, Arts and Crafts Club vertical file, La. Coll., Tulane, folder 1.

38 *States*, Mar. 1, 1929.

39 *New York Herald-Tribune*, 1929, Josephine Crawford, Artists Files, THNOC.

40 Judith Zilczer, "The Dissemination of Post-Impressionism in North America: 1905–1918" in *The Advent of Modernism: Post-Impressionism and North American Art, 1900–1918* (Atlanta: High Museum of Art, 1986), 34.

41 Exhibition brochure, Arts and Crafts Club, Artists Files, THNOC. Information also in Montross Gallery exhibition checklist, Arts and Crafts Club vertical file, La. Coll., Tulane, folder 2.

42 Newspaper clipping, ACC Coll., THNOC, folder 374.

LEFT: Spider Lilies, *between 1935 and 1945, oil on canvas, 30 x 18"; courtesy of Catherine and Hunter Babin*

RIGHT: Calla Lily, *1939, oil on canvas, 27 x 16¼"; courtesy of Martha A. Eshleman*

Stairs to Courtyard Apartment at 612 Royal Street, ca.1935; courtesy of Louise Chapman Hoffman

no introduction—everyone had read *Father Mississippi* and *Fabulous New Orleans*. A profile of Saxon would refer to him as "an artist with a jigger of absinthe" who had just returned from four years in New York to live "in his beloved Royal Street."[43] Living was easier, prices reasonable: dinner cost forty cents (delivered, fifty cents) at the Pitre Restaurant run by Madame Gautreaux at 742 Royal.[44] Saxon resided for a while at 612 Royal, in back of the main house.[45] By this time, Josephine and her sister, Miss Tweety, had moved to the third floor of the 612 Royal Street house, which had been divided into apartments by Tweety.

Josephine had set up her studio on the second floor. Surrounded by the accoutrements of art, she sketched and made drawings, recalling Lhote's advice: "one only learns to paint by drawing." Now and then she might pause to chat with Tweety or stop by the Arts and Crafts Club to see the latest show. Her friend Sarah Henderson served on the committee that organized one of the loan exhibitions—ancestral portraits of Louisianians from private collections (looking backward this time, instead of forward). No doubt Josephine saw likenesses of Valcour Aime, Etienne Boré, and the de Marignys, all prominent in New Orleans's early days.[46] And she enjoyed the social life of the club. She looked forward to the artists ball, called that year *Le Bal des Etoiles*, scheduled for April (1930).[47] Richard Koch was in charge and it is likely that Josephine was on hand to help with arrangements. Only costumed "artistes" would be admitted and whatever the theme, a late night was guaranteed.

Josephine exhibited at the club in 1931 and 1932, prompting Koch to write Sarah Henderson that "we are glad to see that she is getting away from the influence of her Paris instructors."[48] Koch sent periodic reports to Miss Sally, who was often out of town. "The registration for the school . . . is beyond any thing that we expected," he informed her in 1931, "and for the first time in years I find Mr. Bein in a good humor."[49] Besides

43 Magazine clipping, Oct. 4, 1930, ACC Coll., THNOC, folder 391.

44 Advertisement in "Arts and Crafts Review," 1932, ACC Coll., THNOC, folder 63.

45 A 1932 letter confirms the address. Chance Harvey, *The Life and Selected Letters of Lyle Saxon* (Gretna, LA: Pelican Publishing, 2003), 252.

46 *States*, Feb. 25, 1930; newspaper clipping, ACC Coll., THNOC, folder 357.

47 *Times-Picayune*, Apr. 20, 1930. See also *States*, Apr. 17, 1927, for a discussion of a previous artists ball.

48 Richard Koch to Sarah Henderson, 1932, ACC Coll., THNOC.

49 Richard Koch to Sarah Henderson, 1931, ACC Coll., THNOC.

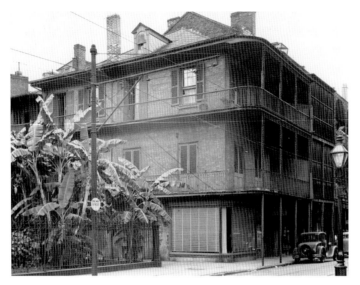

712 Royal Street (second home of Arts and Crafts Club), *undated;*
Vieux Carré Survey at The Historic New Orleans Collection
(square 44)

a healthy number of student artists, Charlie Bein could congratulate the club (and by extension himself) for hanging a modern show (1931), a traveling exhibition of American artists that included Charles Sheeler, Stuart Davis, Max Weber, and Marguerite Zorach.[50] If the modernists proved difficult to appreciate, there would always be another show to appeal to more traditional tastes. It wasn't long before the club mounted an exhibition of old prints and maps. Josephine contributed items from her collection, as did Albert Lieutaud, N. C. Curtis, Mrs. Edgar Stern, and Solis Seiferth, among others.[51]

In 1933, the Arts and Crafts Club moved again—providentially, only one block away from Josephine, in the other direction. Sarah Henderson owned the property at 712 Royal Street where the club made its new home, in local parlance the "uptown river corner" of Pirate's Alley (formerly Orleans Alley). Students could appreciate the view of the cathedral garden, the northern light essential for painting (no shadows), the white walls (the best background for displays of art), and the bottle-green floors.

One of the first shows at 712 Royal showcased paintings done in Mexico by local artists that included works by Caroline Durieux and her friend, famed Mexican artist Diego Rivera.[52] Mexico attracted a number of New Orleans artists. William Spratling had decided to settle in Mexico;[53] others went there to paint—Charles Bein, Alberta Kinsey, and Richard Koch. Caroline Durieux lived in Mexico City for ten years (1926–1936) with her husband, Pierre, who was in the exporting business. Josephine went to Mexico at least once, but she did not

50 Jessie Poesch, "Will Henry Stevens (1881–1949)," in *Will Henry Stevens*, exhibition catalogue (Greenville, SC: Greenville County Museum of Art, 1987), 25.

51 Newspaper clipping, La. Coll., Tulane.

52 *Item*, Nov. 13, 1933. Some of Rivera's work had been on view at the club a few years before (*Item*, Oct. 12, 1928).

53 William Spratling (1900–1967) moved to Mexico in 1929. He became interested in the silver mines in Taxco and is well known for the designs he created for silver jewelry.

By the time the Arts and Crafts Club moved to Pirate's Alley, the organization counted a number of prominent New Orleans artists and art supporters among its membership, including Richard Koch, Paul Ninas, and Enrique Alférez.

TOP LEFT: Pirate's Alley by Daniel S. Leyrer, between 1929 and 1940; The Historic New Orleans Collection (1981.324.1.34), gift of Allan Phillip Jaffe

TOP RIGHT: Enrique Alférez by Daniel S. Leyrer, between 1929 and 1940; The Historic New Orleans Collection (1981.324.2.403), gift of Allan Phillip Jaffe

BOTTOM LEFT: Rudolf Staffel, Julius Woeltz, Richard Koch, Albert Lieutaud, and Paul Ninas, ca. 1940; The Historic New Orleans Collection (1991.116.2), gift of John F. Clemmer

enter any of her Mexican art in the exhibition. Her sketches and watercolors from Mexico evoke a sure hand and a sense of place, but they remain exercises rather than finished works.

The move in the fall of 1933 was celebrated with tea in Pirate's Alley. *States* reporter Elizabeth Kell observed a fine mix of manners and art: she saw "swarthy" Enrique Alférez, teacher and sculptor, along with Charlie Bein discussing pictures with Natalie Scott.[54] Faithful Alberta Kinsey attended, her still-life painting "an example of the steady improvement of this pioneer Vieux Carre artist." Young "Jack" (Nellie May) Bartlett, the club's indispensable secretary, was described as sprightly "in a green crepe de chine dinner gown."[55] Jack talked to Ellsworth Woodward, head of the Newcomb Art School, and to artists Will Henry Stevens and Paul Ninas (who had settled in New Orleans in 1932 after living in Europe and the West Indies). Angela Gregory joined the crowd—but no mention of Josephine. She may have stayed a short while before returning to her studio, for she had important work to do. The deadline for the Benjamin Prize competition approached (not later than 5:00 p.m., January 26, 1934). Back in her studio, Josephine would have looked at her entry, *Rue Kerlerec*, with a critical eye—adding a touch of gray here, a line of black there, and approving the wonderfully long nose in the somber face of a Creole widow, the subject of the canvas.

Civic leader Edward B. Benjamin had established the Blanche Benjamin Prize in 1924 in honor of his wife. Originally, the award went to the best painting of a Louisiana landscape, defined as "any out-of-door view having as its chief point of interest objects typical of the scenery of Louisiana." By 1934—Josephine's year to enter *Rue Kerlerec*—the landscape requirement had been reinterpreted to include any Louisiana subject. Artists were asked to submit oil paintings only, framed without glass, measuring not less than twenty by thirty inches.[56] The canvases were to be displayed at the Arts and Crafts Club and to remain on view for two weeks after the jury decision.[57] Artists were reminded: no signatures on the front of the painting. Past winners included Weeks Hall, Charles Bein, and Boyd Cruise.

Imagine a midwinter day, 1934. First picture the double doors of 612 Royal Street. They are open. Josephine steps outside. She has wrapped a large painting in brown paper, awkward to carry, and begins the familiar walk to the Arts and Crafts Club. She passes a building with a stuccoed façade, now a worn terracotta; next

54 Natalie Scott reported for the *States* and was a friend of the Quarter's artists and authors. An extraordinary woman, she won the Croix de Guerre for bravery during World War I. Her concerns included schools and medical care for the poor in Taxco, Mexico.

55 *States*, Oct. 10, 1933.

56 *Times-Picayune*, Jan. 25, 1934. An earlier requirement asked for canvases not less than sixteen inches in their smallest dimension.

57 Blanche Benjamin Prize notice, Arts and Crafts Club vertical file, La. Coll., Tulane, folder 1.

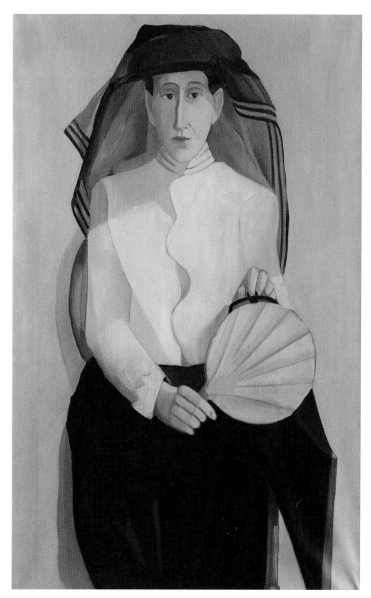

*Rue Kerlerec, 1934, oil on canvas, 38½ x 24"; courtesy of
Micheline M. Bator; photograph by Michael Gould*

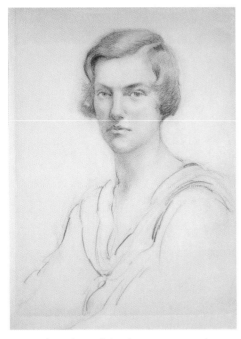

Jack Bartlett Kelleher *by Xavier Gonzales, 1930s, Conté crayon and pencil; courtesy of Jackeen Kelleher Churchill*

door the hue is a soft tan. Shallow pools of water left from last night's rain are drying on flagstones, gray here, lavender-brown there, colors that will find their way to Josephine's palette. Her eye for detail is sharp. She remembers a poem she has written:

> Yellow walls, crimson tiles,
> Iron railings Like a web
> Tracing patterns over all.[58]

The scene shifts. It is January 28, and Josephine is the guest of honor at the annual Benjamin Prize reception. *Rue Kerlerec* is the winner.[59] Charles Bein, an accomplished watercolorist himself, announces the $250 prize; the judges are Juanita Gonzales, Mrs. Alex Leonhardt, and Enrique Alférez. Friends have gathered to toast Josephine: Sarah Henderson, George Westfeldt, Richard Koch, and artist Xavier Gonzalez.[60] Surely Jack Bartlett is there as well—she supervised the gallery and often spent six days a week at the club.[61] And where is the subject of the prize-winning work? The Creole widow—besides existing in Josephine's mind—could be sitting on her porch on Kerlerec Street, where it angles off Frenchmen just below Esplanade Avenue—the area of town beyond the French Quarter known as the Faubourg Marigny.

A columnist praised the restraint in Josephine's *Rue Kerlerec*: "With limited color she has achieved in the painting of the Creole widow both a pathos and humor."[62] Restraint was also the keynote of Evelyn Witherspoon's newspaper column, "Arts and Crafts Club":

> She [the widow] is the essence of a very dear and very remote New Orleanian. . . . The simplicity of the composition, the boldness and the restraint in handling the color say more than any detail—and such color . . . a harmony of warm and cold gray, cream and black gray—a very happy symphony."

58 Crawford, THNOC, folder 151.

59 According to Jack Kelleher, Dr. Joseph Hume purchased *Rue Kerlerec* for $400 almost immediately after the show. When Hume died (1936), his widow returned the painting to Josephine Crawford. Farley, 156–57.

60 Besides teaching at the Arts and Crafts Club, Xavier Gonzalez, a native of Almeria, Spain, was an art instructor at the Newcomb College Art School.

61 Nellie May "Jack" Bartlett married Harry B. Kelleher in 1936.

62 Newspaper clipping, ACC Coll., THNOC, folder 305.

Witherspoon concluded that the 1934 competition was "one of the best" in years, and—a testament to Josephine's standing in the art community—no one was disgruntled with her selection. Josephine was in the company of a distinguished coterie: Charles Hutson, Jane Ninas, John McCrady, Paul Ninas, Clarence Millet, Clayre Barr, Herbert Frère, Marcelle Peret, and Dr. Marion Souchon, among others.[63]

Josephine came into her own in the mid-1930s. The success of *Rue Kerlerec* hints at a special sympathy between artist and subject. Josephine's background made her uniquely suited to capture a disappearing Creole world. And this she did in the person of the little widow in stiff mourning veil, bombazine skirt, palm-leaf fan, and parasol "whom we might see any day on Esplanade Avenue or Kerlerec Street."[64] But Josephine was too busy to spend much time congratulating herself. That spring she exhibited in the club's annual invitational show ("Miss Crawford has just won the Benjamin prize and whatever she shows will be worth seeing") and in the gallery of Dr. and Mrs. Frans Blom at 513 St. Ann Street, in the Lower Pontalba Building facing Jackson Square.[65] At year's end, Josephine had work on view in a group show at the Arts and Crafts Club.[66] She was also creating art for the government—for the Public Works of Art Project (PWAP), the first of the New Deal art programs. And she was creating art for herself, painting family portraits on the wallpaper at home.

Ellsworth Woodward, the New Englander who had devoted his life to art in the South—most especially to the Newcomb College Art School and the Isaac Delgado Museum of Art—had been named director of Region 6 of the PWAP. He supervised artists in Louisiana, Mississippi, Alabama, and Arkansas who had been hired to produce paintings that pertained to the history, industry, and commerce of their states. Art created for the project went to tax-supported buildings and parks. Most important, the PWAP provided work for artists, many of them the old crowd from the Arts and Crafts Club: Enrique Alférez, Clayre Barr, Herbert Frère, Angela Gregory, Alberta Kinsey, Clarence Millet, Nell Pomeroy O'Brien, Gideon Stanton, Lucienne de St. Mart, Daniel Whitney.[67] The PWAP existed from December 1933 until June 1934.

Josephine completed a number of canvases under Woodward's direction, depicting architectural or industrial subjects.[68] Although the whereabouts of the pictures are unknown—and they may not have survived—they live on in the words of one critic.[69] Among hundreds of PWAP works exhibited at the Reed Gallery, just off the courtyard

63 Newspaper clipping, La. Coll., Tulane; newspaper clipping, ACC Coll., THNOC, folder 305.

64 Newspaper clipping, ACC Coll., THNOC, folder 305.

65 *Morning Tribune*, Mar. 23, 1934; Arts and Crafts Club, Artists Files, THNOC. Frans Blom was the director of the Middle American Research Institute at Tulane University.

66 *Item-Tribune*, Dec. 9, 1934. She exhibited along with Xavier Gonzalez, Paul Ninas, and Charles Bein.

67 Patricia Dunn Crosby, "The New Deal Art Projects in Louisiana" (master's thesis, Tulane University, 1981), 186.

68 Mariea Caudill Dennison, "The Art of the American South, 1915–1945: Picturing the Past, Portending Regionalism" (PhD diss., University of Illinois at Urbana-Champaign, 2000), 263.

69 Five of the paintings were loaned to local public schools (see Farley, 171). The National Archives and Records Administration has photographs of ten of the eleven paintings Crawford completed for the PWAP. The paintings are now considered lost.

of the Brulatour mansion, "the pregnant monotones of Miss Josephine M. Crawford" are identified as "the most important." The writer's praise knows no bounds:

> It now begins to appear to be possible . . . that New Orleans at last has acquired a painter, quite probably a great painter, whose work does not remind you of some other great painter . . . but stands alone. . . . New Orleans has a painter's light that is quite unpaintable, and Miss Crawford comes closer to it than any other New Orleans painter and may well become . . . a painter not for New Orleans, but for the world. Miss Crawford has pictured the Old Spanish Arsenal . . . in grays and greens. She has painted the occupations of carting phosphate and trucking cotton, in whites and blues and browns. She has done the Chalmette monument as a shaft of dazzling white design.[70]

During this time, Josephine began to imagine the paintings of her heart. Her ancestors—the aunts and grandmothers and great-grandfathers—had lived in her imagination and emerged in her poetry. Now they took shape on the walls of the Royal Street house. It was an ingenious idea to create the world of her ancestors in paint on the wallpapered parlor walls, to engage in painterly conversation with the ones she knew from family tales or photograph albums.

Was Josephine retreating to the romance of bygone—and thus, better—times? No, and this is what is important: the family figures in the wallpaper paintings did not point backward but served, rather, as Josephine's private world, a bulwark against anxiety. They existed as silent companions while Josephine pursued her artistic vision. If Josephine looked backward, she also looked forward, one of the first New Orleans artists to bring the ideas of modernism to her art.

The portraits that filled the walls are large, vertical murals in muted colors, complementing a room with a fourteen-foot ceiling. The figures are life-sized or larger and evoked with an economy of line; faces are suggested. Josephine has achieved the background by applying a thin coat of gray paint over whitewash.[71] Floral wallpaper not only frames the paintings but also is visible through the background. The murals encircled the room, placed on either side of the massive Greek Revival parlor door, or next to the windows, or beside the mantel. There are eight in all: a Bienvenu aunt; Agatha Bienvenu with a walking stick; a woman with a billowing skirt; an aunt with her suitor; a governess with two Crawford sisters; Josephine's mother, Louise; and father, Charles, with an ancestor, ghost-like, barely visible, behind him. One of the paintings depicts a little boy, not an ancestor. This is Josephine's nephew, Charles Henderson, son of Jeanne and Hunt Henderson, with his nurse Francis (also spelled "Frances") Gains. Josephine's wallpaper portraits would have pleased her former teacher: André

70 Newspaper clipping, ACC Coll., THNOC, folder 320.

71 The images are achieved with pastel, charcoal, gouache, washes, and some collage. Farley, 175.

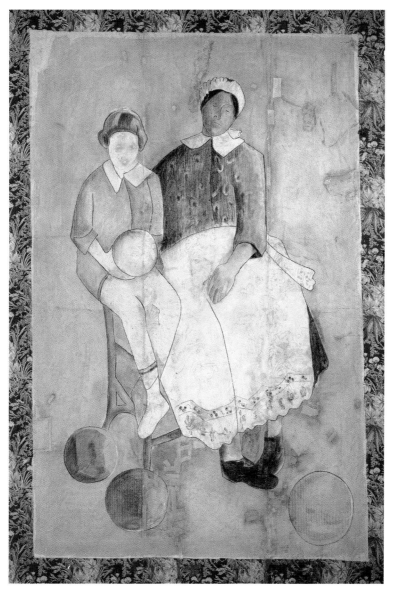

Charles Henderson with His Nurse, Francis Gains, *between January 27 and December 31, 1934; pastel, charcoal, and wash over white and gray grounds on patterned wallpaper, 83⅛ x 57⅞"; The Historic New Orleans Collection (1978.23.63), bequest of Charles C. Crawford*

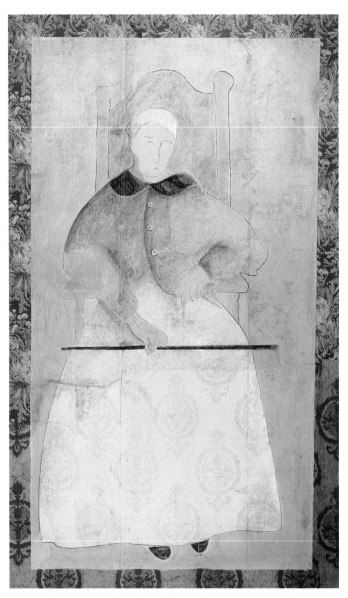

Agatha Bienvenu Seated with Cane, *between January 27 and December 31, 1934; pastel, charcoal, and wash over white and gray grounds on patterned wallpaper, 82¹⁵⁄₁₆ x 51"; The Historic New Orleans Collection (1978.23.65), bequest of Charles C. Crawford*

*Aunt and Her Suitor, between January 27 and December 31, 1934;
pastel, charcoal, and wash over white and gray grounds on patterned
wallpaper, 84⅜ x 58³⁄₁₆"; The Historic New Orleans Collection
(1978.23.66), bequest of Charles C. Crawford*

Aunt as Young Girl, between January 27 and December 31, 1934; pastel, charcoal, and wash over white and gray grounds on patterned wallpaper, 83³⁄₁₆ x 54¼"; The Historic New Orleans Collection (1978.23.68), bequest of Charles C. Crawford

Louise Bienvenu Crawford with Rake and Pail, between January 27 and December 31, 1934; pastel, charcoal, and wash over white and gray grounds on patterned wallpaper, 84³/₁₆ x 53¼"; The Historic New Orleans Collection (1978.23.70), bequest of Charles C. Crawford

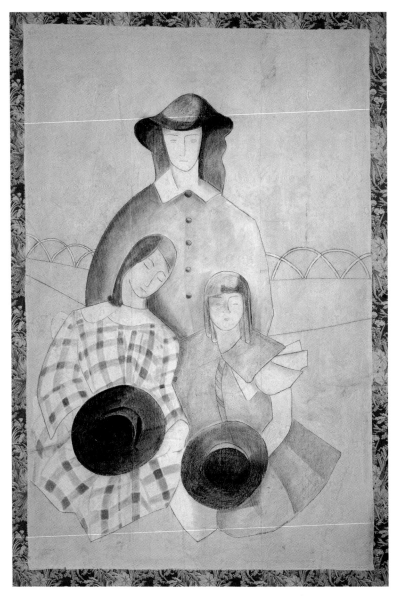

Governess and Crawford Sisters, between January 27 and December 31, 1934; pastel, charcoal, and wash over white and gray grounds on patterned wallpaper, 83¼ x 57¹⁵⁄₁₆"; The Historic New Orleans Collection (1978.23.71), bequest of Charles C. Crawford

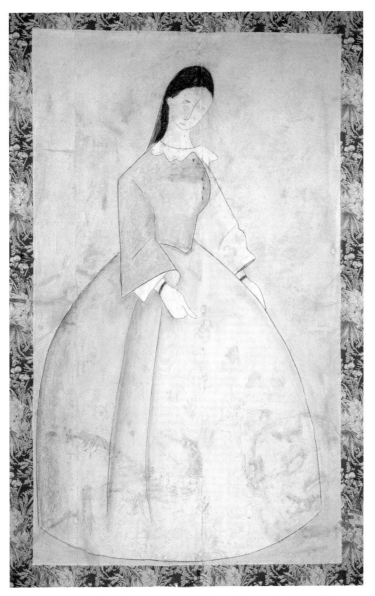

Woman Standing, *between January 27 and December 31, 1934;*
pastel, charcoal, and wash over white and gray grounds on
patterned wallpaper, 83⅛ x 51¹/₁₆"; The Historic New Orleans
Collection (1978.23.64), bequest of Charles C. Crawford

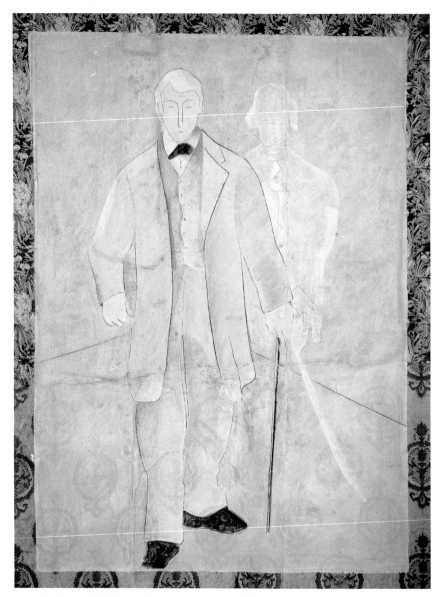

Charles Campbell Crawford and His Grandfather, *between January 27 and December 31, 1934; pastel, charcoal, and wash over white and gray grounds on patterned wallpaper, 83¹⁄₁₆ x 63¹⁄₁₆"; The Historic New Orleans Collection (1978.23.67), bequest of Charles C. Crawford*

Lhote appreciated the limitations of mural painting, welcoming the flat quality that walls ensured. (Lhote painted a number of murals; his large mural, *Le Gloire de Bordeaux*, which he completed in 1955 for the medical school at the University of Bordeaux, can still be seen in the amphitheater of the Institut d'Odonto-Stomatologie.)

Elizabeth Kell interviewed Josephine in her studio in 1934. She found the artist "both amused and agitated that the ancient iron gate that has walled in her family in that house for generations from publicity should suddenly fail her." And Kell discovered the wallpaper paintings:

Le Gloire de Bordeaux (mural in the Institut d'Odonto-Stomatologie at the medical school, University of Bordeaux) *by André Lhote, 1955; © 2008 Artists Rights Society (ARS), New York / ADAGP, Paris; photograph by Louise Chapman Hoffman*

> Around the walls of this combination formal drawing room and studio Josephine Crawford was painting a series of murals. The quaint, stiff-skirted women and even stiffer waistcoated gentlemen of the early 1850's had walked straight out of her family album and ranged themselves about the walls in the half delicate, half luminous colors of a Chinese painting that is characteristic of Miss Crawford's brush.[72]

Just as Josephine had found a perfect subject—the Creole widow—so also had she realized just the right medium she needed for the ancestor paintings.

The Arts and Crafts Club, meanwhile, never rested; shows came and went.[73] None stayed up very long, which raises the question—did they stay up long enough? Crafts were exhibited, art explained, the public educated. But when it came to innovation in art, New Orleanians were often perplexed:

> The Arts and Crafts Club . . . has courageously and independently broken away from the rubber stamp methods of art study. . . . We stress this point because many who have seen these

72 *States*, Feb. 9, 1934.

73 Shows changed monthly and semi-monthly. Report, typescript, Apr. 1927, Arts and Crafts Club vertical file, La. Coll., Tulane, folder 1.

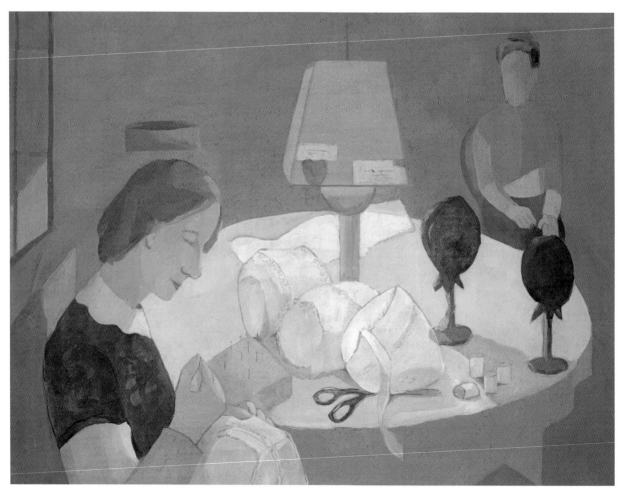

Bonnets, between 1934 and April 15, 1935, oil on canvas, 25 x 33"; The Historic New Orleans Collection (1978.23.69), bequest of Charles C. Crawford

annual exhibitions in past years have misunderstood the purpose behind the work and wrongly spoken of the school, as fostering "that awful modern art."[74]

Despite such resistance, the club continued to reach out to national and international figures. A Western Union telegram from Alice B. Toklas to Sarah Henderson confirmed a memorable visit in 1935. "Miss Stein so pleased with lecture you have arranged for Arts and Crafts Club. Am writing airmail concerning other lectures."[75] Gertrude Stein would present four lectures during her stay in New Orleans. She did not mince words in an address to members and friends of the Arts and Crafts Club. "I don't think about American painting," she told the invited audience at the Presbytère, "because there is no American painting. I say that flatly as a fact."[76] Two nights later she warned club members assembled at 712 Royal: "There is no art in American painting—in electric signs, some—in comic cartoons, some—in architecture, yes—in literature, yes—in painting absolutely nothing—nothing, and furthermore, there will be no art in American painting until the American artist is willing to work eight hours a day."[77]

Whatever anyone thought of Stein's pronouncements, the club continued, as it had since 1922, with education and exhibitions. And whether or not Josephine painted eight hours a day (doubtful), she continued to receive accolades. In the spring of 1935, sculptor Enrique Alférez praised *Bonnets*, Josephine's entry in a members show at the club.[78] "[Josephine has] followed her character of 'Rue Kerlerec' . . . to her home, in this new picture. None of the objects are painted with a desire to portray reality," Alférez observed. "The whole thing is a combination of tones and masses sensitively arranged into a fine pattern."[79] *Bonnets* depicts the interior of a millinery shop; hat stands are evident on a table. It is a return, on canvas, to the environs of Rue Kerlerec—a Creole enclave, almost the stuff of legend, brought to life by a sympathetic eye.

74 *Morning Tribune*, May 17, 1935.

75 Alice B. Toklas to Sarah Henderson, Feb. 1, 1935, ACC Coll., THNOC, folder 107. Stein returned to America for the first time in thirty years in 1934 to attend the performance of Virgil Thomson's opera (Stein's libretto), *Four Saints in Three Acts*. She lectured around the country and returned to Paris in 1935. (Claudia Roth Pierpont, "The Mother of Confusion," *The New Yorker*, May 11, 1998, 88.)

76 Newspaper clipping, Feb. 20, 1935, ACC Coll., THNOC, folder 399. The Presbytère is one of two historic buildings flanking St. Louis Cathedral, facing Jackson Square.

77 *Morning Tribune*, Feb. 22, 1935.

78 Farley writes that the painting is based on the "golden section," a geometrical plan to find the most pleasing placement of a subject. Josephine's class notes from the Académie Lhote refer to a discussion of the golden section. Farley, 194.

79 *Morning Tribune*, Apr. 26, 1935.

Water Lilies, between 1930 and 1940, oil on canvas, 25¼ x 18¼"; from the collection of Dorothy S. Milling, courtesy of Penelope F. Brown

CHAPTER 4

Art at Home and Away

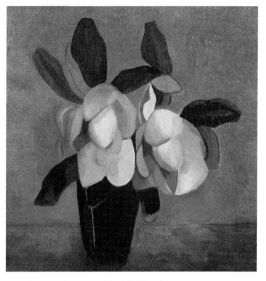

Magnolia, possibly 1927, oil on canvas, 21 x 21"; from the collection of George E. Jordan and Michel G. Delhaise; photograph by Capitol Photo

The artist . . . does differ from other human beings in that he is able to master life by his own specific gifts, and therefore he may be somewhat happier than the man who has no means of creative expression.
—JOHN CLEMMER, *Item*

THE ARTS AND CRAFTS CLUB had given Josephine its highest honor. Now she would see her work appreciated by an artistic community that reached beyond New Orleans.

In 1935 Josephine sent an oil painting, *Magnolia,* to Philadelphia to hang in an invitational exhibition, *Paintings by Artists of the Deep South,* at the Boyer Galleries on Pennsylvania Boulevard. (Her repertoire of flower paintings included several magnolias, a magnolia macrophylla, gloxinias, calla lilies, spider lilies, Orinoco lilies, black lilies, water lilies, camellias, and zinnias.) She joined twenty-six artists from the South, including John McCrady, who would later open his own art school in New Orleans. The Philadelphia *Evening Bulletin* referred to the Southerners' art as sectionalism; the exhibition brochure called the participants "vital personalities in forming the artistic consciousness in their states."[1] Modesty would have prevented Josephine from agreeing.

While Southern art traveled North, there was no lack of activity at home. The 1935–36 brochure of the Arts and Crafts Club's art school offered an ambitious number of classes: life drawing, portrait, sculpture, landscape, design, composition, still life, history of art, and a

1 *Evening Bulletin,* Mar. 1935, ACC Coll., THNOC, folder 289; *Paintings by Artists of the Deep South,* exhibition catalogue (Philadelphia: Boyer Galleries, 1935).

children's class taught by Charles Bein, Paul Ninas, Weeks Hall, Enrique Alférez, Juanita Gonzales, and Jean-nette LeBeuf.[2] Sarah Henderson received reports from board member Richard Koch—and, in the way of good friends, perhaps shared Koch's observations with Josie. Koch had learned from some of the instructors that one exhibition was a "little too somber." He admired the figures of sculptor Rai Graner and relayed a request on behalf of Enrique Alférez:

> He has been doing some rather large figures which he is giving to the City Park. . . . Miss Bartlett tells me he is badly in need of some models to finish this work and would you authorize these models and charge them to our model fund?[3]

The club continued placing on view an eclectic mix of crafts and art: Guatemalan Indian costumes (brought from Guatemala by Matilda Geddings Gray)[4] followed by a traveling show of watercolors by Charles Demuth, George Overbury "Pop" Hart, Charles Burchfield, Preston Dickinson, Edward Hopper, and Maurice Prendergast.[5] Club members could be amused or annoyed, or both, by Caroline Durieux's oils lampooning social pretensions; they could hear visiting artist Thomas Hart Benton suggest that the country's art center would move out of New York (as he had); and they could see the latest work of Paul Ninas and Enrique Alférez, described by one reporter as the "enfants terribles of the Vieux Carre."[6]

In May 1936, Josephine learned that her good friend Charlie Bein had resigned as head of the art school ("I have complete faith in the aims and every hope for the future of the Arts and Crafts Club and I love it," Bein wrote).[7] Paul Ninas, named head instructor, announced the sixteenth year of the club with optimism:

> Our school has gone along with all others in searching out the spirit of the times. We do not run to fads but to sound technique and honest effort at independent thinking and expression. But we do encourage each student to seek beauty for himself, to seek to develop his own means of expressing it within the limitation of sound practice.[8]

Josephine did have "sound practice," which made this period her most productive. Each group show was almost certain to include a Crawford work. A "technically perfect, softly shaded painting of two hands holding a pigeon"

2 Arts and Crafts Club's art school brochure, 1935–36, ACC Coll., THNOC, folder 65.

3 Richard Koch to Sarah Henderson, Mar. 24, 1935, ACC Coll., THNOC, folder 114.

4 *Morning Tribune*, Feb. 7, 1936. Matilda Geddings Gray of Lake Charles, Louisiana, was a wealthy art patron.

5 *Morning Tribune*, Feb. 1, Mar. 27, 1936.

6 *Item-Tribune*, Feb. 23, 1936; *Times-Picayune*, Apr. 11, 1936; *Item*, Apr. 20, 1936.

7 Charles Bein to Board of Directors of New Orleans Arts and Crafts Club, May 21, 1936, ACC Coll., THNOC, folder 116.

8 *Item-Tribune*, Sept. 26, 1937.

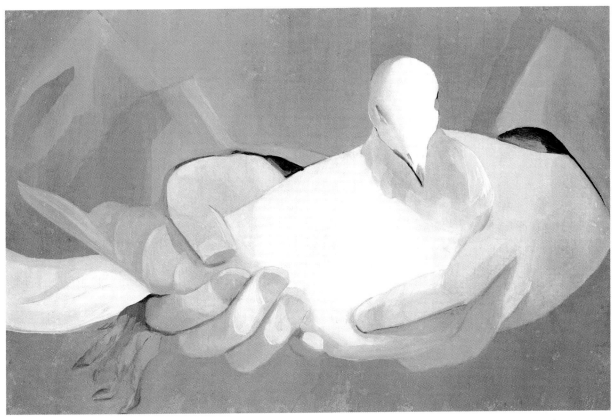

Pigeon in Hand, 1935, oil on canvas, 16⅛ x 24"; The Historic New Orleans Collection (1978.23.20), bequest of Charles C. Crawford

was singled out, at one club exhibition, for special praise.[9] In 1937, Josephine's paintings could also be seen in Baton Rouge, in the art gallery at Louisiana State University, where her *Magnolia* reminded a reviewer of Georgia O'Keeffe.[10]

Girl Under Mosquito Net, Josephine's large, horizontal painting of a nude, was packed up for New York and exhibited in the Second National Exhibition of American Art. Presenting "a cross-section of the creative art of this country," the show ran from June 16 to July 31, 1937, at the American Fine Arts Society Galleries on West 57th Street. All of the states (and U.S. possessions and territories) were invited to send paintings and sculptures that "truly represent the expression of their artists."[11] The national committee allotted Louisiana eight oil paintings and one piece of sculpture. Ellsworth Woodward, Hunt Henderson, and chairman John S. Ankeney of the LSU fine arts department, among others, judged the competition that artists entered by invitation.[12] Familiar names in the New Orleans art world of the 1930s exhibited along with Josephine: Conrad Albrizio, Caroline Durieux, Xavier Gonzalez, Clarence Millet, Paul Ninas, Will Henry Stevens.

The supporters of the Arts and Crafts Club could point to these artists and their association with the club as measures of success, but financial and administrative struggles intruded. Club treasurer George Westfeldt wrote regularly to Sarah Henderson. All too often the topic was the same: money or the lack of it. One of Westfeldt's letters stated that he and Sarah needed to guarantee $1500; this was a familiar refrain for Sarah, the main guarantor of the club. The end of the school year frequently brought a money shortage. "The reason I am going along further with the Arts and Crafts Club," Westfeldt announced, "is that upon looking into it I really believe a great deal is being accomplished for those who could not get it otherwise." But a month later: "Unless there is a marked change in receipts for the 1938–39 season, the Art School just cannot go on."[13] Yet a strong faculty persisted—Paul Ninas, Enrique Alférez, Julius Woeltz, Rudolf Staffel, Boyd Cruise. The club's letterhead listed the availability of paintings, reproductions, ceramics, textiles, silver, and glass—some to view, some to purchase. The number to call was RAymond 0129. Exhibitions continued: Jacob Epstein sculptures; paintings from the Museum of Modern Art; and prints and drawings from the Hunt Henderson collection—Toulouse Lautrec, Odilon Redon, Raoul Dufy, Pierre Renoir.[14]

9 Newspaper clipping, ACC Coll., THNOC, folder 414.

10 Dennison, 265.

11 Mrs. Henry Breckinridge, foreword to *Second National Exhibition of American Art*, exhibition catalogue (New York: Municipal Art Committee, 1937).

12 *Item-Tribune*, May 30, 1937.

13 George Westfeldt to Sarah Henderson, Apr. 28, 1938, ACC Coll., THNOC, folder 135. George Westfeldt to Sarah Henderson, May 28, 1938, ACC Coll., THNOC, folder 139.

14 Historical sketch of Arts and Crafts Club, Arts and Crafts Club vertical file, La. Coll., Tulane, folder 1; Arts and Crafts Club brochure, ACC Coll., THNOC, folder 55; exhibition announcement, Mar. 5, 1939, ACC Coll., THNOC, folder 438. Hunt Henderson died in 1939.

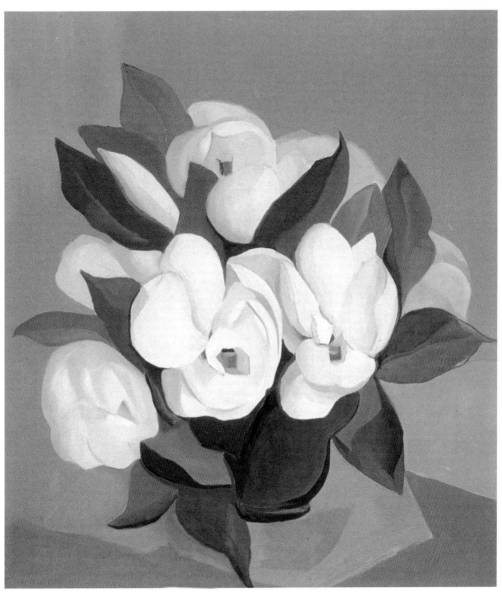

Magnolias, 1936, oil on canvas, 25 1/16 x 21 7/8"; The Historic New Orleans Collection
(1978.23.14), bequest of Charles C. Crawford

In 1940 the club mailed invitations to a one-man show featuring an Arts and Crafts favorite: Josephine. This was, perhaps, the highpoint of her career. The usual Sunday reception officially launched the exhibition on the third of March from four to six p.m.[15] A price list indicates the show's contents: *Girl Under Mosquito Net*, exhibited previously in New York, $300; *London Night*, $125; *Her First Communion*, $85; *Pigeon*, $60; *Zinnias in Greys*, $65. Several other works are valued at $50 and under: *Rooster*, *At Rest*, *Clouds*, *Calla Lily-Yellow*, *Pink Perfection*, *Camellias*, *Zinnias in Vase*, *Black Lily*. And paintings on loan: *Rue Kerlerec* and *Portrait* (both lent by the artist), *Magnolias*, *Magnolia Macrophylla*, and *Water Lilies*.[16]

Josephine was sixty-two when the show opened, sixty-three in December, and so brought a lifetime of experience to her art. Imagine her standing near the gallery door of the club. She warmly greets everyone who comes to the opening reception. Her manner is engaging with a hint of shyness. She has dressed comfortably and her hair is pulled back in a no-nonsense bun. A few strands of hair escape. Age and Biloxi summers have put crow's feet at the corners of her eyes. It is a fine moment for an artist who came late to painting. She has pleased the critics.

One review described Josephine's use of smooth, very thin paint and her efforts to achieve what she conceived painting to be: "the covering of a flat surface with an ornamental design." People are patterns, flowers are shapes—objects broken down to their basic forms. There is sophistication in the simplified widow of *Rue Kerlerec*—"a delicate and understanding character reading." Josephine placed white over white in *Girl Under Mosquito Net*. Grays, tans, and off-whites are her emblematic colors; the paintings, static and quiet.[17]

Critics continued to take note of the subtle patterns and colors of Josephine's work. Art columnist W. M. Darling described Josephine's entry in a 1940 members show as a "neat, flat procession of 'Guineas.'"[18] Not long afterward, a still life caught the eye of a columnist as he reviewed an exhibition: "The subdued coloring of Miss Crawford's work does not make it any less bright in its own way than the sharp contrasting color of Mr. Frere."[19]

Exhibitions may have proceeded in an orderly manner, but there was always a bit of drama behind the scenes. Toward the end of summer, 1940, Josephine's good friend Enrique Alférez caused a stir when he abruptly left the city. Instructor Xavier Gonzalez wrote Sarah Henderson (in Biloxi) that the volatile Enrique "left for San Francisco. This time he disposed of everything he owned and gave up his studio. . . . [this] distresses me

15 Exhibition announcement, Mar. 3, 1940, ACC Coll., THNOC, folder 55; the show ran for two weeks.

16 Exhibition price list, ACC Coll., THNOC, folder 439. The author has adjusted four titles from the exhibition list. *Girl Under Mosquito Bar* becomes *Girl Under Mosquito Net* and *First Communion* becomes *Her First Communion* for consistency. *Calla-Yellow* becomes *Calla Lily-Yellow* for explanatory purposes. *Magnolia Macrophila* becomes *Magnolia Macrophylla* to correct the spelling error.

17 *Item-Tribune*, Mar. 3, 1940.

18 Newspaper clipping, ACC Coll., THNOC, folder 401.

19 *Item-Tribune*, Jan. 12, 1941. Herbert Frère (d. 1960) studied at the Arts and Crafts Club and won a scholarship to the Art Students League in New York.

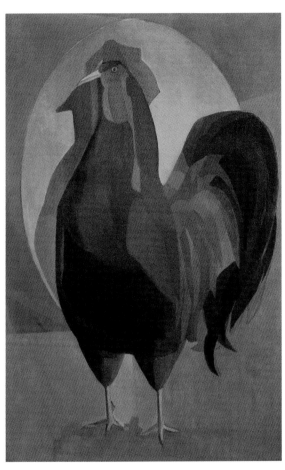

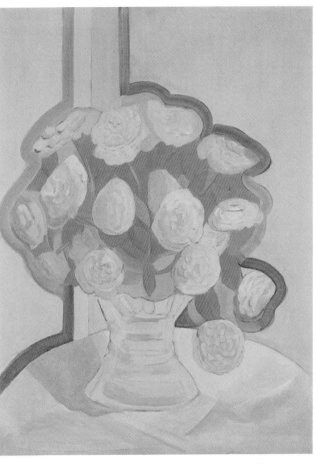

Rooster, 1936, oil on canvas, 28 x 18"; from the
collection of George E. Jordan and Michel G.
Delhaise; photograph by Capitol Photo

Zinnias, 1937, oil on canvas, 30 x 22"; courtesy of Louise
Chapman Hoffman

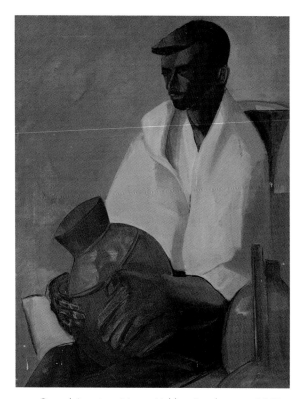

Central American Native Holding Pot, *between 1928 and 1940, oil on canvas, 28⅞ x 22"; The Historic New Orleans Collection (1978.23.5), bequest of Charles C. Crawford*

because he's an excellent artist and craftsman but he is also such a child."[20] But the sculptor returned in time for his opening, November 1940, a few months later.[21] No doubt Josephine, remembering Enrique's high praise for her work, was on hand to welcome the colorful artist back to town.

In spring 1941, a selection of contemporary American art traveled to Guatemala, El Salvador, Honduras, and the Canal Zone, under the sponsorship of the Middle American Research Institute of Tulane University. Josephine and several of her Arts and Crafts Club colleagues were among the twenty-six artists invited to participate. Under a reciprocal arrangement, the work of Central American artists was displayed in the United States. A reporter for an English-language newspaper, the *American*, declared with a bit of hyperbole and no lack of enthusiasm: "A number of those participating . . . are nationally and even internationally known."[22]

Painting was not all consuming. Josephine served on the board of the Arts and Crafts Club beginning in 1940 and chaired the art school committee. Richard Koch, ever vigilant, questioned Josephine's report on the operation of the school ("where is the $650 [tuition and dues] coming from?"). He wrote "Dear Miss Henderson" that Josephine's report did not coincide with "my understanding of conversations that you have had with her and Mr. Westfeldt. And if I am wrong, I wish to be corrected."[23] Koch was Teutonic, meticulous, and kept a sharp eye on the workings of the club. He was concerned in this instance with the club's precarious financial situation, not with the accuracy of Josephine's report. Josephine and Dick Koch were good friends, and whatever was amiss would be amicably straightened out. George Westfeldt had previ-

20 Xavier Gonzalez to Sarah Henderson, Aug. 10, 1940, ACC Coll., THNOC, folder 145.

21 *Item-Tribune*, Nov. 24, 1940.

22 *American*, Apr. 1941, ACC Coll., THNOC, box 10 [oversize].

23 Richard Koch to Sarah Henderson, Apr. 23, 1942, ACC Coll., THNOC, folder 150. Architect Richard Koch was a partner in the firm of Koch and Wilson. A preservationist and garden enthusiast, he lived in the Garden District, corner of Fourth and Coliseum streets.

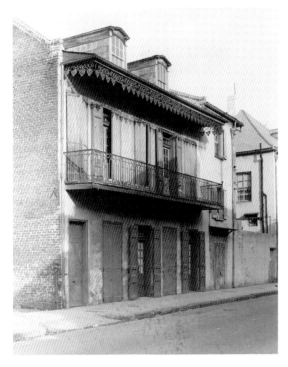

LEFT: *713 Governor Nicholls (art school's pottery studio) by Richard Koch, 1930–1959; The Historic New Orleans Collection (2004.0095.165), gift of Hermann-Grima/Gallier Historic Houses*

RIGHT: Floor Plan for 713 Governor Nicholls; *Vieux Carré Survey at The Historic New Orleans Collection (square 44)*

ously warned Koch about the installation of two telephones at the club, one costing $10.40. The club "can't afford this!" he wrote.[24] But the club's budget did include kilns for the pottery school at 713 Governor Nicholls Street, at the lower end of the Quarter, in a building owned by Sarah Henderson.[25]

Letters to Sarah, while often reciting financial woes, reflected world events as well. In 1942 Abraham Rattner, whom Josephine had met in Paris, was given another show in New Orleans. World War II had changed everything. Rattner, a Jewish artist, had left Paris on the eve of the Nazi occupation, leaving behind most of his paintings. These works he now considered lost—"No word from France," he wrote. His gratitude to the club, and Sarah in particular, was evident: "I believe you are and always have been the keystone and mainstay to the life and nature of the Arts and Crafts Club." He remembered Paris: "My souvenirs of what you did in the past, during those days in Paris, are not forgotten," and continued, ". . . Of all the important exhibitions I've had, this

24 George Westfeldt to Richard Koch, May 11, 1940, ACC Coll., THNOC, folder 25.

25 The Gov. Nicholls Street building was where Rudolf Staffel instructed students in the art of pottery, as had Juanita Gonzales, who taught pottery in the early 1930s.

The Green Shutter by William Spratling, 1926; The Historic New Orleans Collection (Westfeldt, Eshleman, and McIlhenny Family Papers, 2001-52-L, box 6), bequest of Mettha Westfeldt Eshleman

one scares me to death . . . because of the personal nature of this event."[26]

France was very much on the mind of Josephine's friend Martha Gasquet Westfeldt when she designated the Green Shutter Tea Room, her shop on Royal Street, "The Free French Shop," a meeting place for those helping in the war effort. Josephine, a frequent visitor to the Green Shutter, probably met Thérèse Fitzgerald, a diligent volunteer who worked for Fighting French Relief. Fitzgerald, an artist, lived in New Orleans for a few years in the early 1940s.[27]

Josephine, speaking for the art school, announced in 1942 that Paul Ninas was leaving to join the army. The committee struggled with the perennial questions: Could the day school continue? Who would teach in the night school?[28] Yet the club persevered, with social niceties observed. Everyone was there—meaning the art community—at the club's reception to open the annual membership competition in February 1943. A certain formality prevailed. Prominent supporters were invited to "receive." A highlight—Sarah Henderson in attendance. And Josephine. She rarely missed a reception, this time accompanied by her sister Jeanne Henderson. Edith Norris and Anita Nolan mingled in the crowd.[29]

Shaky finances notwithstanding, the club recognized, in 1944, that the time had arrived for a retrospective show. Mounted in two parts, the exhibition opened with a survey of pictures and ceramics dated between 1923 and 1933. Josephine's *Crepe Myrtles* was on view (on loan from Martha Westfeldt).[30] The second half of the retrospective followed, with examples from 1933 through 1943. Once again *Rue Kerlerec* hung at the Arts and Crafts Club.[31]

26 Abraham Rattner to Sarah Henderson, Jan. 15, 1942, ACC Coll., THNOC, folder 149.

27 Thérèse Fitzgerald, autobiographical statement, Westfeldt, Eshleman, and McIlhenny Family Papers, THNOC, acc. no. 2001-52-L, box 6.

28 Minute book, board of directors, Oct. 2, 1942, ACC Coll., THNOC, folder 49.

29 *Times-Picayune*, Feb. 24, 1943.

30 Arts and Crafts Club member exhibition book, ACC Coll., THNOC, folder 55.

31 Ibid. At this date, *Rue Kerlerec* was back in Josephine's possession after ownership by Dr. Joseph Hume. Josephine's great-niece Micheline Martin Bator inherited the painting.

Through the mid-1940s, Josephine continued to exhibit in members shows.[32] A twenty-fifth anniversary exhibition allowed Josephine, perhaps for the last time, to show her work at the club. The mood was more nostalgic than celebratory. Sarah Henderson, that peerless benefactor, had died in 1944, aged seventy-three, a loss that had been feared for some time.[33] Several years before, rumors of Sarah Henderson's resigning from the board—her health was a factor—caused the following outburst from one of her staunch admirers: "You have meant everything to the Arts and Crafts Club and the board cannot picture its existence without you."[34] Now with "Miss Henderson" gone, how much longer could the club expect to survive? An indifferent public was a disheartening reality. A critic congratulated the club, but was less sanguine about the city's appreciation of new trends in art:

> New Orleans has developed as a center of art
> study and achievement without much awareness
> on the part of her citizens as a whole. It is doubtful
> whether the twenty-five years of gallant endeavor
> by the Arts and Crafts Club group has penetrated
> the tradition-bound consciousness of this city.[35]

By 1948, the board announced a new director of the art school, John Clemmer, a young artist who had been a student first and then a teacher at the school. The following year, Clemmer's work hung in a one-man show. But time was running

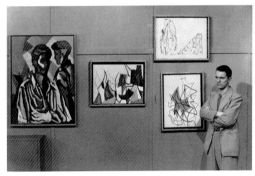

TOP: John Clemmer and Earlee Dedeaux at the Arts and Crafts Club, *1940s; The Historic New Orleans Collection (1993.36.7), gift of John F. Clemmer*

BOTTOM: John Clemmer, *1949; The Historic New Orleans Collection (1993.36.9), gift of John F. Clemmer*

short. The building on the corner of Royal Street and Pirate's Alley was sold. The art school could no longer be sustained, and the club, renamed the Arts and Crafts Gallery, moved once more—in the fall of 1950—to 900 Royal Street, the Miltenberger house. A few exhibitions followed, but the high energy of earlier days was gone—and finances remained uncertain. In March 1951, the club finally closed its doors.

32 John Clemmer, interview by author, Mar. 8, 2007.

33 Sarah Henderson died at her residence on Prytania Street in the Garden District.

34 Nellie Bartlett Kelleher to Sarah Henderson, Mar. 17, 1938, ACC Coll., THNOC, folder 128.

35 Newspaper clipping, Josephine Crawford, Artists Files, THNOC.

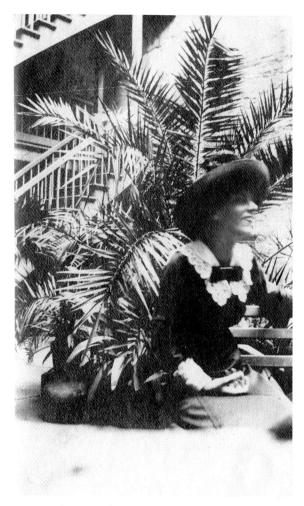

Josephine Crawford, *ca. 1910; courtesy of*
Mrs. Edmund McIlhenny

From Royal Street to East Beach

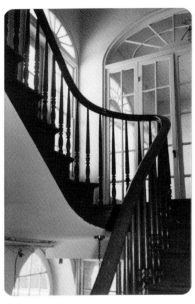

Staircase and Loggia at 612 Royal Street, 1980; courtesy of Louise Chapman Hoffman

We will walk—let us say—down Royal Street, once the main thoroughfare of the city. Six short squares from Canal Street . . . you will come upon a row of three-storied brick-and-plaster houses set side by side, filling the square from end to end. . . . The entrance to the house proper is through a large double door, kept always tightly shut. . . . It seems that you have entered another world.

—LYLE SAXON, *Fabulous New Orleans*

JOSEPHINE CRAWFORD AT HOME. Picture her as she returns from the Arts and Crafts Club, entering the doors of 612, walking through the half-domed carriageway. She looks with pleasure at the plastered walls and arched opening to the courtyard, her eyes once again taking in the familiar landscape. This is her childhood home and the embodiment of "at-homeness," a source of her strength.

Josephine imagines the presence of those who had inhabited the house—or a previous house—on Royal Street. Besides three generations of her family, there were also names from the early days of New Orleans—French and Spanish names—with ties to the parcel of land where 612 now stands. Sarpy and Fortin. Almonester and Castillon. Pontalba, Devèze, and Bosque. The property (not the present structure) served for a while as the site of the French Consulate. Add to the list an Anglo-American name for good measure—attorney John R. Grymes, who had

Architectural Detail over Doorway at 612 Royal Street, 1980; *courtesy of Louise Chapman Hoffman*

Ceiling Medallion at 612 Royal Street, 1980; *courtesy of Louise Chapman Hoffman*

represented the legendary Lafitte brothers against a charge of piracy.[1] Grymes aligned himself with Creole aristocracy when he married Suzette Bosque, Governor W. C. C. Claiborne's widow.[2]

The house that Josephine knew was probably constructed either during the Devèze or the Grymes ownership, around 1830. In 1835, a Monsieur Pichot purchased the property, described as "a lot with improvements thereon consisting of a dwelling house with two stores, two dining rooms, four large rooms, two small bedrooms, a kitchen with four servants rooms, a stable and a large entry calculated to receive a four-wheeled carriage and a gig."[3] Bienvenu ownership began when Mélicourt, Josephine's grandfather, bought the house in 1839. He may have added the Greek Revival ornamentation during a remodeling at this time. Josephine's mother, Louise, inherited the property from her father in 1879. The lot measured approximately forty-five feet front by seventy feet in depth on a square bounded by Royal, Toulouse, St. Peter, and Chartres streets. The succession situates the house: bounded on the Toulouse Street side by the Ducatel property and on the St. Peter Street side by the Labatut property.[4] The family's ownership would last for one hundred and twenty-seven years.

1. The Lafitte brothers were privateers. They are credited with giving assistance to General Andrew Jackson at the Battle of New Orleans. Pierre Lafitte had been arrested for piracy (1813); Jean, his brother, persuaded Grymes (with the help of a handsome retainer) and Robert Livingston to defend Pierre, which they did, successfully.

2. Edith Long, property description, Sept. 22, 1964, Vieux Carré Survey, 610–14 Royal Street, square 42, THNOC.

3. Chain of title, Wulfan Adolphe Wenceslaus Pichot from John R. Grymes, July 31, 1835, Vieux Carré Survey, 610–14 Royal Street, square 42, THNOC.

4. Chain of title, Mrs. Louise Bienvenu Crawford from the Succession of François Mélicourt Bienvenu, June 19, 1879, Vieux Carré Survey, 610–14 Royal Street, square 42, THNOC.

It is no wonder that Josephine found inspiration at home. She grew up accustomed to the great winding staircase that spiraled upward in a graceful curve and to the high ceiling in the parlor where her mother received. If she looked up to the parlor's immense doorframe, she saw an anthemion crest and decorative carving in the Greek Revival style of a former day (the 1830s and '40s). And she could see the crystal prisms of the chandelier that hung from a plaster medallion. Styles came and went, but the Creole town house kept its integrity.

Dining Room at 612 Royal Street, ca. 1900; courtesy of Louise Chapman Hoffman

Josephine lived with a mix of furniture acquired over the years—Victorian chairs, a secretary with pigeon holes, armoires (there were no closets), and small French side tables that could be used anywhere. A wicker table and potted palm placed at the foot of the stairs gave the illusion of coolness when there was none.

Flagstones paved the courtyard—damp and cool in summer. A lantern (it hangs there still) cast shadows on the carriageway ceiling. Arches in back echoed the façade. Five arched openings defined the front of the building, two on either side of the large central porte-cochère. Josephine remembered the long, heavy key that opened the entrance doors. In one poem she wrote that Prosper, the Swiss manservant, was the keeper of the keys; another time, her mother, Louise.

This was home. The litany of details found in her poems includes water jars in the courtyard, the flagged corridor, and carved cornices. The perfume of old wood captured her imagination. She could walk through the French windows of the parlor and onto the small balcony to see a blend of colors on the buildings up and down the street, different shades of rose or yellow or tan, with Royal Street beneath her and the spire of St. Louis Cathedral to her right. For a creative spirit, place mattered, and the place was beautiful.

Sometime after her parents' deaths, Miss Tweety divided the house into apartments.[5] It was customary for a business to be installed in the ground-floor quarters. On the *première étage*, one floor up, the rooms on the uptown side of the house formed one apartment, while the formal double parlors became Josephine's studio. Tweety and Josephine lived together in one of two apartments on the *deuxième étage*, while an additional apartment was formed from rooms in the service wing.[6]

5 Miss Tweety (Louise Harriet Crawford) was the oldest of the Crawford children still living in New Orleans. Practical and economical, she turned the Royal Street house and the Howard Avenue house in Biloxi into income-producing property. She died June 20, 1943.

6 Louise C. Hoffman, "A History of 612 Royal Street," Southeastern Architectural Archive, Special Collections, Tulane.

This latter apartment, described as "the courtyard house at 612 Royal," was the one rented by Lyle Saxon.[7] No doubt Saxon and Josephine would see each other as they passed in the carriageway, stopping to talk and exchanging a story or two. Here was a Creole living in the old family house—just the scenario that kindled Saxon's imagination! Next door, he would find the Puigs, descendants of Dr. Isidore Labatut, who built the house and the one adjacent on the downriver side of the Crawfords in 1831. The two families, both fixtures on Royal Street, shared a longstanding friendship.[8] Jeanne Henderson would often invite Félix and Evelyne Puig "across the lake" to visit her summer home in Biloxi. Going across the lake—Lake Pontchartrain—was just the right antidote to the confines of the Quarter. White linen slipcovers, whirring fans, and a shaded courtyard helped combat the heat of summer for only so long. Then it was time to close the shutters and pack a bag for the Coast.

> There was sun and [a] peaceful sort of light, great tranquility, a kind of inner breathing came on, the wind made the old trees whisper and stirred the long moss hanging to the ground. To open your eyes on a new day was happiness. The things I remember: 'Po' Boys and Gumbo' for twenty-five cents. 'All the Shrimp You Can Eat' for a dollar. The piers stood out in the water and ladies in their summer dresses used to sit out on them under big umbrellas, talking through the twilight.
>
> —ELIZABETH SPENCER, *The Salt Line*

New Orleanians went to Biloxi in summer to escape the city's heat or in winter to breathe fresh air and to recuperate from city life. They went to Biloxi whenever possible, and that is what the Crawfords did. Biloxi was a constant. Josephine could not remember a time when she did not know Biloxi.

Beginning with the first Biloxi property (1871), the Crawfords invited friends and family members to visit. Guests responded with thank-you notes—de rigueur—and exclaimed about the beauty of the Gulf Coast:

> I see you lying on the sofa reading [Sir Walter] Scott with Miss Tweedy and Charlotte by your side. . . . I see the beautiful wide-spreading oak-tree, the sandy soil, the bath house . . . and the pelicans and seagulls lighting on the water below . . . Never shall I forget my visit to Biloxi.[9]

7 Chance, 64.

8 The Puig name is Basque. Regardless of how "Puig" was pronounced in the ancestral land, the Crawfords resolutely called their friends "Pooch."

9 Charley Ox. to "My dear Mother-in-law," Aug. 28, 1888, Crawford Family Papers, Tulane, folder 2. Another note came from Morgan Whitney, a member of the family that founded the Whitney National Bank in New Orleans. He wrote "Willie" Crawford that he was sorry he could not come to Biloxi and thanked him for the invitation. (Morgan Whitney to Willie Crawford, May 23, 1893, Crawford Family Papers, Tulane, folder 3.)

Biloxi Scene Depicting the Crawford Family and Household Servants, between 1928 and 1945, oil on canvas, 35 x 55½"; courtesy of Micheline M. Bator; photograph by Michael Gould

A friend in Switzerland remembered

> *le souvenir des heures agréables que j'ai passées avec vous à Biloxi, en face de ce beau golfe qui, quoi qu'on dise, peut être comparé à bien des sites plus admirés et plus connus.*[10]

> (the souvenir of the pleasant hours that I spent with you in Biloxi, in front of that beautiful Gulf, which, whatever anyone says, can be compared with any number of the most admired and well-known vistas.)

Josephine spent childhood days fishing or crabbing. She ate fresh figs picked that morning and was careful not to step on small, prickly burrs ("rockachaws" the natives called them) hidden in the grass.[11] She wrote "My dear Tweety" that she caught a redfish. "Harry and Frank Howard are having a public school built. Kiss Mamma and Aunt Laure." She concluded with a "P.S. Billy cat is catching a mouse."[12]

As an adult, Josephine may have stayed from time to time in a cottage at 1200 East Howard Avenue at the back of the Crawford property, which fronted on the beach. Miss Tweety, with her practical eye, had arranged for the cottage—formerly a gardener's cottage—to be raised, creating a new first floor that became one apartment (the entire upstairs was a second apartment, no interior stair). The beachfront property (953 East Beach) remained in the family, undivided among Louise Bienvenu Crawford's heirs, until 1927 when it was sold.[13]

Jeanne and Hunt Henderson were not far away. They had bought a nearby cottage at 829 East Beach, with high ceilings, French doors, and a wide gallery in front to catch the breeze.[14] The house was well known: from a distance, visitors first saw the live oak in front, girdled with a white structure (steps leading to a "gallery" with an encircling bench), called a garden house or a shoofly, neither quite the right descriptive noun.

Life on the Mississippi Gulf Coast proceeded at a slower, cooler, pace. Waveland, Bay St. Louis, Pass Christian, Biloxi, Ocean Springs, all geographically part of Mississippi, were considered New Orleans outposts as

10 A. Beuguet (?) to "Ma chère amie," Aug. 1, 1892, Canton de Valois, Suisse, Crawford Family Papers, Tulane, folder 3.

11 There are a number of sand burrs that are called rockachaws, or *racacha*. The origin of the word *racacha* is thought to come, via the Spanish, from the Quechua Indians of South America. Walter C. Holmes, *Flore Louisiane: An Ethno-Botanical Study of French-Speaking Louisiana* (Lafayette, LA: Center for Louisiana Studies, University of Southwestern Louisiana, 1990), 19.

12 "Tom boy, your loving sister" to "My dear Tweety," Sept. 17, 1888, Crawford Family Papers, Tulane, folder 2.

13 Land and Deed Record, Harrison County, MS, Sept. 30, 1927, Book 172, pp. 246–47. Louise Bienvenu Crawford's will gave the property to her daughters with the provision that their ownership would cease if they married. The Crawford land was adjacent to the property where the Toledano house stood, which was later known as the Tullis-Toledano Manor, a ca. 1850s brick house that was destroyed during Hurricane Katrina.

14 Charles Lawrence Dyer, *Along the Gulf* (1895; reprint, Pass Christian, MS: Women of Trinity Episcopal Church, 1971), unpaginated. The cottage at 829 East Beach was the former home of George Smith.

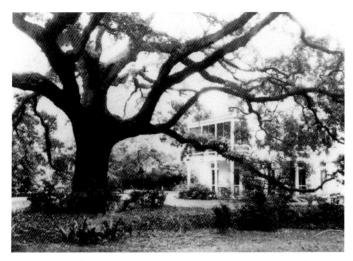

LEFT: Crawford Cottage at 1200 East Howard Avenue in Biloxi, *1966; courtesy of Louise Chapman Hoffman. This house was destroyed by Hurricane Katrina.*

RIGHT: Tree House (Shoofly), Biloxi, Mississippi, *between 1928 and 1935, charcoal on wove paper, 11⅞ x 8⅞"; The Historic New Orleans Collection (1978.23.220i), bequest of Charles C. Crawford*

well. Any number of New Orleans families—Woods, Farrars, Denègres, Tullises, Minors, and Baldwins—spent the "warm season," the euphemism for summer, in Biloxi.[15]

Live oaks, wreathed in Spanish moss and resurrection fern, softened the landscape, but it was the seascape that really defined the place—Deer Island on the horizon; sailboats anchored close to shore, the beautiful *Windjammer* (the Tullis schooner) gracing the water; seawalls with steps that ended where the beach began. People sat on their galleries, usually in the late afternoon, often with something cool to drink in hand, more than likely a highball.

The Henderson house looked out across the beach and Mississippi Sound. A guest cottage was next door, a replica, though smaller, of the main house. Josephine and Tweety began to stay in the little house after Hunt Henderson died in 1939.[16] In one of the rooms, Josephine placed an easel, with the requisite sketching paper, canvases, and tubes of paint close at hand.

15 Nenette Denègre Keenan Reed, interview by author, July 1, 2005.
16 Farley, 235.

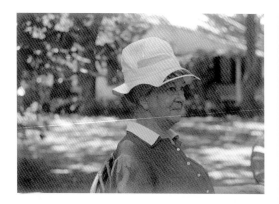

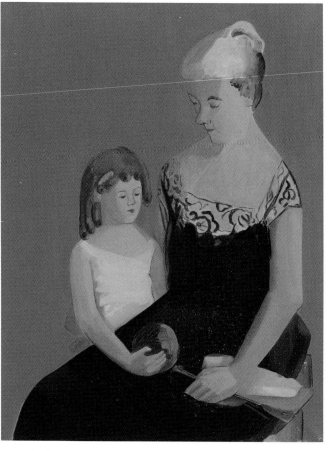

TOP: Charlotte Crawford d'Heur in Biloxi, *ca. 1940; courtesy of Louise Chapman Hoffman*

BOTTOM: Guest cottage at 829 East Beach in Biloxi (home of Jeanne and Hunt Henderson), *1966; courtesy of Catherine Chapman Babin. After 1939, Josephine stayed in this cottage when in Biloxi.*

Charlotte d'Heur with Granddaughter Micheline Martin, *1930s, oil on canvas; courtesy of Micheline M. Bator; photograph by Michael Gould*

It is very likely that Josephine painted *Girl Under Mosquito Net* in Biloxi, but just where she posed her model is a matter of conjecture. The nude was painted before Josephine had set up her summer studio in the Henderson cottage. She needed a place to paint and might have created a makeshift studio at the back of the Baldwin Wood house. People said an artist—she had hired a model—was painting in a building, perhaps a stable, on the property that extended through the block to the street behind the beach road.[17] Children in the neighborhood

17 Reed, interview. Engineer Albert Baldwin Wood (1879–1956) invented the pumps used to drain water from the low-lying areas of New Orleans.

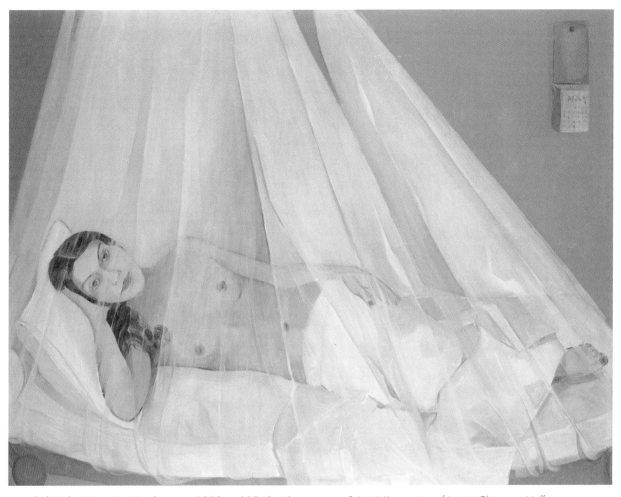

Girl Under Mosquito Net, *between 1930 and 1940, oil on canvas, 34 x 44"; courtesy of Louise Chapman Hoffman*

heard their mothers gossiping: "Had anyone seen the girl? Was she a local girl?" News of Josephine's nude would travel quickly in a small community.

Girl Under Mosquito Net follows in the tradition of the reclining nude in nineteenth- and early twentieth-century painting. Josephine's *Girl* is lying on a bed, resting on an arm. She looks directly at the viewer. She is seen through mosquito netting, bringing to mind hot weather and wide-open windows. A small wall calendar in the upper right-hand corner of the canvas tells the month. It is May. The sense of place is unmistakable.

It is impossible to recreate Josephine's life, the "everyday-ness" of it, but if the setting is familiar and a sampling of information is available, it is not difficult to create a scene that would fit comfortably into her routine. Here is Josephine in Biloxi. She is up early and in the garden, deadheading zinnias. Back to the studio before the day gets too hot. Propped on a chair is *Red Snappers on Ice*, which she has promised to Martha Westfeldt.[18] The fish, mounded on a circular tray, form an intricate pattern of light and dark: a circle with neither beginning nor end, here and there a fish eye providing a dark accent against the lighter colors. On Josephine's easel is a painting that she is trying to finish—*Camellias* (the favorite flower). She is painting now from memory, as camellia season is long past. She remembers André Lhote warning his students that "the more colors you use the less important they become. God alone is the genius who is at liberty to be prodigal of color." She glances at her collection of African art, reassured by its familiarity, and thinks again of Lhote and his pieces of Art Nègre from the port of Bordeaux.

The nephews arrive. Charles Henderson and Allard d'Heur have stopped by to see "Tante" before they begin tomorrow's fishing expedition in the Gulf, out past the coastal islands—Cat, Ship, Horn—after navigating through Dog Keys Pass. Josephine finds her straw hat as she heads back to the garden. A stand of vetiver needs thinning. The figs are not yet ripe. But 'Mrs. Hunt Henderson' is blooming, Jeanne's namesake lily—propagated by Jeanne herself. The heat of midday is coming on and Josephine has returned to the cool of the house. She looks at a recipe she has copied from a friend, chocolate pudding with Maillard's chocolate (six eggs, one-half pint whipping cream, six tablespoons black coffee, six sticks Maillard chocolate). There is another recipe on her desk, and Josephine wonders if she will ever use it. Pepper marinade calls for twelve large green peppers, thirteen red peppers, eight large onions, four cups vinegar, three cups sugar, and two tablespoons salt.[19] Probably not. She puts the recipes aside and reaches for a book, *A Carolina Rice Plantation of the Fifties*, to contemplate the impressionistic watercolors by Alice Ravenel Huger Smith.[20] Lhote again: "It is no use trying to be an impressionist—that was a phase that has passed."

18 *Red Snappers on Ice* would later take pride of place in the summer home of Mettha Westfeldt Eshleman (Martha's daughter) in Waveland, Mississippi. *Red Snappers*, lost when Hurricane Camille came ashore on Aug. 17, 1969, now exists only in a small photograph. (Westfeldt, Eshleman, and McIlhenny Family Papers, THNOC, acc. no. 2001-52-L, box 6.)

19 Recipes written on 829 East Beach, Biloxi, stationery, private collection. Maillard's Chocolate Factory was located in New York.

20 Alice R. Huger Smith, *A Carolina Rice Plantation of the Fifties* (New York: W. Morrow and Co., 1936).

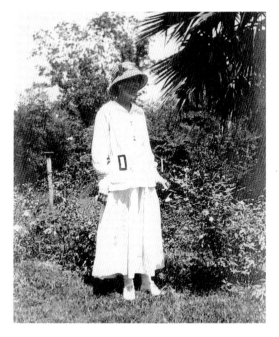

LEFT: Josephine Crawford in Biloxi, *ca. 1910; courtesy of Mrs. Edmund McIlhenny*

RIGHT: Josephine Crawford with Dogs in Biloxi, *ca. 1910; courtesy of Mrs. Edmund McIlhenny*

Camellias in Bowl, *between 1931 and 1950, oil on canvas, 19⅛ x 24"; The Historic New Orleans Collection (1978.23.35), bequest of Charles C. Crawford*

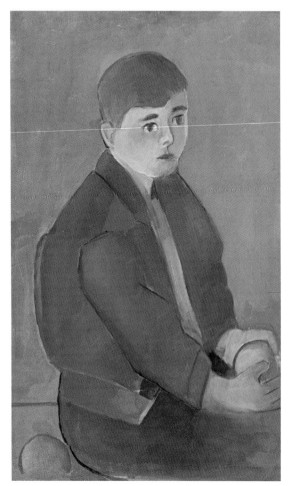

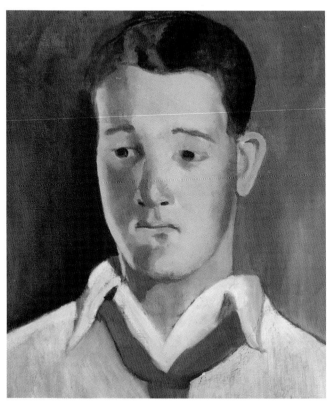

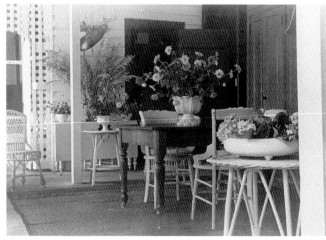

TOP LEFT: Charles Henderson, *between 1928 and 1932, oil on Masonite, 20 x 12"; The Historic New Orleans Collection (1978.23.34), bequest of Charles C. Crawford*

TOP RIGHT: Allard d'Heur, *between 1926 and 1930, oil on canvas, 16¼ x 14"; courtesy of Louise Chapman Hoffman*

BOTTOM RIGHT: Porch at 829 East Beach in Biloxi (home of Jeanne and Hunt Henderson); *courtesy of Louise Chapman Hoffman*

Deer Island, between 1926 and 1945, pencil on wove paper, 4⁹⁄₁₆ x 9⁷⁄₈"; The Historic New Orleans Collection (1978.23.230), bequest of Charles C. Crawford

The Mound beckons. Its name an echo of Indian burial sites, the Mound is land on the Tchoutacabouffa River behind Biloxi's Back Bay, five or so miles from the coast.[21] Jeanne owns the land; Josephine cultivates it. She is creating a wildflower garden, or preserve, with plants native to Mississippi. There is no house, but as a concession to visitors, Josephine has placed a cypress bench, weathered a silver-gray, along one of the paths. You might see, depending on the season, star anise (*Illicium floridanum*); meadow beauty (*Rhexia alifanus*); passion flower (*Passiflora incarnata*), and coral bean or *mamou* (*Erythrina herbacea*)—Josephine takes pride in knowing the Latin names. Here at the Mound, in her wildflower garden, Josephine is painting, in a sense, with a larger palette, yet another way of finding the spirit of place.

Josephine was at home in Biloxi. From the front gallery of her cottage, she could see across the Sound to Deer Island, and she could stand on her sister's pier to feel the wind pick up just before a storm. Flowers were a passion. Perhaps she contemplated future plantings when she made a list, found among her papers: bridal wreath, trailing periwinkle, purple montbretia, creamy oleander, love-lies-bleeding, spider lilies, hemerocalis.[22] Porches and galleries, brick walks, straw rugs, bowls of blue hydrangeas: these were the elements of everyday during Josephine's Biloxi summers.

Back on Royal Street, behind the carriage doors, she returned to the familiarity of high ceilings, marble mantels, and the stream of light pouring through the fan-shaped transoms.

21 Farley, 234.

22 Crawford, THNOC, folder 154. Josephine also wrote a short history of the camellia.

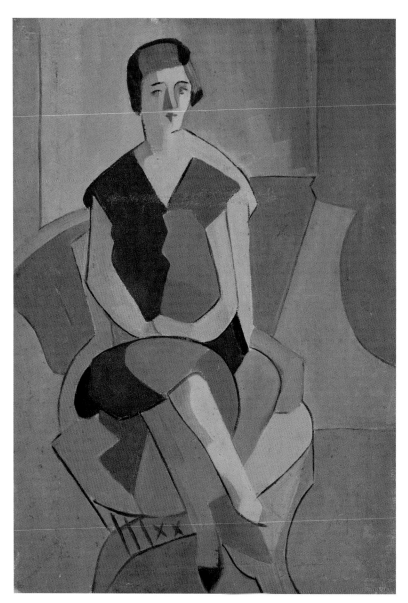

Mrs. Jean Martin (Josephine d'Heur), *between October 1, 1927, and 1932,*
oil on canvas, 19 x 13¼"; The Historic New Orleans Collection
(1978.23.30), bequest of Charles C. Crawford

CHAPTER 6

Considering Josephine

As far back as I can remember I have had two personalities—which is the real—the one I present to the world or the other known only to me.

—JOSEPHINE CRAWFORD, notebook

EVENTUALLY, WE COME TO KNOW JOSEPHINE through her art. She had a recognizable style that critics through the years have described as "simplified, shallow, flat, opaque" (Judith Bonner); "the decoration of a flat canvas to hang on a flat wall" (Edith Norris); and an ability to concentrate on the essentials, "rendering them as simply as Whistler did" (John Ankeney).[1] And this: Josephine was "one of the most experimental painters of the New South between 1900 and 1950" (George Jordan).[2] Josephine had grasped the modern movement and assimilated Lhote's teaching.[3] She, Paul Ninas, and Will Henry Stevens are credited with introducing Cubism to New Orleans.[4] Her art represented a new way of looking at the world.

To understand Josephine's vision one must consider, first, certain influences and movements that shaped twentieth-century art. Cézanne eliminated spatial depth from his work, arranging scenery as flat planes. Braque and Picasso experimented with Cubism (Matisse commented—it may be apocryphal—that Braque's pictures were "made of little cubes").[5] An early definition of

1 Judith Bonner, "The Laura Simon Nelson Collection of Louisiana Art: An Exhibition in Three Parts," *The Historic New Orleans Collection Quarterly* 14 (Spring 1996): 1–6; newspaper clipping, La. Coll., Tulane; newspaper clipping, Josephine Crawford, Artists Files, THNOC.

2 George E. Jordan, "The South Forsaken," *The New Orleans Art Review* 4 (Feb.–Mar. 1985): 12–13.

3 Mariea Caudill Dennison writes that Josephine's notes from classes at the Académie Lhote express the tenets of modernism. Dennison, 259.

4 Judith Bonner, "Paintings from the Permanent Collection of the Historic New Orleans Collection," in *Complementary Visions of Louisiana Art: The Laura Simon Nelson Collection at the Historic New Orleans Collection*, eds. Patricia Brady, Louise C. Hoffman, and Lynn D. Adams (New Orleans: The Historic New Orleans Collection, 1996), 82.

5 Bougault, 84.

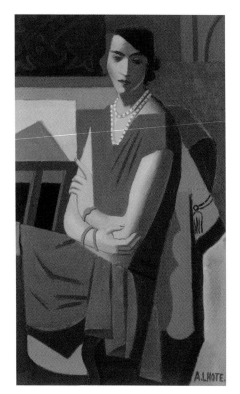

Portrait de Femme *by Andre Lhote, 1925, oil on canvas, 36¼ x 22½", Musée des Beaux-Arts, Nantes, France; courtesy of Réunion des Musées Nationaux/Art Resource, NY; photograph by Gerard Blot; © 2008 Artists Rights Society (ARS), New York/ADAGP, Paris*

Cubism held that "an object has no absolute form but several, as many forms as there are levels of meaning."[6] Cubism divides a subject into its several geometries—the viewer becomes a participant; subjects are distorted to achieve clarity and emphasis (although the general public would not see the "clarity"). André Lhote, an early Cubist, chastised the Ecole des Beaux-Arts for teaching the "inferior values"—anatomy, perspective, and local color.[7] But he disagreed with later tendencies in Cubism toward more abstraction.

Modernism, of which Cubism was but one manifestation, was no singular movement. It was, rather, a break with past conceptions about what art should be, and an attempt to discover different approaches to painting. European modernism spread to America, that is, New York, through Alfred Stieglitz's 291 Gallery (Hunt Henderson knew Stieglitz, who probably advised him on art purchases), and modernism was officially introduced to the public via the Armory Show of 1913, with its groundbreaking display of European and American art.[8] The Pennsylvania Academy of the Fine Arts mounted its version of the Armory Show, *Paintings and Drawings by Representative Modern Masters*, in 1920, with mainly European works, followed by *Later Tendencies* the next year.[9] But people complained. Art had turned away from the academic tradition; subjects were no longer "eternally true."[10] Critics wondered, "What does it mean?" and "Is it only for a chosen few?" Collector Marius de Zayas said to forget about prior conceptions of art: "The best artist is sensitive to the spirit of the times."[11] Other groups promoted modernism: the Society

6 Albert Gleizes and Jean Metzinger, *On Cubism [Du Cubisme]*, quoted in Bougault, 91.

7 André Lhote, "L'académisme ou la tradition mal comprise," *Revue du Caire* 27 (Oct. 1951): 174, quoted in Grammont, 106–7.

8 Stieglitz closed "291" in 1917 but remained a leading force in avant-garde art, later opening the Intimate Gallery in 1925 and An American Place in 1929.

9 Sylvia Yount, "Rocking the Cradle of Liberty: Philadelphia's Adventures in Modernism," in *To Be Modern: American Encounters with Cézanne and Company*, exhibition catalogue (Philadelphia: Museum of American Art of the Pennsylvania Academy of the Fine Arts, 1996), 6, 17.

10 Elizabeth Johns, "Early American Modernists and Their Viewers," in *To Be Modern*, 32.

11 Johns, 33. Marius de Zayas (1880–1961), a Mexican caricature artist, was part of Alfred Stieglitz's avant-garde circle.

Carousel, between 1928 and 1940, oil on canvas, 19³/₁₆ x 26⅛"; The Historic New Orleans Collection (1978.23.1), bequest of Charles C. Crawford

of Independent Artists held privately run exhibitions, and the Société Anonyme, established by Katherine Dreir, Marcel Duchamp, and Man Ray, publicized modern art through traveling shows.[12] Man Ray said, "We cannot do better than the old masters or the generation before us, we can only do something different."[13]

Modernism spread to the South—slowly. A modernist was not easy to find in the New Orleans of the 1920s. Will Henry Stevens, who began teaching in the Newcomb College art department in 1921, was a contemporary of Josephine's—and, like her, receptive to the latest movements in the arts. For both artists, the years 1926 and 1927 proved important: Josephine traveled to Paris to study with André Lhote; Stevens attended an exhibition at the Brooklyn Museum organized by Katherine Dreir and the Société Anonyme that would lead him to modernism. By 1930, Stevens was using a Cubist structure in his work; in the 1940s he had moved toward abstraction in his search for an "American message that spoke to the modern world."[14]

Josephine's art never became completely abstract. Her paintings represent people, animals, flowers, objects; but her method of portraying some of her subjects could be described as "representational Cubism."[15]

12 Yount, 16.

13 "Then and Now."

14 Poesch, "Will Henry Stevens," 22, 29.

15 Marilyn Laufer, *Modernism in the South: Mid-Twentieth-Century Works in the Morris Museum Collection,* exhibition catalogue (Augusta, GA: Morris Museum of Art, 2002), 16.

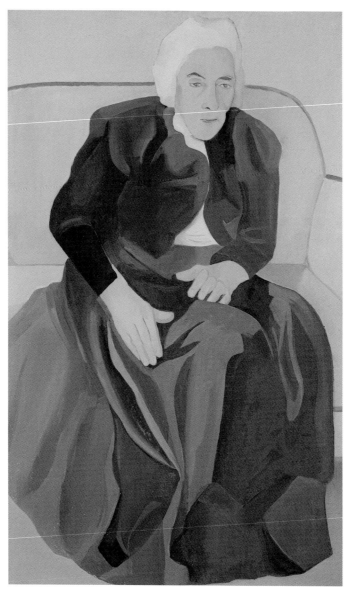

Elderly Woman Seated on Sofa, between 1932 and 1936, oil
on canvas, 39⁹⁄₁₆ x 24"; The Historic New Orleans Collection
(1978.23.62), bequest of Charles C. Crawford

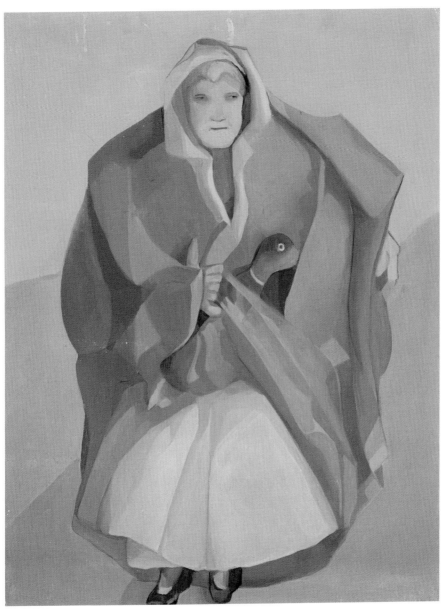

Woman with Duck, between 1928 and 1940, oil on canvas, 24 x 19¼"; courtesy of A. M. Nelson

Goats, *1936, oil on canvas,
16¼ x 20½"; from the collection
of Dorothy S. Milling, courtesy of
Penelope F. Brown*

Boats in Harbor at Cannes, *between
February 4 and 19, 1928, pastel over pencil
on wove paper, 7¾ x 9"; The Historic New
Orleans Collection (1978.23.378.18),
bequest of Charles C. Crawford*

Man Standing in Doorway, *undated, oil on canvas, 13½ x 11¼"; from the collection of George E. Jordan and Michel G. Delhaise; photograph by Capitol Photo*

If Josephine evoked the past in a number of her artworks, she framed her subjects in a distinctly modern style. Think of the ancestor paintings on wallpaper. Nostalgia ("She's drawn against the flowered wall / in azure pleated silk"[16]) combines with modernist principles, each adding value to the other. The true-to-life depiction of a subject—the illusion of reality—was no longer of primary importance, or important at all. Some of the concerns of modernism (flattened forms and elimination of detail) are there in the portrait of an ancestor, a Tante de Morant or Tante Bienvenu, whose face is only suggested, whose gown ends in a short ripple of a line, both flat against a flat background. The ancestors are reminiscent of the spare, poignant portraits of Amedeo Modigliani.[17]

Look at Josephine's *Young Woman Wearing White Gloves.* There are no brushstrokes, only washes of color: white for the dress, gray-green for the background. Her style brings to mind an early modernist, Charles Demuth, who had studied in Paris (académies Modern, Colarossi, and Julian), returning to the States after the Armory Show. His subjects are representational, easily recognized, but they are also patterns, defined by "atmospheres of color."[18]

Of the elements of art—line, color, shape, and texture—Josephine was more interested in line, color, and shape (or form), less in texture.[19] She chose gray (pale gray, dark gray, white-gray), cadmium yellow (pale hue), muted reds, black, and she had a special preference for white (*Girl Under Mosquito Net, White Horses on Beach, Charles Henderson in Crib, Old Woman with Cane*). Josephine spoke to her viewer with white, the non-color. The voice was quiet.

16 Poem, Crawford, THNOC, folder 137.

17 George E. Jordan, "Josephine Marien Crawford (1878–1952)" in *Eight Southern Women: Blanche Lazzell, Josephine Marien Crawford, Nell Choate Jones, Clara Weaver Parrish, Alice Ravenel Huger Smith, Helen M. Turner, Mary Harvey Tannahill, Anne Goldthwaite*, exhibition catalogue (Greenville, SC: Greenville County Museum of Art, 1986), 7.

18 Barbara Haskell, *Charles Demuth*, exhibition catalogue (New York: Whitney Museum of American Art, in association with Harry N. Abrams, 1987), 27.

19 *Item-Tribune*, Mar. 3, 1940.

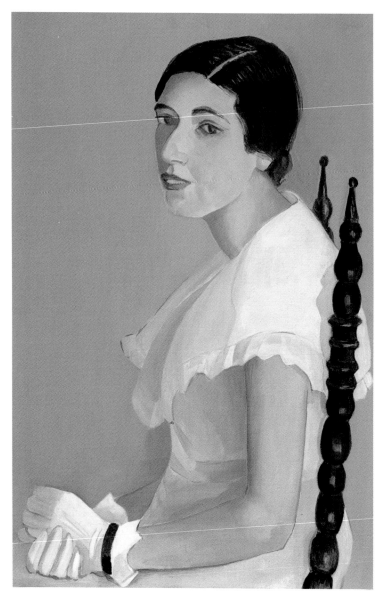

Young Woman Wearing White Gloves, *between 1928 and 1935,*
oil on canvas, 28⅛ x 18⅟₁₆"; The Historic New Orleans Collection
(1978.23.4), bequest of Charles C. Crawford

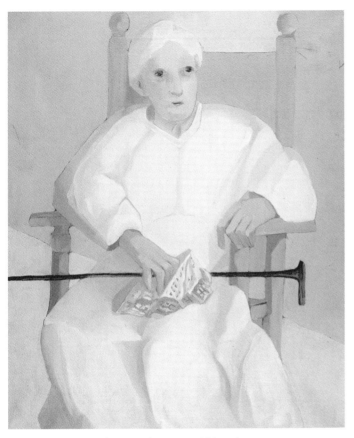

Old Woman with Cane, *between 1930 and 1940, oil on canvas, 21⅞ x 18"; The Historic New Orleans Collection (1978.23.45), bequest of Charles C. Crawford*

Charles Henderson in Crib, *between 1933 and 1945, oil on canvas, 26¼ x 16⅞"; The Historic New Orleans Collection (1978.23.53), bequest of Charles C. Crawford*

*Daisy's Parlor, February 18, 1896, pencil on wove paper,
4⅞ x 7"; The Historic New Orleans Collection
(1978.23.379.5), bequest of Charles C. Crawford*

Contemporary events or social concerns were not part of that voice; Josephine was not *engagée*, in the political sense. Her voice spoke of the fundamental things of life: the dignity of the individual (*Francis Gains; Her First Communion*), the beauty of simplicity (*Still Life with Melon and Oranges; Magnolia*), the importance of work (*Throwing the Net; Bonnets*).

Painting in a modern style met with resistance in the South, certainly more than in the cosmopolitan cities of the East. Leaving the South was an option for an artist—but not for Josephine. But neither did she become an artistic recluse just because her style differed from swamp scenes, foggy bayous, or the Impressionistic brush of the Woodwards—a sun-flecked fountain by Ellsworth, a stormy sky by William. She may have retired to her studio to paint behind the doors of Royal Street, but that did not mean she was cut off from the life of the Arts and Crafts Club or from her friends.

People often think that an unmarried woman who lives at home and enjoys time alone is reclusive. But those who knew Josephine saw things differently. Friends who dropped by to see Josephine's paintings ended up staying much longer than intended. Hugh Crawford, an Irish cousin who arrived in New Orleans unannounced to find his Crawford relations, soon discovered that the person to see was Josie. And Josie, not surprisingly, invited her cousin to stay at 612—a lengthy stay, as it turned out.

She was a regular at club shows and generous with praise for fellow artists.[20] The opening receptions—Josie was sure to be there—prompted Charlotte, writing from New York, to say to her sister, "You are gay with all your parties but don't get too fat."[21]

Josephine kept a sketchbook as early as 1888, filled with scribbles, drawings, and spirited comments.[22] *Daisy's Parlor*, sketched in 1896 when she was eighteen, is an immature work, done long before she listened to André Lhote's modernist theories or studied with Daniel Whitney at the art school. Once Josephine began classes at Lhote's academy, her sketches became simplified—a seated nude, somewhat Cubist in feeling, a few words penciled top left: "*jeu de ligne, jeu de l'ombre et lumière*" (play of line, play of shadow and light).

20 Clemmer, interview.

21 Charlotte d'Heur to Josephine Crawford, May 27, 1941, Crawford, THNOC, folder 3. Because of problems with her eyes, Charlotte added, "I hope I will be able to see your . . . paintings."

22 "You are one of the biggest frauds in the University, but I am not going back on you," Josephine observed at one point—the object of her pique unidentified. See Josephine Crawford's sketchbook, THNOC, acc. no. 1978.23.379.18ii.

White Horses on Beach, *between 1928 and 1940, oil on canvas, 21¹⁵⁄₁₆ x 28⅛"; The Historic New Orleans Collection (1978.23.28), bequest of Charles C. Crawford*

Still Life with Melon and Oranges, *between 1932 and 1940, oil on canvas, 15¼ x 19⅛"; The Historic New Orleans Collection (1978.23.58), bequest of Charles C. Crawford*

Francis Gains, between 1928 and 1935, oil on canvas, 24¾ x 20"; The Historic New Orleans Collection (1978.23.12), bequest of Charles C. Crawford

Throwing the Net, *between 1927 and 1940,
oil on canvas, 31⅞ x 15⅛"; The Historic New
Orleans Collection (1978.23.18), bequest of
Charles C. Crawford*

TOP LEFT: Fishmonger, Marseilles, *1928, pastel over pencil on wove paper, 9 x 7¾"; The Historic New Orleans Collection (1978.23.378.20), bequest of Charles C. Crawford*

TOP RIGHT: Fish Market, Marseilles, *1928, pastel over pencil on wove paper, 7¾ x 9"; The Historic New Orleans Collection (1978.23.378.19), bequest of Charles C. Crawford*

BOTTOM LEFT: Breton Peasants Harvesting Shellfish, *1929, pencil on wove paper, 13¾ x 9¹¹⁄₁₆"; The Historic New Orleans Collection (1978.23.289), bequest of Charles C. Crawford*

BOTTOM RIGHT: Breton Peasant Women, *between January 31, 1928, and 1929, charcoal on wove paper, 12⅛ x 9¼"; The Historic New Orleans Collection (1978.23.287), bequest of Charles C. Crawford*

Another nude, another notation about proportion of light and dark ("*ne répéter [repétez] pas les valeur[s] dans le nu*"). Josephine conscientiously practiced drawing Lhote's models (but took time to sketch a border of little mice on the reverse of one *nu*). She traveled with her *Album à Dessin* (nine francs at Sennelier on Quai Voltaire) to the South of France, where she sketched rooftops and boats in Cannes, towers in Avignon, and clustered houses in Cagnes-sur-Mer. The fish market in Marseilles held a special allure. Josephine drew a fishmonger beside her rows of sea creatures. The woman's figure is rounded, the bins of fish and shells flattened, and the effect is a decorative pattern—no attempt at perspective. The Marseilles fruit-market sketch repeats the pattern. Josephine's travel drawings—three towers (Carcassonne) rendered in charcoal and village scenes (Beaucaire)—reflected her emerging style. She was learning her craft.

Josephine continued to experiment with style during a 1929 trip to Pont-Aven in Brittany, a small town on the Aven River close to the seacoast.[23] She was on sacred ground. The Pont-Aven School flourished in the late nineteenth century under the influence of Paul Gauguin and included such artists as Emile Bernard, Maurice Denis, Armand Seguin, and Paul Sérusier. Josephine's sketches of Breton fishermen and women tending their nets evoke the spirit of place in the tradition of Bernard's *Les ramasseuses de coquillages* (*The Shellfish Gatherers*, 1891) and Gauguin's *Deux Brettonnes sur la route* (*Two Women of Brittany on the Road*, 1894). In charcoal, sanguine, and collage, Josephine's Breton peasants are depicted in a modern style; details and depth are eliminated. The figures are stocky, the feet rounded (the rounded feet became a motif in her paintings). The solid figures come from a simpler time, a reminder of the ennobling power of work and the connection the Bretons have with sea and land.[24]

Travel in Mexico inspired her art. She sketched Mexican women in profile with baskets on their heads and braids down their backs; she drew a mother and baby at market. Her numerous drawings of daily life are stylized and unmistakably Mexican but recall in form the Breton peasants harvesting shellfish on the beach.

Josephine's studies for her oil paintings allow a glimpse of the artist's mind at work, an invitation to go backstage. A sketch for *Rue Kerlerec* shows the Creole widow with a prominent hat, absent from the completed image. But the wavy lines of her blouse ("waist") are found in both sketch and oil. Does Josephine's finished painting pay homage to Lhote's *Deuil* (*Mourning*)? Executed in 1915, this lithograph may have been on view when Josephine visited Lhote's studio. Both share the same viewpoint (the subjects look directly at the viewer) and an elaborate mourning veil.

Pencil studies indicate Josephine's approach to a four-paneled dressing screen. Completed in the mid-1930s, the screen would depict Mettha Westfeldt (daughter of best friend Martha Westfeldt) as a child with her brother and two sisters: George Jr. (Sunny), Ethel Jane, and baby Francis (Coo).[25] The young Westfeldts are

23 See Farley, 143. Josephine's traveling companion on the Brittany trip was her friend Martha Westfeldt.

24 Josephine traveled again to Europe and possibly to Russia with her friend Dot Milling. The date is unknown but was probably some time after the trip to Brittany. Penny Brown, interview by author, May 13, 2008.

25 Lhote painted a screen—*un paravent*—in 1910: *Le bassin d'Arcachon*. See *André Lhote, 1885–1962*, color plate 16.

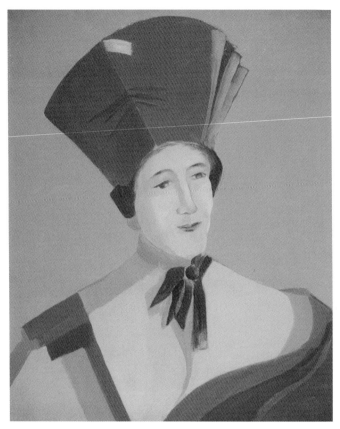

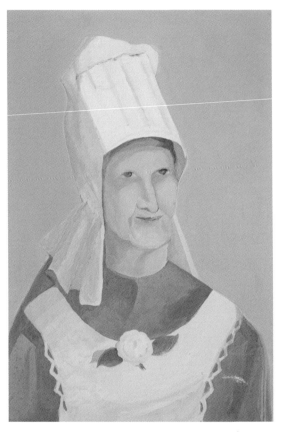

Woman in Breton Hat, *between 1928 and 1935, oil on canvas, 18¾ x 15¼"; The Historic New Orleans Collection (1978.23.9), bequest of Charles C. Crawford*

Woman in Native Dress (Bretonne woman—from Brittany), *1938, oil on canvas, 22⅛ x 15"; courtesy of Raburn Blanc Monroe Kelly*

Mexican Mother with Baby and Seated Woman, *between 1930 and 1932, watercolor over pencil on wove paper, 9¹⁵⁄₁₆ x 6¹⁵⁄₁₆"; The Historic New Orleans Collection (1978.23.267), bequest of Charles C. Crawford*

Indian Mother with Child at Market in Mexico, *between 1930 and 1932, watercolor over pencil on wove paper, 9¹⁵⁄₁₆ x 7"; The Historic New Orleans Collection (1978.23.269), bequest of Charles C. Crawford*

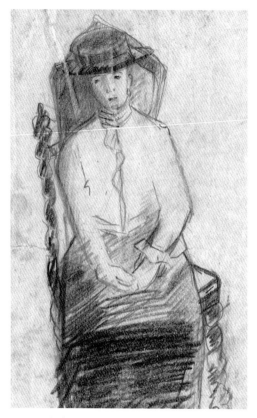

Study for Rue Kerlerec, between 1932 and January 27, 1934, pencil and crayon on brown wove paper, 8⅛ x 5½"; The Historic New Orleans Collection (1978.23.377.24), bequest of Charles C. Crawford

Deuil by André Lhote, ca. 1916, lithograph; courtesy of Dominique Bermann Martin; © 2008 Artists Rights Society (ARS), New York / ADAGP, Paris

placed against a gray background. The composition encourages the eye to move in a diagonal line from lower left (where Sunny contemplates an escaped hat, round and dark, that anchors the work) to the top of Coo's head, upper right. No fussy details, only the essence of childhood, captured in front of a porch in summer. The screen, a tour-de-force, was presented as a gift to Mettha Westfeldt Eshleman.

"Only by drawing" (do you learn how to paint)—Josephine remembered Lhote's rule. The evolution of *Throwing the Net* (a fisherman in Biloxi), *Dr. Joseph Hume* (the good friend), and *Bonnets* (a milliner's shop, very likely on Kerlerec Street where the Creole widow lived) can be traced by looking at the preliminary sketches. *Josephine d'Heur in Bathtub* is first seen in a study.

Dressing Screen of Westfeldt Children, *mid-1930s, pastel, charcoal, wash, and gouache over gray oil-based ground on wood, 64¾ x 67¼"; courtesy of the Mettha Westfeldt Eshleman Family*

Reclining Nude with Mosquito Net, between 1930 and 1935, oil on board, 6¾ x 8⅞"; The Historic New Orleans Collection (1978.23.381), bequest of Charles C. Crawford

And there is the nude—all the nudes leading to this one—*Girl Under Mosquito Net*. In the study, the nude is lying on a *lit de repos* with a black cat at the foot of the bed, watercolor on cardboard. (Was cardboard the only material at hand at the moment?) The black cat catches the eye and enhances, by contrast, the flesh tones and white netting. Perhaps Josephine was thinking of Lhote's *jeu de l'ombre et lumière*—but then, it seems, she followed her own inclination and painted the nude without the cat. More studies: the shoofly in Biloxi, woman in red, camellias, and Japanese magnolias. The shoofly must have been a subject irresistible to an artist. It exists in pencil but was never transferred to oil, at least not by Josephine.

A self-portrait is also irresistible. And here, too, Josephine would hone her craft through sketching, drawing, and painting. A self-portrait, probably a charcoal drawing, was included in the brochure of a posthumous exhibition at the Isaac Delgado Museum of Art.[26] In this drawing—a true likeness—Josephine presents herself in profile.

26 See *The World of Miss Josephine Crawford, 1878–1952*, exhibition catalogue (New Orleans: Isaac Delgado Museum of Art, 1965), unpaginated. The current location of the drawing is unknown to this author.

Josephine d'Heur in Bathtub, between 1930 and 1935, oil on canvas, 18¼ x 12¹⁄₁₆"; The Historic New Orleans Collection (1978.23.59), bequest of Charles C. Crawford

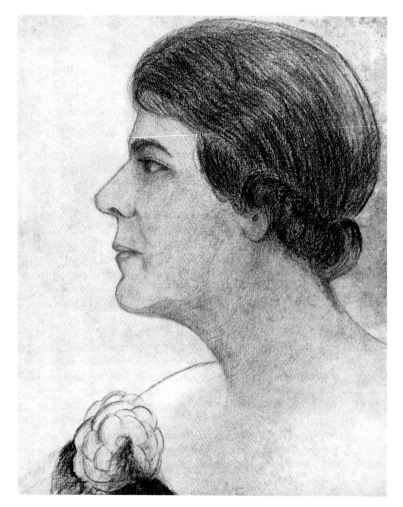

Self-Portrait from The World of Miss Josephine Crawford *(New Orleans, 1965); The Historic New Orleans Collection (77-846-RL)*

She does not look directly out of the picture, and thus appears less assured (or more modest) than a subject whose eyes confront the viewer. But the profile view does allow one to discern a slight smile and a friendly eye that convey her generosity of spirit. The signature camellia ('Pink Perfection'?) is there, close to Josephine's draped shoulder. Another self-portrait, this one an oil at the Morris Museum of Art in Augusta, Georgia, depicts a woman's face in a three-quarter pose, sharp featured, against a dark background of stylized leaves. She is younger, intense; face, dress, and background create a flattened, patterned effect. This is not the Josephine of the charcoal drawing and was probably painted in the late 1920s during or just after Josephine studied at the Académie Lhote.

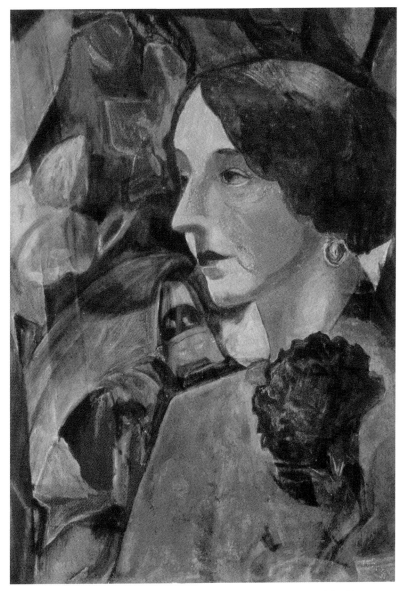

Self-Portrait, 1927–28, oil on Masonite, 21 x 15½"; courtesy of the Morris
Museum of Art, Augusta, Georgia (1989.05.256)

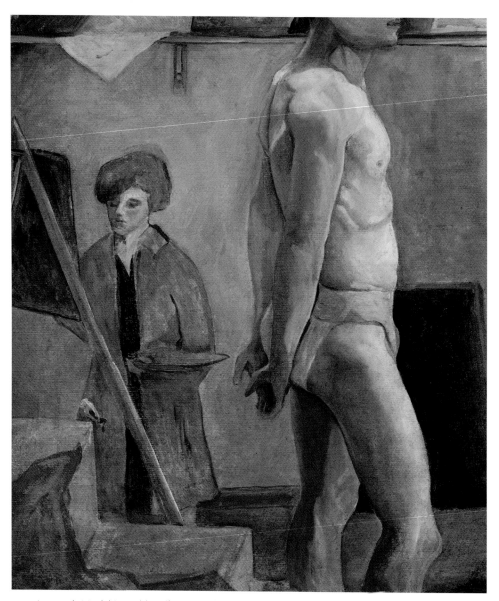

Artist with Model (possibly self-portrait), *between 1926 and 1930, oil on canvas, 21 x 18½";* *courtesy of Stephanie and Robin Durant*

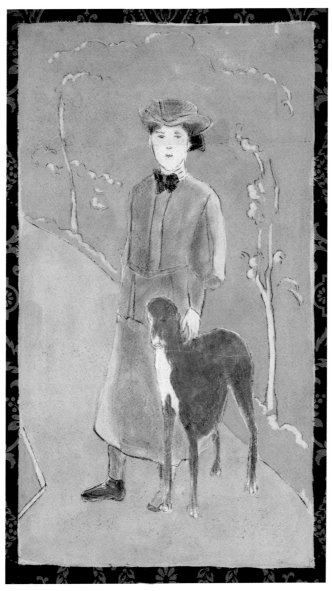

Woman with a Dog (possibly self-portrait), between 1928
and 1940, gouache with wallpaper border, 20 x 15"; gift to
Mary Lee Brown Tullis from Josephine Marien Crawford

Guinea Hens, *between 1926 and 1945, oil on canvas, 20½ x 26½"; courtesy of Mrs. Edmund McIlhenny*

While there is some emotional reserve in Josephine's work, there is also a sense of intimacy in her choice of subjects—guinea hens, red snappers on ice, a baseball player with catcher's mitt, Miss Tweety sewing (an electric fan in the foreground). The art reveals a quiet joy that Josephine found in her observations of the world. There is wit, too: a sense of humor that ran to oddities. Josephine must have smiled as she titled one series of sketches Opus I through Opus VII.[27] The subject of the series? Outhouses. With her collector's eye and penchant for the picturesque, Josephine no doubt delighted in finding these structures tucked away in the coastal countryside of Louisiana and Mississippi.

Her sly sense of humor and her talent for subtleties emerge in *Rue Kerlerec*, the earnest Creole widow who has not neglected a single item of funeral attire. Just as Josephine preserved the widow at a pivotal moment in

27 The sketches, with occasional notations by Josephine, depict outhouses at the Crawford house in Biloxi ("note the antique door with modern ventilation introduced in 1900") and a neighboring house on Howard Avenue; Pascagoula ("ferns and honeysuckle," "the old fig tree"), Gautier, Vancleve, and Fort Bayou, on the Mississippi Gulf Coast east of Biloxi; and Pearl River, Louisiana. Crawford, print case 3A, THNOC.

Fish and Shrimp on Ice, *between 1935 and 1940, oil on canvas, 21½ x 28½"; courtesy of Jackeen Kelleher Churchill*

Catcher, between 1932 and 1940, oil on canvas, 24⅛ x 16¹⁄₁₆"; The Historic New Orleans Collection (1978.23.61), bequest of Charles C. Crawford

Louise Crawford Sewing by Fan, between 1926 and 1930, oil on paste board with border of unpainted ground, 14 x 10"; The Historic New Orleans Collection (1978.23.50), bequest of Charles C. Crawford

her life, so also does she commemorate another milestone in *Her First Communion*. A young girl—candle in hand, pristine in her communion dress—looks out from the picture, wide-eyed with innocence and awe. Besides the emotion conveyed, the painting is a study in black and white, each adding value to the other to achieve a dramatic effect.

Josephine's work has a soft strength, but she is not a "pretty painter."[28] Lhote's rule, probably nestled in her subconscious, would come back to her now and then—to learn your trade first, then put your personality into the painting. Josephine had learned her trade. Her art had evolved into a recognizable style, distinctly her own: her study with Lhote was a way station toward discovering her vision.[29] Works from private collections inspired her, particularly the collection of her brother-in-law, Hunt Henderson, which was available whenever she wanted to see it. The Arts and Crafts Club school and the influence of modernism had refined her art.

She had a trained eye. She browsed in print shops in the Quarter, finding from time to time the very thing she wanted: a "Plan de la Nouvelle-Orléans" showing Rue Royale between Rue de Toulouse and Rue St. Pierre, the 600 block. Old maps of Peru (with an area designated "Missions Espagnoles") and Marseilles (1705) were Quarter discoveries or, perhaps, souvenirs from travels in France. Her prints of Degas's ballet dancers came from the stay in Paris.

A fellow artist recalled a presence that could light up a room—a gentle presence, but one that

No. 1200 E. Howard, Opus I (outhouse series), *between 1896 and 1926, pencil on wove paper, 15¹⁵⁄₁₆ x 11"; The Historic New Orleans Collection (1978.23.239), bequest of Charles C. Crawford*

28 Clemmer, interview.
29 "You do not see Lhote in Crawford," her friend John Clemmer said. Clemmer, interview.

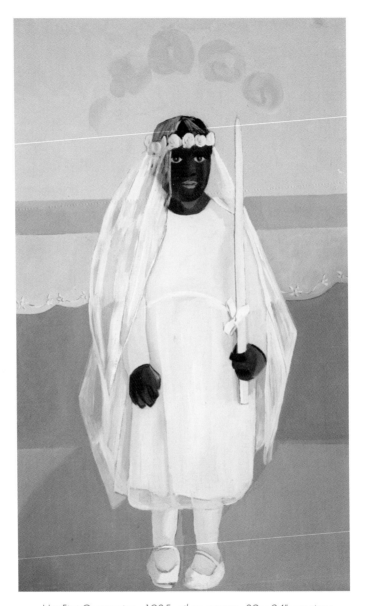

Her First Communion, 1935, oil on canvas, 39 x 24"; courtesy
of the New Orleans Museum of Art: Gift of Mr. and Mrs. Richard
B. Kaufmann, in honor of E. John Bullard, 93.167

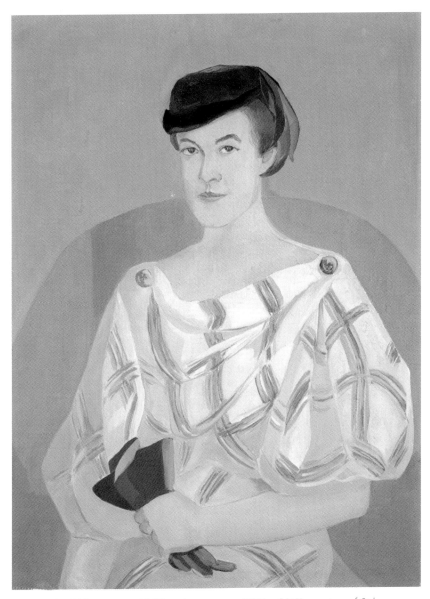

Mettha Eshleman, ca. 1930s, oil on canvas, 29¾ x 21¾"; courtesy of Sidney Eshleman Thornton

Fête Champêtre, between 1928 and 1940, oil on wood, 9¾ x 22"; courtesy of Sidney Eshleman Thornton. Josephine painted this scene on the top of a rectangular box for Mettha Eshleman, who kept it in her Waveland, Mississippi, summer home. The piece survived Hurricane Camille. Mettha found the top of the box in the yard, dancing scene intact. The sides and bottom of the box were gone.

everyone noticed and missed when she was not there.[30] Friends described "her sparkling eyes and delightful wit."[31] Josephine was clever with words (a journal notation refers to *un calembour*, "pun" in French). She answered to a number of names, always a sign of affection—Jo, José, Miss Jo, Miss Josie, Josie, Tante. She embraced the younger generation, joining enthusiastically in a birthday celebration for Mettha Westfeldt at the Green Shutter Book Bindery in 1933.[32] And she was embraced by her peers: Le Petit Salon, the distinguished women's organization on St. Peter Street, recognized Josephine with honorary membership.[33]

30 Clemmer, interview.

31 Josephine Crawford exhibition brochure, THNOC, 1978.

32 The Green Shutter Book Bindery, part of the Green Shutter Tea Room, was both an artistic and social hub in the 1930s. As reported in the *Item* (Dec. 14, 1933), Josephine joined the group of younger women, Newcomb Art School graduates, who assembled for lunch at "the long, high table in the little bookbinding workshop that Mettha Westfeldt, Betty Koonan, and Elizabeth Villere" were running on Royal Street.

33 Le Petit Salon counted, among its honorary members, other names familiar to the New Orleans art world: Sarah Henderson, Caroline Durieux, Angela Gregory, Alberta Kinsey, Vera Morel, Helen Turner, Gertrude Roberts Smith, and Ella Wood. See Genevieve Munson Trimble, *Le Petit Salon: A History of Its Fifty Years, 1924–1974* (1974; reprint, New Orleans: Le Petit Salon, 2005).

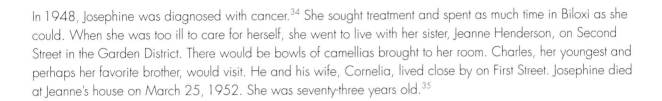

In 1948, Josephine was diagnosed with cancer.[34] She sought treatment and spent as much time in Biloxi as she could. When she was too ill to care for herself, she went to live with her sister, Jeanne Henderson, on Second Street in the Garden District. There would be bowls of camellias brought to her room. Charles, her youngest and perhaps her favorite brother, would visit. He and his wife, Cornelia, lived close by on First Street. Josephine died at Jeanne's house on March 25, 1952. She was seventy-three years old.[35]

34 Farley, 258.
35 *Times-Picayune*, Mar. 26, 1952.

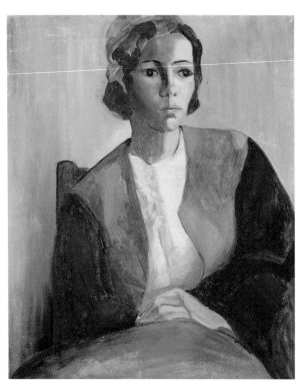

Portrait of Young Woman, *between 1928 and 1932,*
oil on canvas, 27½ x 22¼"; The Historic New
Orleans Collection (1978.23.54), bequest of Charles
C. Crawford

Unfinished Portrait of Young Woman, *between 1928*
and 1932, oil on board, 16¼ x 13⅞"; The Historic
New Orleans Collection (1978.23.42i), bequest of
Charles C. Crawford

CHAPTER 7

An Artist's Vision

This is old New Orleans, caught by the keen eye and trained brush of one of her native daughters.
—ALBERTA COLLIER, *Times-Picayune*

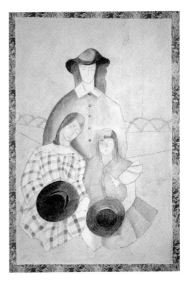

Governess and Crawford Sisters

HERE WAS THE PROBLEM OF THE ANCESTORS—the ones looking down from the high parlor walls. Selling the Royal Street house, when the time came, would mean losing the ancestors.[1] Painted on wallpaper, they could not be moved. Or could they? Charles Crawford decided to save his sister's wallpaper paintings. He asked the respected firm of Knoedler & Company of New York (and Paris and London) to find conservators to perform the painstaking job. The paintings were removed, mounted on board, and hung at Charles's First Street house. It was extravagant, people said, what Charles had done. No one had ever heard of such a thing before—removing what was painted on the walls. Imagine the care and precision involved—not to mention the cost!

Charles was more than a dutiful brother. After consulting with his sister Jeanne, he decided to share Josephine's exceptional art with a wide audience. Besides saving the ancestor paintings, he arranged for the Knoedler Company to organize a retrospective of Josephine's work at the Isaac Delgado Museum of Art (the present-day New Orleans Museum of Art). *The World of Miss Josephine Crawford, 1878–1952*, scheduled to open in mid-September 1965, also included paintings by the modernists who had exhibited in Paris galleries during Josephine's studies at the Académie Lhote: Derain, Dufy, Gleizes, Léger, Lhote, Metzinger, Picabia, Segonzac, and Picasso.

An exhibition checklist identified these artists as "noted contemporaries, many of whom she knew as pupil and friend." But Josephine did not know Picasso or Dufy or Picabia or any of the

1 The house sustained some damage from Hurricane Betsy in 1965 and was sold in 1966.

others, except Lhote, during her stay in Paris. Nevertheless, these modernists, their art on loan from the Knoedler Galleries, added luster to the show. More important, they provided a context in which to place Josephine's accomplishments.

Weather intervened. Hurricane Betsy pounded New Orleans during the night of Thursday, September 9, causing major damage. The informal opening reception was rescheduled from Monday, September 13, to Monday, September 20. Trees were down, power was out, roofs leaking, but the exhibition opened, hailed by art critic Alberta Collier as "one of the best shows of the year!"[2]

Josephine's work was displayed in the museum's Downman Auditorium. Thanks to photographs taken by a representative from Knoedler, it is possible to see where a number of the better-known paintings were placed. Not to be missed among the numerous works on display were the ancestors on wallpaper, the pride of the Knoedler conservation project, and *Her First Communion*, privately owned at the time, now in the holdings of the New Orleans Museum of Art. *Girl Under Mosquito Net* was beside *Flute Player*; farther along were *Dr. Joseph Hume* and *Moth*. *Red Snappers on Ice* faced *Bonnets* and *Guineas* across the room. *Rue Kerlerec* and *Francis Gains* were hung in a far corner. Mettha Eshleman's four-panel screen picturing the Westfeldt children was set up on the opposite side of the room. Other oil paintings filled the walls. Also included was a large collection of Josephine's watercolors and drawings. Alberta Collier again:

> As one enters the room, one has the feeling of complete peace—the kind of peace that comes from fulfillment in an artistic life. There is a glow of soft color from the walls which are filled with half-suggested portraits of her forebears; ironic, but loving, likenesses of her friends and neighbors; and paintings of the hundred other things that made up Miss Josephine's life.[3]

Collier does not equate Josephine's art with that of the masters loaned by Knoedler that were exhibited in the museum's large entrance hall. She explains that Josephine "was instead, a very fine and individual painter whose delicate melodies are as valid as the crashing symphonies of her friends" ("friends" in quotes, that is). Josephine would have been amused that Picasso and Braque were her friends.

The Delgado exhibition catalogue features an evaluation by James R. Mellow. A respected biographer and art critic—author of a major study of Gertrude Stein—Mellow does not see greatness in Josephine's art. The tone of his appraisal is kindly, avuncular. Josephine's watercolors and paintings deserve our attention "not for what they dared . . . but for what they secured in the realm of the private sensibility." The art takes "no heroic stance Her work recalls an older attitude towards life and towards art—less hurried, more content with smaller gains—which brought with it its own satisfactions."[4] Praise, but small praise.

2 *Times-Picayune*, Sept. 19, 1965.

3 Ibid.

4 *The World of Miss Josephine Crawford*, unpaginated.

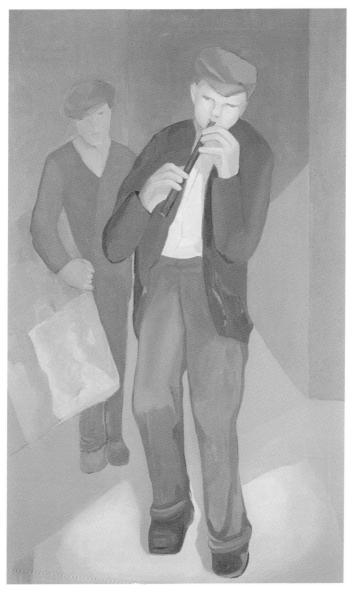

Flute Player, *1937, oil on canvas, 39 x 24"; courtesy of Louise Chapman Hoffman*

Charles Henderson, *1930s, oil on canvas; courtesy of
Micheline M. Bator; photograph by Michael Gould*

Preacher, between 1930 and 1940, oil on canvas, 30 x 21¹⁵⁄₁₆"; The Historic
New Orleans Collection (1978.23.8), bequest of Charles C. Crawford

Included in the catalogue are remarks reprinted from a 1934 column by *States* reporter Elizabeth Kell, written just after Josephine had won the Benjamin Prize—and providing some balance to Mellow's view. She writes, in part:

> When this artist decided . . . to study painting at the Arts and Crafts school she turned naturally to reproducing in her individual way the life that she knows perhaps better than any other artist in the Quarter—the inner lives of the men and women of old New Orleans which strangers are never permitted to see.[5]

Josephine eschewed sentiment. The flat, decorative qualities in her paintings mingle compatibly with her sense of place, a vision that is filtered through a modernist's eye.

Josephine's art came before the public again in *Louisiana Artists* (1968), a show held at the Union Building at Louisiana State University in Baton Rouge. The catalogue (the cover featured Ellsworth Woodward's self-portrait) listed three paintings by Josephine: a self-portrait "done in her studio in Europe," perhaps the portrait at the Morris Museum;[6] a portrait of family friend Lydia Brown, now part of the Laura Simon Nelson Collection at The Historic New Orleans Collection; and *Portrait of a Negro Gentleman*.

Josephine was prolific. After her death, Charles Crawford became the keeper of her oils, sketches, watercolors, notebooks, and sketchbooks. He wisely kept the collection together, eventually designating it as a bequest to The Historic New Orleans Collection on Royal Street, only a block away from 612. Josephine's art was coming home. Charles died in 1977; The Collection mounted an exhibition the following year that traveled to the Louisiana Arts and Science Center in Baton Rouge for a second showing.[7] (No cause to worry—hurricane season was over.) On view once more were *Apple Still Life*, *Throwing the Net*, *Horses on Beach*, along with numerous oils, charcoal and pastel drawings, pencil sketches, watercolors—"neither clichéd nor avant-garde." "The subjects and styles she developed were completely her own," the exhibition brochure affirmed, "subtle, gentle, very personal, and sometimes satiric."[8]

In 1984, the Arts Council of New Orleans inaugurated a show called *Seldom Seen*, featuring portraits from private collections and a few institutions. Josephine's *Dr. Joseph Hume* was chosen by The Historic New Orleans Collection to join a large selection of artworks exhibited at 521 Tchoupitoulas Street in the Warehouse District. The proximity of the 1984 World's Fair, which had just closed, had given a boost to the area, conveniently

5 Ibid.

6 "Her studio in Europe" refers to her work at Lhote's academy.

7 Charles Campbell Crawford Jr. died June 30, 1977. The exhibition ran at The Collection from Nov. 21, 1978, to Jan. 6, 1979, and in Baton Rouge from Jan. 9 to Apr. 29, 1979. The Louisiana Arts and Science Center is now the Louisiana Art and Science Museum.

8 Exhibition brochure, 1978, Josephine Crawford, Artists Files, THNOC.

Horses on Beach, *between 1928 and 1940, oil on canvas, 14⅝ x 19"; The Historic New Orleans Collection (1978.23.2),*
bequest of Charles C. Crawford

located near Canal Street and the Central Business District.[9] (*Hume*, one of the oils hung in The Collection's 1978 Crawford exhibition, was not as "seldom seen" as some of the other portraits.)

The exhibition *Eight Southern Women: Blanche Lazzell, Josephine Marien Crawford, Nell Choate Jones, Clara Weaver Parrish, Alice Ravenel Huger Smith, Helen M. Turner, Mary Harvey Tannahill, Anne Goldthwaite* opened at the Greenville County Museum of Art (Greenville, South Carolina) in August 1986. Josephine's art was in good company: the eight women were chosen for overcoming "the formidable currents of chauvinism and provincialism" to achieve "independent, creative lives."[10] Of the eight, two artists, besides Josephine, had New Orleans connections. Helen Turner had taught at the art school of the Arts and Crafts Club in the mid-1920s (and later in New York); the Delgado Museum held a retrospective of her work in 1949. Anne Goldthwaite, an Alabama native who taught at the Art Students League for more than twenty years, had exhibited at the Delgado and at the Arts and Crafts Club. The Historic New Orleans Collection sent five paintings from the Crawford bequest: *Seated Woman with Hands in Lap, Guineas, Woman with Walking Stick, House on Hill,* and *Hibiscus.* They are unmistakably Crawford: women and house, spare and simplified; *Guineas* and *Hibiscus,* decorative patterns. After its run in Greenville, *Eight Southern Women* moved to the Gibbes Museum of Art in Charleston.[11]

In 1991, several Crawford works were selected for an exhibition, *Downriver: Currents of Style in Louisiana Painting, 1800–1950,* at the New Orleans Museum of Art. The Historic New Orleans Collection contributed *Bonnets* (titled *The Milliner's Shop* in the exhibition) and *Parakeets in a Cage* (titled *Parrots in a Cage*) to the show, while the Morris Museum loaned *Self-Portrait.* And the public would again see Josephine's work in *The Arts and Crafts Club: An Artistic Legacy* in 2006–07, an exhibition organized jointly by The Historic New Orleans Collection and the New Orleans Museum of Art and held at NOMA. Crawford's *Lydia Brown, Francis Gains,* and *Her First Communion* joined an important assemblage of artists and artifacts associated with the influential club.

Now picture this scene in 1964. There is to be a gathering; the ancestor paintings will be admired. No, it is not an exhibition, but a literary club, invited to Charlie Crawford's to hear Jack Bartlett Kelleher give a paper, "New Orleans Art in the '30s."[12] The Crawford house is very grand, an Italianate mansion in the American section of town, quite the opposite of the Crawford town house in the French Quarter, approached at the back via a carriageway. Here in the Garden District there are massive live oaks that define the property, surrounded

9 The building at 521 Tchoupitoulas Street was owned and renovated by The Historic New Orleans Collection. The property was sold in 2007.

10 Thomas W. Styron, introduction to *Eight Southern Women,* 5.

11 The exhibition ran in Greenville from Aug. 5 to Sept. 14, 1986, and in Charleston from Sept. 25 to Nov. 2, 1986.

12 Nellie B. Kelleher, "New Orleans Art in the '30s," paper given Apr. 21, 1964, Quarante Club Papers, MSS 401, box 4, Special Collections, Tulane.

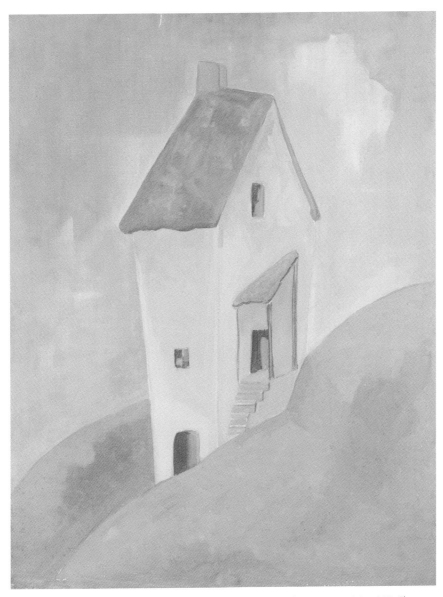

House on Hill, *between October 1, 1927 and 1940, oil on canvas, 29 x 22"; The Historic New Orleans Collection (1978.23.51), bequest of Charles C. Crawford*

Parakeets in a Cage, between 1926 and 1945, oil on canvas, 24¹/₁₆ x 19⅛"; The Historic New Orleans Collection (1978.23.6), bequest of Charles C. Crawford

Muscovy Ducks, between 1930 and 1940, oil on canvas, 22 x 30"; The Historic New Orleans Collection (1978.23.17), bequest of Charles C. Crawford

by a high iron fence. The members arrive at the front door. Jeanne Henderson is a guest. Jack will talk about four artists: Josephine Crawford, Charles Bein, Xavier Gonzalez, and Enrique Alférez. (Jack, the secretary of the Arts and Crafts Club in the early '30s, knew all the artists.) She tells her audience that Josephine often stopped by the Green Shutter Tea Room to meet Dot Milling in the afternoon. And Josephine had many "dear friends": Charlie Bein, Dick Koch, Enrique Alférez, Mrs. Frans Blom, Paul Ninas, and Dan Whitney.

Moving from the general to the specific, Jack remembers the artist:

> Often seen scurrying along Royal Street during the '30s was a small, brown-clad figure of a woman. As soon as she spoke to you, you were aware of her shining, darting eyes that seemed to take in everything and everyone around her.

Jack talks about the other artists, but Josephine is the star of the paper. Over tea, the members are eager to find out who has a Crawford painting. They look at the wallpaper paintings, now in their second home, and ask Jeanne Henderson to identify the ancestors.

The Paris journals, early sketchbooks, and poems contain Josephine's "voice," but there are no letters, or very few, to round out the picture. If there were letters, they are lost. The biographer longs for things that are unrecoverable, Edmund Morris writes, and is "hardly assuaged by the recovery of trifles—an oar or a floating hat, after everything else has gone over the weir."[13]

And yet. A trifle or two—the "floating hat"—will linger in the mind and call up a scene and with it, a picture of Josephine.

She is in Biloxi. On her desk is a preserved seahorse, very small. Did she find it or buy it? It doesn't matter. She carefully places the seahorse in an equally small cardboard box lined with cotton. Josephine will send it to a young friend who loves curiosities. She glances at a key, long and heavy, that she uses as a paper weight. This is the key (no longer used) to Royal Street, the one old Prosper had dangling on a key ring. Small things bring Josephine a bit closer.

Little remains of Josephine's world. The carriageway at 612 Royal Street is hung with paintings for the tourist trade. A nondescript apartment building stretches along the rue d'Odessa where André Lhote's académie once stood, the Tour Montparnasse looming just behind. In Biloxi, the East Beach houses gave way in Hurricane Camille, and Hurricane Katrina washed through the house at 1200 East Howard Avenue. Only memory reconstructs.

13 Edmund Morris, *Dutch: A Memoir of Ronald Reagan* (New York: Random House, 1999), 5.

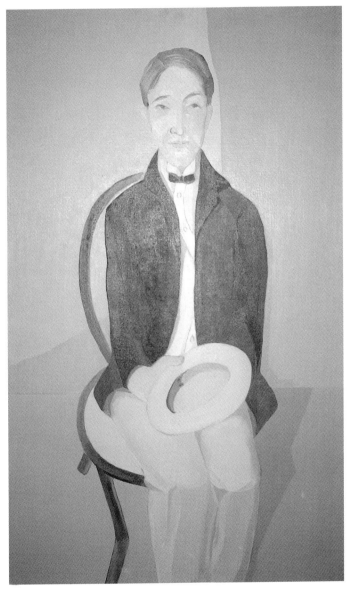

Seated Man (lost in Hurricane Katrina), *between 1930 and 1940,*
oil on canvas; courtesy of the late Marcia Milling Monroe Conery

Imagine, now, that you take the heavy key to 612 Royal Street and enter. You remember the wallpaper paintings and sense a presence or two:

> Still about the old house
> Linger spirits of the past . . .
> Prisoned in the lofty walls . . .

You think of Josephine's art school days, the group shows, the hours spent creating the ancestor portraits, the wildflower garden. There is the bracing scent of oil paints, the lemony fragrance of magnolias. But something is always held back, something unknown. Josephine can best be found through her art. And that is how it should be. We can admire her work and let the art speak for itself.

It is not easy to tie up the loose ends of a life. But this, perhaps, is as good a summing up as any: Charles Henderson, Josephine's nephew, said, "Everybody loved Josie."

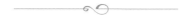

One last picture. Josephine looks out of a photograph, smiling, slightly inclined forward. She is at The Mound, river sand at her feet, a path through the trees behind her. As she smiles, she is thinking of the sweet bay (*magnolia virginiana*) she has just planted.

Josephine Crawford at The Mound

Selected Bibliography

ARCHIVES AND SPECIAL COLLECTIONS CONSULTED

NEW ORLEANS

Christ Church Cathedral
_____. Marriage records.
The Historic New Orleans Collection
_____. Artists Files: Arts and Crafts Club, Josephine Crawford, Paul Ninas.
_____. Arts and Crafts Club Collection, MSS 247, acc. no. 76-159-L.
_____. Josephine Marien Crawford Papers, 1862–1965, MSS 248, acc. no. 78-36-L.
_____. New Orleans city directory, 1884, 1896.
_____. Vieux Carré Survey.
_____. Westfeldt, Eshleman, and McIlhenny Family Papers, acc. no. 2001-52-L.
Louisiana State Museum, Historical Center
Louisiana State University Libraries, Special Collections
Newcomb College Center for Research on Women
New Orleans Public Library
_____. Obituary files.
_____. Marriage files.
Trinity Episcopal Church
_____. Baptism records.
Tulane University, Howard Tilton Memorial Library
_____. Art clippings file, Louisiana Collection, Special Collections.
_____. Arts and Crafts Club vertical file, Louisiana Collection, Special Collections.
_____. Crawford Family Papers, 1856–1944 (Pearl River Series), MSS 371A, Special
 Collections.

_____. Quarante Club Papers, MSS 401, Special Collections.
_____. Southeastern Architectural Archive, Special Collections.

MISSISSIPPI
Second District, Harrison County, MS
_____. Land and Deed Records.

SELECTED BIBLIOGRAPHY

The Advent of Modernism: Post-Impressionism and North American Art, 1900–1918. Atlanta: The High Museum of Art, 1986.

Agee, William C. "Into the New Century: After the First Wave." In *The Advent of Modernism,* 43–56.

André Lhote: 1885–1962, Rétrospective présentée au Musée de Valence du 15 juin au 28 septembre 2003. Paris: Réunion des musées nationaux, 2003. An exhibition catalogue.

Bienvenu, Willie Z., M.D. "The Bienvenu Family of St. Martinville." *Attakapas Gazette* 15 (Spring 1980): 2–8. Lafayette: Attakapas Historical Association, published in cooperation with the Center for Louisiana Studies, University of Southwestern Louisiana.

Blistène, Bernard. *A History of 20th-Century Art.* Translated by David R. Howell. Paris: Flammarion and *Beaux-Arts* magazine, 2001.

Bonner, Judith. "All the Artful and Crafty Ones." In *The Historic New Orleans Collection Quarterly* 11 (Winter 1993): 4–6.

_____. "The Laura Simon Nelson Collection of Louisiana Art: An Exhibition in Three Parts." *The Historic New Orleans Collection Quarterly* 14 (Spring 1996): 1–6.

_____. *The New Orleans Arts and Crafts Club: An Artistic Legacy.* New Orleans: New Orleans Museum of Art and The Historic New Orleans Collection, 2007. An exhibition catalogue.

_____. "Paintings from the Permanent Collection of the Historic New Orleans Collection." In *Complementary Visions of Louisiana Art: The Laura Simon Nelson Collection at the Historic New Orleans Collection.* Edited by Patricia Brady, Louise C. Hoffman, and Lynn D. Adams, 61–86. New Orleans: The Historic New Orleans Collection, 1996.

Bougault, Valérie. *Paris Montparnasse: The Heyday of Modern Art, 1910–1940.* Translated by Murray Wyllie. Paris: Finest SA/Editions Pierre Terrail, 1997.

Breckinridge, Mrs. Henry. Foreword to *Second National Exhibition of American Art.* New York: Municipal Art Committee, 1937. An exhibition catalogue.

Clemmer, John. *Item.* June 4, 1950.

Collier, Alberta. "The Art Scene in New Orleans—Past and Present." In *The Past as Prelude: New Orleans, 1718–1968,* edited by Hodding Carter et al., 146–65. New Orleans: Tulane University, 1968.

_____. *Times-Picayune*, Sept. 19, 1965.

Crawford, Hugh. "An Account of the Crawford Families of Baidland in Ayrshire and Crawfordsburn, County Down." 1972. Private collection.

Crosby, Patricia Dunn. "The New Deal Art Projects in Louisiana." Master's thesis, Tulane University, 1981.

Curtis, Nathaniel C. *New Orleans: Its Old Houses, Shops and Public Buildings*. Philadelphia: J. B. Lippincott, 1933.

Dennison, Mariea Caudill. "The Art of the American South, 1915–1945: Picturing the Past, Portending Regionalism." PhD diss., University of Illinois at Urbana-Champaign, 2000.

Dyer, Charles Lawrence. *Along the Gulf*. 1895. Reprint, Pass Christian, MS: Women of Trinity Episcopal Church, 1971.

Eight Southern Women: Blanche Lazzell, Josephine Marien Crawford, Nell Choate Jones, Clara Weaver Parrish, Alice Ravenel Huger Smith, Helen M. Turner, Mary Harvey Tannahill, Anne Goldthwaite. Greenville, SC: Greenville County Museum of Art, 1986. An exhibition catalogue.

Farley, Catharine Jean. "The Life and Art of Josephine Marien Crawford, 1878–1952." Master's thesis, Tulane University, 1988.

Fernandez, Frank and William M. Hyland. "Tour of Historic Saint Bernard Parish." Privately printed, n.d.

Ganteführer-Trier, Anne. *Cubism*. Translated by Sean Gallagher. Cologne: Taschen, 2004.

Garcia, Françoise. "Lhote: la gloire de Bordeaux." In *André Lhote: 1885–1962*, 94–99.

Godwin, Gail. *A Southern Family*. New York: William Morrow and Company, 1987.

Grammont, Claudine. "Un académisme abstrait? Lhote et l'enseignement des Beaux-Arts." In *André Lhote: 1885–1962*, 100–111.

Harvey, Chance. *The Life and Selected Letters of Lyle Saxon*. Gretna, LA: Pelican Publishing, 2003.

Haskell, Barbara. *Charles Demuth*. New York: Whitney Museum of Art, in association with Harry N. Abrams, 1987. An exhibition catalogue.

Holditch, W. Kenneth. "The Brooding Air of the Past: William Faulkner." In *Literary New Orleans: Essays and Meditations*, edited by Richard S. Kennedy, 38–50. Baton Rouge: Louisiana State University Press, 1992.

Holmes, Walter C. *Flore Louisiane: An Ethno-Botanical Study of French-Speaking Louisiana*. Lafayette: The Center for Louisiana Studies, University of Southwestern Louisiana, 1990.

Johns, Elizabeth. "Early American Modernists and Their Viewers." In *To Be Modern*, 26–34.

Jordan, George E. "Josephine Marien Crawford (1878–1952)." In *Eight Southern Women*, 6–7.

_____. "The South Forsaken." *The New Orleans Art Review* 4 (Feb.–Mar. 1985): 12–13.

_____. "Suggested Contours: Examining the Art of Josephine Crawford, 1878–1952." *Louisiana Cultural Vistas* 13 (Winter 2002–03): 48–51.

Kazin, Alfred. "The Past Breaks Out." In *Inventing the Truth: The Art and Craft of Memoir*, edited by William Zinsser, 119–39. Boston: Houghton-Mifflin, 1998.

Keefe, John Webster, Michelle Y. Castro, and Clarke "Doc" Hawley. "Selections from the Samuel Collection." In *A Keen Eye: Louisiana Art from the Martha Ann and Ray Samuel Collection*, 8–60. New Orleans: New Orleans Auction Galleries, 2006.

Kenavo Monsieur Gauguin. Pont-Aven: Musée de Pont-Aven, 2003. An exhibition catalogue.

Laufer, Marilyn. *Modernism in the South: Mid-Twentieth-Century Works in the Morris Museum Collection*. Augusta, GA: Morris Museum of Art, 2002.

Lemann, Bernard. *The Vieux Carré: A General Statement*. 1966. Reprint, New Orleans: Louisiana Landmarks Society, Samuel Wilson Jr. Publication Fund, in cooperation with Tulane University School of Architecture, 2001.

Lemmon, Alfred E., John T. Magill, and Jason R. Wiese, eds. *Charting Louisiana: Five Hundred Years of Maps*. New Orleans: The Historic New Orleans Collection, 2003.

Lemoine, Serge. "L'atelier d'André Lhote: entretien avec Aurelie Nemours" and "Retrouver André Lhote." In *André Lhote, 1885–1962*, 112–17, 118–21.

Lottman, Herbert R. *Man Ray's Montparnasse*. New York: Harry N. Abrams, 2001.

Menn, Joseph Karl. *The Large Slaveholders of Louisiana, 1860*. Gretna, LA: Pelican Publishing, 1964.

Morris, Edmund. *Dutch: A Memoir of Ronald Reagan*. New York: Random House, 1999.

Paintings by Artists of the Deep South. Philadelphia: Boyer Galleries, 1935. An exhibition catalogue.

Pennington, Estill Curtis. *Downriver: Currents of Style in Louisiana Painting, 1800–1950*. Gretna, LA: Pelican Publishing, 1991.

Pierpont, Claudia Roth. "The Mother of Confusion." *The New Yorker*, May 11, 1998, 80–89.

Pizer, Donald. *American Expatriate Writing and the Paris Moment: Modernism and Place*. Baton Rouge: Louisiana State University Press, 1996.

Poesch, Jessie. "Will Henry Stevens (1881–1949)." In *Will Henry Stevens*, 7–64. Greenville, SC: Greenville County Museum of Art, 1987. An exhibition catalogue.

Saward, Susan. *Knute Heldner and the Art Colony in Old New Orleans*. New Orleans: Jean Bragg Gallery, 2000. An exhibition catalogue.

Saxon, Lyle. *Fabulous New Orleans*. New Orleans: Robert L. Crager and Company, 1950.

Seebold, Herman Boehm de Bachellé. *Old Louisiana Plantation Homes and Family Trees*, vol. 1. Gretna, LA: Pelican Publishing, 1941.

Seligmann, Herbert J. "291: A Vision Through Photography." In *America and Alfred Stieglitz: A Collective Portrait*, edited by Waldo Frank et al., 105–25. New York: The Literary Guild, 1934.

Smith, Alice R. Huger. *A Carolina Rice Plantation of the Fifties*. New York: W. Morrow and Co., 1936.

Spencer, Elizabeth. *On the Gulf*. Jackson: The University Press of Mississippi, 1991.

_____. *The Salt Line*. 1984. Reprint, Baton Rouge: Louisiana State University Press, 1995.

Stanonis, Anthony J. *Creating the Big Easy: New Orleans and the Emergence of Modern Tourism, 1918–1945*. Athens: The University of Georgia Press, 2006.

Stewart, Rick. "Toward a New South: The Regionalist Approach, 1900–1950." In *Painting in the South: 1564–1980*, edited by David S. Bundy, 105–40. Richmond: Virginia Museum of Fine Arts, 1983.

Styron, Thomas W. Introduction to *Eight Southern Women*, 5.

"Then and Now: A Symposium on the Expatriate Tradition in Paris," presented at the American Center for Students and Artists (Paris, 1964). Remarks from the symposium's round table discussion were published in the *Paris Review* 33 (Winter–Spring 1965).

To Be Modern: American Encounters with Cézanne and Company. Philadelphia: Museum of American Art of the Pennsylvania Academy of the Fine Arts, 1996. An exhibition catalogue.

Toklas, Alice B. *What is Remembered*. New York: Holt, Rinehart and Winston, 1963.

Trimble, Genevieve Munson. *Le Petit Salon: A History of Its Fifty Years, 1924–1974*. 1974. Reprint, New Orleans: Le Petit Salon, 2005.

Waterfield, Will Douglas. "Paul Ninas: The Dean of New Orleans Art." Master's thesis, Louisiana State University, 1997.

Whitney, Daniel. *Times-Picayune*. July 15, 1928.

Wilson, Samuel, F.A.I.A. *Plantation Houses on the Battlefield of New Orleans*. 1965. Reprint, New Orleans: Louisiana Landmarks Society, 1996.

Weisberg, Gabriel P. and Jane R. Becker, eds. *Overcoming All Obstacles: The Women of the Académie Julian*. New York: Dahesh Museum, in association with Rutgers University Press, 1999. An exhibition catalogue.

The World of Miss Josephine Crawford, 1878–1952. New Orleans: Isaac Delgado Museum of Art, 1965. An exhibition catalogue.

Young, Perry. *The Mistick Krewe: Chronicles of Comus and His Kin*. New Orleans: Louisiana Heritage Press, 1969.

Yount, Sylvia. "Rocking the Cradle of Liberty: Philadelphia's Adventures in Modernism." In *To Be Modern*, 9–22.

Zacharie, James S. *The New Orleans Guide*. New Orleans: New Orleans News Company, 1885.

Zilczer, Judith. "The Dissemination of Post-Impressionism in North America: 1905–1918." In *The Advent of Modernism*, 23–39.

Index

Page numbers in italics refer to illustrations.

291 Gallery, 100, 100n8
417 Royal Street, 40, 40n7
520 Royal Street, 40–42, 40n6, *40, 41*
612 Royal Street
 address of, 18n5
 description of, 17–18, 53, 85–87
 division into apartments, 53, 87–88
 history of, 85–86
 key to, *27*
 photographs of, *xvi, 16, 17, 46, 53, 85, 86, 87*
 purchase of by Bienvenu family, 17
 selling of, 133, 133n1
712 Royal Street, 54, *54*
713 Governor Nicholls Street, 81, *81*

A

Abbott, Berenice, 2, 3n5
Académie Julian, 2n2
Académie Lhote, 2, 5–6
Albrizio, Conrad, 76
Alférez, Enrique, *55, 56*, 59, 71, 74, 76, 78, 80, 144
Anderson, Sherwood, 42, 42n17, 44
Anderson, Walter, 42, 42n14
Ankeney, John S., 76
Armory Show (exhibition), 2, 2n3, 100
Art, modern trends in, 45, 48, 69, 71, 83. *See also* Modernism
Art Nègre (African Art), 8, 8n33, 10
Artists Guild, 40, 40n3, 40n5. *See also* Arts and Crafts Club
Arts and Crafts Club. *See also* Artists Guild
 affiliation with Southern States Art League, 44

art school
 activities by, 45
 class offerings by, 73–74
 Crawford's enrollment in, 2, 42
 financial problems of, 76
 life-drawing class, *45*
 Ninas named head instructor of, 74
 pottery studio, 81, *81*
 quality of instruction by, 48
 Bein's resignation from, 74
 during World War II, 82
Bal des Etoiles, Le, 53
beaux-arts balls, 46, 53
closure of, 83
Crawford's service on board, 80
exhibitions by, 46, 53, 54, 54n52, 69, 69n73, 74, 76, 78, 81, 82, 83
financial situation of, 44, 76, 80–81, 83
locations of, 40–42, 40n6, 54, 81, *81*
and modern trends in art, 45, 48
move to Pirate's Alley, 54, 56
organization of, 40–41
popularity of, 46
Stein's address to, 71
during World War II, 81–82
Arts and Crafts Club: An Artistic Legacy (exhibition), 140
Arts Council of New Orleans, 138
Atget, Eugène, 3, 3n5
Austria, 14
Avignon, France, 14, 113

B

Bal des Etoiles, Le, 53
Barr, Clayre, 59

Bartlett, Jack (Nellie May). *See* Kelleher, Jack (Nellie May) Bartlett
Bartlett, Paul, 12, 12n42
Bassin d'Arcachon, Le (painted screen) (Lhote), 113n25
Bator, Micheline Martin, 82n31, *92*
Battle of New Orleans, 20, *21*, 86n1
Beaucaire, France, 14, 113
Bein, Charles, 46, 51, 53, 54, 56, 59n66, 74, 144
Belfast, Ireland, 19n8, 31, 33
Belle Augustine, La (Gregory), 48
Benjamin, Edward B., 56
Benton, Thomas Hart, *74*
Bernard, Emile, 113
Bienvenu (family), 19–22
Bienvenu, Agatha, *62*
Bienvenu, François Mélicourt, 17, 18, 19
Bienvenu, Louise. *See* Crawford, Louise Bienvenu
Biloxi, Mississippi
 Crawford (family) property in, 33, *33*, 87n5, 88, 90, 90n13, *91*
 Crawford's everyday life in, 94, 97
 Crawford's residences in, 90, *91*, *91*, *92*
 Crawford's studios in, *91*, *92*
 friends' recollections of, 88, 90
 as haven, 33–34
 Henderson property in, *xv*, 90, 90n14, *91*, *92*, 96
 Mound, The, xiii, *xiii*, *97*, *146*
 seascape, *91*
 sketches of outhouses in, 124, 124n27, *127*
 as summer retreat, 88, 90–91
 wildflower garden in, 97
Bisland, Bessie, 31n50
Blanchard, Maria, 10
Blanche Benjamin Prize, 46, 56, 56n56, 58–59
Blom, Frans, 59, 59n65
Blom, Mrs. Frans, 59, 144
Bonnets (Crawford). *See* Crawford, Josephine (art): paintings
Bosque, Suzette, 86
Boyer Galleries, 73
Braque, Georges, 7, 99
Brennan's, 40n7
Brittany, France, *112*, 113, *114*
Brown, Douglas, 51
Brown, Lydia, 41, 43, 140
Brulatour mansion, 40–42, 40n6, *40*, *41*
Burchfield, Charles, 74

Burkenroad, Mrs. David, 41n8

C
Café du Dôme. *See* Dôme, Le
Cagnes-sur-Mer, France, 14, 113
Calder, Alexander, 2
Cannes, France, *104*, 113
Carcassonne, France, 14, *15*, 113
Cartier-Bresson, Henri, 5
Cat Island, 94
Cenas Institute for Young Ladies, 26
Central America, traveling exhibition in, 80
Cézanne, Paul, *7*, 14, 99
Clemmer, John, 83, *83*, 127n29
Collier, Alberta, 134
Colomb, Bessie, *xvi*
Color
 Crawford's use of. *See* Crawford, Josephine (art)
 Lhote on. *See* Lhote, André
 in modernism, 105
Cornell University, 31
Coupole, La (café), 3, 3n9, 10
Crawford (family), 19, 19n8, 31, 32, 33, 35
Crawford, Charles Campbell (brother), xiv–xv, 19, 32, 131, 133, 138
Crawford, Charles Campbell (father), 1, 18, 25, 27–28, 32, 32n57, 33, 34, *68*
Crawford, Charlotte. *See* D'Heur, Charlotte Crawford
Crawford, Hugh, 108
Crawford, James Charles, 19, 31
Crawford, Jeanne. *See* Henderson, Jeanne Crawford
Crawford, John de Morant, 19, 31, *31*
Crawford, John IV, 33
Crawford, John M., 33
Crawford, Josephine (life)
 baptism of, 25
 birth of, 1
 death of, 131
 education of, 26, 28, 30
 health of, 26, 34
 houses of. *See* 612 Royal Street; Biloxi, Mississippi: Crawford (family) property in; Biloxi, Mississippi: Crawford's residences in
 name, spelling of, 1n1
 occupation of, 42n11
 photographs of, *xiii*, *2*, *14*, *29*, *34*, *36*, *84*, *95*, *146*

travel by, 37, 113n24
 in Austria, 14
 in France, 2, 3–5, 8, 10, 12–14, 37, 113
 in Mexico, 54, 113
Crawford, Josephine (art)
 color, use of, 78, 105, 127
 critics on, 42, 58, 78, 99, 134, 138
 drawings, 8
 Daisy's Parlor, 108, 108
 of Biloxi, 91, 97
 of France, 15, 104, 112, 113
 of Mexico, 56, 113, 115
 of nudes, 13
 of outhouses, 124, 124n27, 127
 early appreciation for, 42
 emotion in, 124, 127
 exhibitions of, 46, 48, 51, 53, 59, 76, 78, 82–83,
 133–134, 138, 140
 humor in, 124
 intimacy in, 124
 introduction of Cubism to New Orleans, 99
 Kelleher's recollections of, 140, 144
 lithography, 14–15
 nostalgia in, 105
 paintings
 of ancestors, 60, 62–64, 67, 68, 69, 105, 133
 of animals, 48, 74, 75, 76, 78, 79, 104, 105, 109,
 124, 125, 134, 138, 139, 140, 142, 143
 Bonnets, 70, 71, 108, 116, 134, 140
 of Central America, 80
 Dressing Screen of Westfeldt Children, 113, 116, 117,
 134
 of family members, viii, 60, 61, 65, 66, 68, 89, 92,
 96, 98, 105, 107, 116, 119, 126, 133, 136
 Fête Champêtre, 130
 of flowers, 9, 52, 72, 73, 73, 76, 77, 78, 79, 82,
 94, 95, 108, 140
 of France, 48, 114
 of friends, 43, 47, 116, 129, 134, 138, 140
 Girl Under Mosquito Net, 76, 78, 92, 93, 94, 105,
 118, 134
 Her First Communion, 78, 108, 127, 128, 134, 140
 landscapes, 78, 140, 141
 of nudes, 48, 49, 50, 51, 122

of people, 24, 101, 130
 Red Snappers on Ice, 94, 94n18, 134
 Rue Kerlerec, ii, 56, 57, 58–59, 58n59, 78, 82,
 82n31, 113, 124, 134
 Throwing the Net, 108, 111, 116, 138
 Young Woman Wearing White Gloves, 105, 106
 poetry, 14, 17, 19, 22–23, 25–26, 25n24, 36
 portraits, viii, 11, 43, 47, 49, 50, 51, 57, 61–68, 70,
 80, 92, 93, 96, 98, 102, 103, 105, 105, 106,
 107, 108, 110, 114, 117, 119, 122, 123, 126,
 128, 129, 132, 133, 134, 135, 136, 137, 138,
 140, 145
 restraint in, 58, 124
 self-portraits, 118, 120, 120–123
 still lifes, 42, 108, 109, 138
 studies, 113, 116, 116, 118, 118
 for Girl Under Mosquito Net, 118, 118
 for Rue Kerlerec, 113, 116
 style of
 descriptions of, 99
 development of, 108, 113, 116, 127
 as modern, 105
 as "representational Cubism," 101
 subjects, choice of, 124
Crawford, Lewis Bienvenu, 19, 32n53
Crawford, Louise Bienvenu, 1, 18, 25, 27, 32, 33, 34, 65
Crawford, Louise Harriet (Miss Tweety), 18, 53, 87, 87n5,
 90, 124, 126
Crawford, Marion, 33
Crawford, Theodosia, 33
Crawford, William Gordon (mother's first husband), 18, 33
Crawford, William Gordon (brother), 18, 31
Creoles
 attachment to French Quarter, 36
 Crawford family as, 19, 35
 Crawford's portrayal of, 59, 71. See also Rue Kerlerec;
 wallpaper portraits
 explanation of, 19n8
Cruise, Boyd, 56, 76
Cubism
 In Crawford's style, 101
 explanation of, 7n23, 99–100
 introduction of to New Orleans, 99
 Lhote on, 6–7, 100

D

Daisy's Parlor (Crawford). *See* Crawford, Josephine (art): drawings
Darling, W. M., 78
Davis, Stuart, 2, 54
De Morant (family), 22, 22n19
De Zayas, Marius, 100, 100n11
Dedeaux, Earlee, *83*
Deer Island, 97
Delgado Museum of Art, 44, 59, 133–134, 140
Demuth, Charles, 74, 105
Denis, Maurice, 113
Deuil (Mourning) (Lhote), 113, *116*
Deux Brettonnes sur la route (*Two Women of Brittany on the Road*) (Gauguin), 113
D'Heur, Allard, 30, *30*, 94, 96
D'Heur, Charlotte Crawford, 19, 19n7, 30, *30*, 92
D'Heur, Josephine. *See* Martin, Josephine d'Heur
D'Heur, Pierre Joseph, 30, 30n44
Dickinson, Preston, 74
Dix, Dorothy, 51
Dôme, Le (café), 3n9, 10, *12*
Double Dealer (magazine), 42, 44, 44n18
Downriver: Currents of Style in Louisiana Painting, 1800–1950 (exhibition), 140
Drawing. *See also* Crawford, Josephine (art): drawings
 Crawford's early study of, 26
 Lhote on, 5n14, 116
Dreir, Katherine, 101
Dressing Screen of Westfeldt Children (Crawford). *See* Crawford, Josephine (art): paintings
Duchamp, Marcel, 3, 101
Dufy, Raoul, 76
Dundee bag, 28n38
Durieux, Caroline, 45, 54, 74, 76, 130n33

E

Eckles, Adele Godchaux, 51
Ecole des Beaux-Arts, 2n2
Eight Southern Women (exhibition), 140
Elliott, Mrs. Noel F., 41n8
Epstein, Jacob, 76
Eshleman, Mettha Westfeldt, 113, 116, *117, 129,* 130
Exhibitions
 Armory Show, 2, 2n3, 100

by Arts and Crafts Club, 46, 53, 54, 54n52, 69, 69n73, 74, 76, 78, 81, 82, 83
Arts and Crafts Club: An Artistic Legacy, 140
in Central America, 80
Crawford's one-woman show, 78
Downriver: Currents of Style in Louisiana Painting, 1800–1950, 140
Eight Southern Women, 140
Later Tendencies, 100
Lhote's works in, 8, 10
Louisiana Artists, 138
at Montross Gallery, 51
Paintings and Drawings by Representative Modern Masters, 100
Paintings by Artists of the Deep South, 73
Rattner's, 48, 81–82
Second National Exhibition of American Art, 76
Seldom Seen, 138, 140
World of Miss Josephine Crawford, The, 133–134, 138

F

Faulkner, William, 42, 44
Fête Champêtre (Crawford). *See* Crawford, Josephine (art): paintings
Fitzgerald, Thérèse, 82
Fighting French Relief, 82
Four Saints in Three Acts (Thomson/Stein), 71n75
France. *See also* specific cities
 Crawford in. *See* Crawford, Josephine (life): travel by
 in World War II, 82
 South of, 113
French Quarter, 18n4, 18n5, 19n9, 36, 39–40, 42, 44, 45–46
Frère, Herbert, 59, 78, 78n19

G

Gains, Francis, *viii,* 60, *61,* 108, *110,* 134, 140
Gauguin, Paul, 113
Gilmer, Elizabeth M. (Dorothy Dix), 51
Girl Under Mosquito Net (Crawford). *See* Crawford, Josephine (art): paintings
Gloire de Bordeaux, Le (Lhote), 69, *69*
Goats (Bein), 51
Golden section, 71n78
Goldthwaite, Anne, 140
Gonzales, Juanita, 81n25

Gonzales, Xavier, 58, 58n60, 59n66, 76, 78, 144
Governor Nicholls Street, 81, *81*
Graham, Don, 51
Gray, Matilda Geddings, 74
Green Shutter, The (Spratling), *82*
Green Shutter Book Bindery, 130, 130n32
Green Shutter Tea Room, 40, 82, 130n32, 144
Gregory, Angela, 3, 48, 56, 59, 130n33
Grymes, John R., 85–86

H

Hall, Weeks, 51, 56
Hambourg, Jan, 12
Hardee, Thomas S., 1
Hart, Charles Overbury (Pop), 74
Hartung, Hans, 5
Hassam, Childe, 44, 44n20
Heldner, Knute, 44, 44n19, 51
Henderson, Charles, *viii*, 60, *61*, 94, 96, *107*, *136*
Henderson, Hunt, 46, 48, 51, 76, 90, 91, 100, 127
Henderson, Jeanne Crawford, 14, *14*, 19, 19n7, 32, *32*, 46, 82, 88, 90, 131, 144
Henderson, Sarah, 12, 28, *28*, 40, 41n8, 44, 46, 51, 53, 58, 74, 76, 82, 83, 83n33, 130n33
Her First Communion (Crawford). *See* Crawford, Josephine (art): paintings
Histoire Naturelle (Buffon), 20, 20n14, 28
Historic New Orleans Collection, The, 138, 140
Hopper, Edward, 74
Horn Island, 94
Hume, Joseph, *47*, 46, 58n59, 82n31, 116, 134, 138, 140
Hurricane Betsy, 133n1, 134
Hutson, Charles Woodward, 51, 59

I

Impressionism, 7, 94
International Exhibition of Modern Art. See Armory Show
Irby, William Ratcliffe, 40
Ireland, 19n8, 31, 33

J

Jack Bartlett Kelleher (Gonzales), *58*
Jewell, Foster, 51
Jolas, Eugene, 2
Jolas, Maria, 3

K

Keiffer, Walter Brown, 41n8
Kell, Elizabeth, 56, 69, 138
Kelleher, Jack (Nellie May) Bartlett, 56, 58, *58*, 58n61, 140, 144
Kenilworth Plantation, 21–22, 21n16
Kinsey, Alberta, 40, 41, 51, 54, 56, 59, 130n33
Koch, Richard, 40, 46, 53, 54, 58, 74, 80, 80n23, 144
Kunstgewerbeschule, 14

L

Labatut, Isidore, 88
Lafitte brothers (Jean and Pierre), 86n1
Later Tendencies (exhibition), 100
Latour, Arsène Lacarrière, 20
Léger, Fernand, 12
Lempicka, Tamara de, 5
Lhote, André
 career of, 6
 on color, 8, 8n32, 94
 Crawford's descriptions of, 3–5, 8, 10
 on Cubism, 6–7, 100
 on drawing, 5n14, 116
 in exhibitions, 8, 10
 on Impressionism, 7, 94
 influence on Crawford, 127, 127n29
 mural by, 69, *69*
 photographs of, *4*, *7*, *10*
 school of, 2, 5–6
Lieutaud, Albert, *55*
Lithography. *See* Crawford, Josephine (art)
Louisiana Artists (exhibition), 138

M

Mackintosh, Harriet, 33
Man Ray, 2, 101
Marseilles, France, 14, *112*, 113
Martin, Micheline. *See* Bator, Micheline Martin
Martin, Josephine d'Heur, 30, *30*, 30n44, 98, 116, *119*
Masks, ceremonial, 8n33. *See also* Art Nègre
Mason-Smith, Marguerite, 41n8
Matisse, Henri, 99
McCrady, John, 59, 73
Mellow, James R., 134
Mexico, 54, 56, 113, *115*
Millet, Clarence, 51, 59, 76

Milliner's Shop, The (Crawford). *See Bonnets* (Crawford);
 Crawford, Josephine (art): paintings
Milling, Dot, 113n24, 144
Modernism. *See also* Art, modern trends in
 Armory Show, 2, 2n3, 100
 color in, 105
 exhibitions of, 2, 2n3, 51, 100
 New Orleans's reception of, 69, 71
 spread of to America, 2, 100–101
 tenets of, expressed in Crawford's notes, 99n3
 in wallpaper portraits, 105
Mondrian, Piet, 12
Monet, Claude, 3, 3n6
Montparnasse. *See* Paris, France
Montross Gallery, 51
Morel, Vera, 42, 48, 130n33
Morgan, Elemore Jr., 23, 25, 25n23
Morphy, Paul, 40, 40n7
Mound, The, xiii, *xiii,* 97, 146
Mural painting, 69. *See also* wallpaper portraits

N
Nahmias, Albert, 12
Nemours, Aurelie, 5
New Deal. *See* PWAP
New Orleans
 as art center of America, 48
 Crawford's home in. *See* 612 Royal Street
 Crawford's return to, 15
 French Market, 23, *23, 35*
 French Quarter, 18n4, 18n5, 19n9, 36, 39–40, 42, 44,
 45–46
 Governor Nicholls Street, 81, *81*
 introduction of Cubism to, 99
 maps of, *xvi,* 1
 reception of modern trends in art by, 45, 48, 69, 71, 83
 Royal Street, *19,* 19n9. *See also* specific addresses
 St. Peter Street, *xvi*
 Valentinien Grocery Store, *38*
New Orleans Museum of Art, 140. *See also* Delgado
 Museum of Art
New York City, 51, 76
Newcomb College, 28, 30, 59
Ninas, Jane, 59
Ninas, Paul, 5, *55,* 56, 59, 59n66, *74,* 76, 82, 99, 144

Nolan, Anita, 82
Norris, Edith, 82
Nymphéas (Monet), 3

O
O'Brien, Nell Pomeroy, 59
Ocean Springs Art Colony, 42
O'Keeffe, Georgia, 48, 48n36
Orgeat, 25n29
Outhouses (Opus I–VII), 124, 124n27, *127*

P
Paintings and Drawings by Representative Modern Masters
 (exhibition), 100
Paintings by Artists of the Deep South (exhibition), 73
Paris, France, 2–3, 10, 12, *12,* 13–14
Patio Royale, 40n7
Pennsylvania Academy of the Fine Arts, 100
Peret, Marcelle, 59
Petit Salon, Le, 40n2, 130, 130n33
Petit Théâtre du Vieux Carré, Le, 40
Philadelphia, Pennsylvania, 73
Picasso, Pablo, 7, 12, 99
Pirate's Alley, 54, *54, 55,* 56
Pitot, Genevieve, 46
Plantations, Bienvenu, 19–22, *21*
Poetry. *See* Crawford, Josephine (art)
Pont-Aven, France, and School, 113
Poppy (O'Keeffe), *xv,* 48, 48n36
Portrait de Femme (Lhote), *100*
Pradat, Mathilde, 33
Prendergast, Maurice, 74
Presbytère, 71, 71n76
Proust, Marcel, 12
Puig (family), 39, 88, 88n8
PWAP (Public Works of Art Project), 59–60, 59n69

Q
Quartier Club, 40, 40n2

R
Ramasseuses de coquillages, Les (*The Shellfish Gatherers*)
 (Bernard), 113
Rattner, Abraham, 12, 48, 81–82
Recipes, 94

Red Snappers on Ice (Crawford). *See* Crawford, Josephine (art): paintings
Redon, Odilon, 76
Religion, 25
Renoir, Pierre, 76
Rivera, Diego, 54, 54n52
Robb, James, 28, 28n42
Rockachaws, 90n11
Rotonde, La (café), 3n9, 10
Royal Street, *19*, 19n9. *See also* specific addresses
Rue Kerlerec (Crawford). *See* Crawford, Josephine (art): paintings

S
Salon d'Automne, 6
Salon des Indépendants, 6
Saxon, Lyle, 39, *39*, 51, 53, 88
Scott, Natalie, 56, 56n54
Second National Exhibition of American Art (exhibition), 76
Seguin, Armand, 113
Seldom Seen (exhibition), 138, 140
Sérusier, Paul, 113
Sessums, Davis, 25
Sheeler, Charles, 54
Sherwood Anderson and Other Famous Creoles (Spratling and Faulkner), 44
Ship Island, 94
Smith, Alice Ravenel Huger, 94
Smith, George, 90n14
Smith, Gertrude Roberts, 41, 51, 130n33
Société Anonyme, 101
Society of Independent Artists, 100–101
Souchon, Marion, 59
Southern States Art League, 44
Spratling, William, 44, 54, 54n53
St. Mart, Lucienne de, 51, 59
Staffel, Rudolf, *55*, 76, 81n25
Stanton, Gideon, 44n18, 51, 59
Stein, Gertrude, 71, 71n75
Stevens, Will Henry, 41, 51, 56, 76, 99, 101
Stieglitz, Alfred, 100, 100n8, 100n11

T
Terre-aux-Boeufs, 21
Thérèse (Crawford's nurse), 25–26
Thomson, Virgil, 71n75

Throwing the Net (Crawford). *See* Crawford, Josephine (art): paintings
Toklas, Alice B., 3, 71
Topographical Map of New Orleans and Surroundings (Hardee), *xvi*, 1
Toulouse Lautrec, Henri de, 76
Traité de la figure (*Figure Painting*) (Lhote), 6
Traité du paysage (*Landscape Painting*) (Lhote), 6
transition (magazine), 2
Turner, Helen, 130n33, 140
Tweety, Miss. *See* Crawford, Louise Harriet

V
Valentinien Grocery Store, *38*
Vieux Carré. *See* French Quarter

W
Wallpaper portraits, *viii*, 60, *61–68*, 69, 105, 133, *133*
Weber, Max, 54
Westfeldt, Ethel Jane, 113, *117*
Westfeldt, Francis (Coo), 113, *117*
Westfeldt, George, 40, 41n8, 44, 58, 76, 80
Westfeldt, George Jr. (Sunny), 113, *117*
Westfeldt, Martha Gasquet, 40, 41n8, 44, 46, 82, 113, 113n23
Westfeldt, Mettha. *See* Eshleman, Mettha Westfeldt
Whitney, Daniel, 42, 46, 48, 51, 59, 144
Whitney, Morgan, 88n9
Witherspoon, Evelyn, 58–59
Woeltz, Julius, *55*, 76
Women, exclusion of from art academies, 2n2
Wood, Albert Baldwin, 92n17
Wood, Ella, 130n33
Woodward, Ellsworth, 44n22, 56, 59, 76
World of Miss Josephine Crawford, The (exhibition), 133–134, 138
World War II, 81–82
Writers, in French Quarter, 42, 44

Y
Young Woman Wearing White Gloves (Crawford). *See* Crawford, Josephine (art): paintings

Z
Zorach, Marguerite, 54

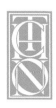

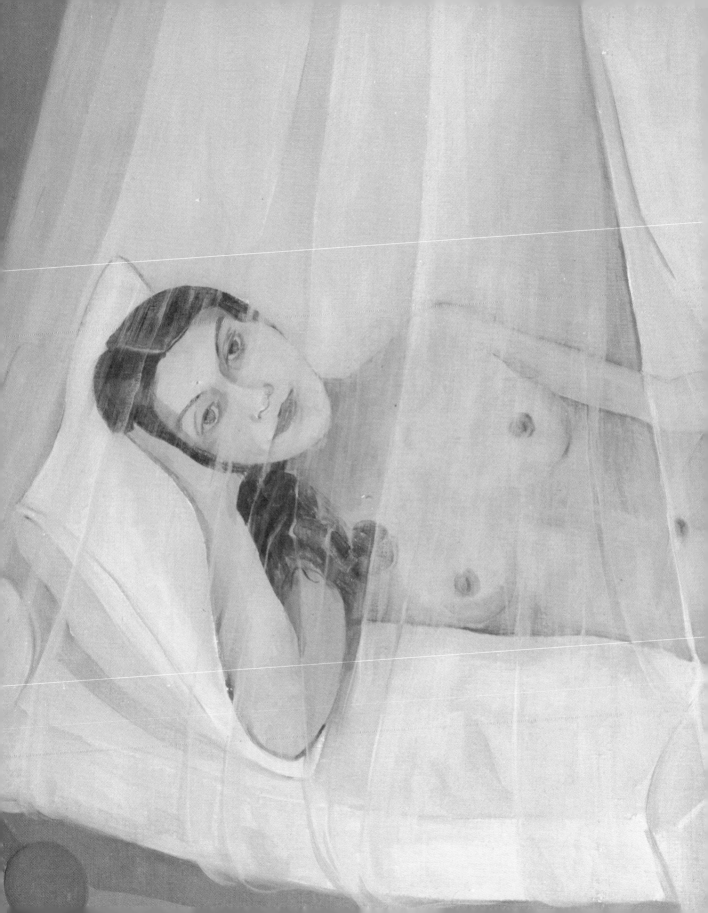